ALEX COLVILLE
DIARY OF A WAR ARTIST

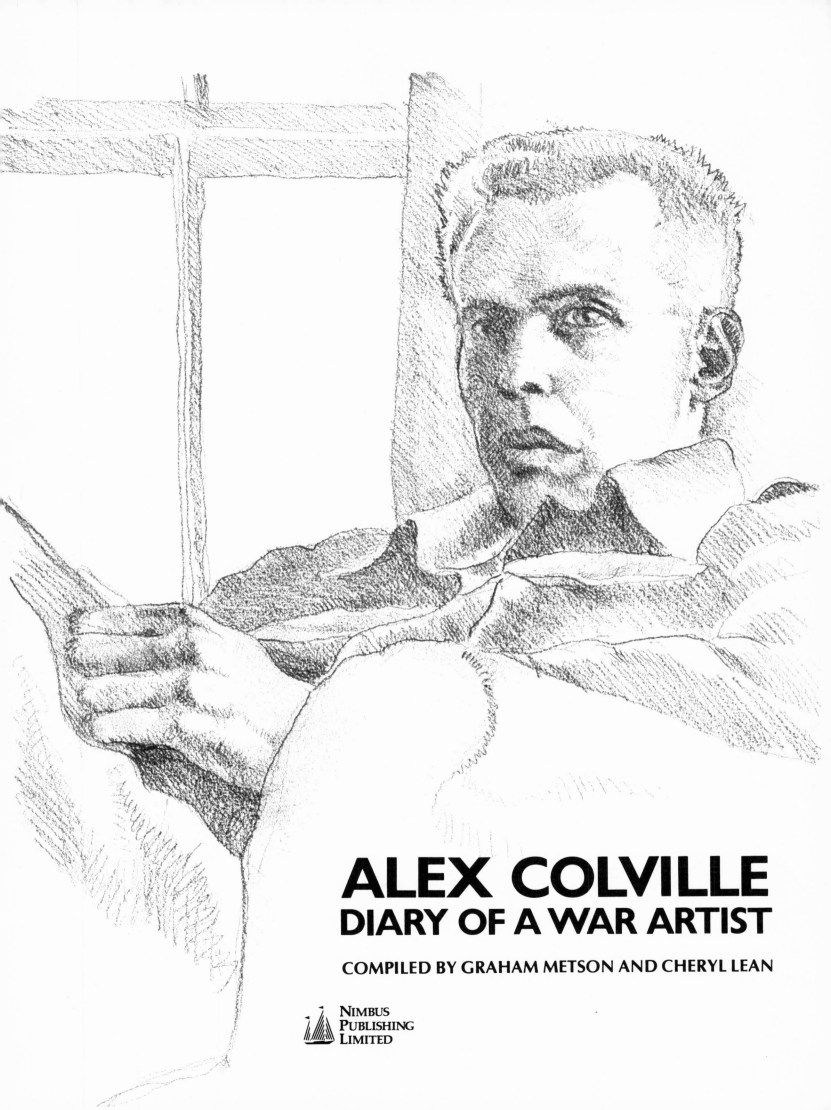

ALEX COLVILLE
DIARY OF A WAR ARTIST

COMPILED BY GRAHAM METSON AND CHERYL LEAN

NIMBUS
PUBLISHING
LIMITED

ALEX COLVILLE
DIARY OF A WAR ARTIST

Designed by L & M Associates
Typography by Steven Slipp
Typesetting by Earl Whynot & Associates Graphics Limited

Text set in Optima Light 10/12. Display type Gill Sans
Printed on Curtis Tweedweave 80 lb.
Printed and bound in Canada

Published by NIMBUS PUBLISHING LIMITED
 P.O. Box 9301
 Station A
 Halifax, Nova Scotia
 B3K 5N5

ISBN 0-920852-11-4

ACKNOWLEDGEMENTS

Acknowledgement is made to Canada Council Explorations Grant
Program. To L. H. Murray and the Canadian War Museum, National
Museum of Man, National Museums of Canada, for permission to
reproduce works from their collection. To Hugh Halliday, Curator of the
War Art, and to his staff. To Michael McKinnirey for permission to use
transcripts of an interview with Alex Colville from the National Film Board
film *Ashes of War*.
 The Road to Nijmegen from: THE COLLECTED POEMS OF EARLE BIRNEY by Earle
Birney. Reprinted by permission of the Canadian Publishers McClelland
and Stewart Limited, Toronto.
 This book is published with the kind assistance of the Canada Council and
the Nova Scotia Department of Culture, Recreation and Fitness.

All dimensions given are in inches. Numbers given at the end of captions
indicate acquisition numbers of the Canadian War Museum collection.

Sources of numbered quotations throughout text:

1 **Alex Colville,** National Film Board interview for the film *Ashes of War*

2 **Stanley Royle** ARCA, *My Attitude Toward Painting*. MARITIME ART, The
 Journal of the Maritime Art Association. February, 1941, Vol. 1 No. 3.

3 **Alex Colville** interview with Graham Metson, Wolfville, Nova Scotia,
 November, 1980.

4 **Alex Colville** interview with Hugh Halliday, Curator of Canadian War
 Art, The Canadian War Museum, Ottawa, 1980.

5 **Rhoda Colville** interview with Cheryl Lean, Wolfville, Nova Scotia,
 May 1981.

2945

Then came, at a predetermined moment, a moment in
 time and of time,
A moment not out of time, but in time, in what we call
 history transecting, bisecting the world of time, a
 moment in time but not like a moment of time,
A moment in time but time was made through that moment:
 for without the meaning there is no time, and
 that moment of time gave the meaning.

from Choruses from 'The Rock'
Selected Poems by T. S. Eliot
Faber and Faber, 1973

CATALOGUE OF WORKS

NOTE:
All dimensions given are in inches.
Numbers given at end of captions indicate acquisition numbers of the Canadian War Museum collection.

WORKS FROM THE COLLECTION OF THE CANADIAN WAR MUSEUM, OTTAWA

Convoy in Yorkshire No. 2 June 1944, Oils on canvas, 30 × 40, 12137
Mechanical Transport Park June 1944, Oils on canvas, 23 × 29, 12181
HMCS PRINCE HENRY in Corsica 1944, Oils on canvas, 30 × 40, 10198
Nijmegen Salient Dec. 1944, Oils on canvas, 30 × 40, 12188
Messerschmitt Jan. 1945, Oils on canvas, 24 × 32, 12184
Infantry, Near Nijmegen, Holland 1946, Oils on canvas, 40 × 48, 12172
Exhausted Prisoners 1946, Oils on canvas, 30 × 40, 12152
Eighty-Eight Feb. 1945, Oils on paper, 19× 26, 12149
Bodies in a Grave 1946, Oils on canvas, 30 × 40, 12122
Tragic Landscape 1945, Oils on canvas, 24 × 36, 12219
The Provost 24 Nov. 1944, Watercolour Drawing, 15 × 22, 12202
Improvised Stoves 2 June 1944, Watercolour Drawing, 15 × 18, 12169
Tank Transporters in Park 4 June 1944, Watercolour Drawing, 12⁷/₈ ×19³/₄, 12216
Tank Transporters Tractors 5 June 1944, Watercolour Drawing, 12¹/₄ × 12³/₄, 12215
The "Bullpen" 6 June 1944, Watercolour Drawing, 13 × 19, 12129
Field Kitchens 8 June 1944, Watercolour Drawing, 13⁷/₈ × 22, 12155
Convoy in Yorkshire 9 June 1944, Watercolour Drawing, 13³/₄ × 20³/₄, 12136
Parked Convoy 10 June 1944, Watercolour Drawing, 13 × 19¹/₂, 12194
Fitters 'Break' Period Oil on canvas, 24 × 29³/₄, 12156
MT Workshop Watercolour Drawing, 21¹/₈ × 27³/₄, 12186
Noon Hour Break June 1944, Watercolour Drawing, 15¹/₄ × 22¹/₂, 12190
HMCS PRINCE DAVID in Barry, Wales 23 July 1944, Watercolour Drawing, 15¹/₄ × 22¹/₂, 10191
In the Bay of Biscay 26 July 1944, Watercolour Drawing, 12⁷/₈ × 20⁵/₈, 10191
Ratings Look at Gibraltar 28 July 1944, Watercolour Drawing, 12¹/₄ × 19¹/₂, 10199
Misty Morning in Naples 1 Aug. 1944, Watercolour Drawing, 15 × 22⁵/₈, 10194
A Night Exercise 3 Aug. 1944, Watercolour Drawing, 11³/₄ × 15³/₈, 10195
The Deploy 4 Aug. 1944, Watercolour Drawing, 12¹/₄ × 19³/₄, 10188
American Destroyers in Naples 6 Aug. 1944, Watercolour Drawing, 15 × 22¹/₂, 10187
HMCS PRINCE HENRY Re-Fueling in Corsica 16 Aug. 1944, Watercolour Drawing, 15 × 22, 12167
A German Flare Goes Up 21 Aug. 1944, Watercolour Drawing, 14 × 22, 10189
Painting the Ship 29 Aug. 1944, Watercolour Drawing, 22¹/₂ × 15¹/₄, 10196
A Loaded L.C.M. 11 Aug. 1944, Watercolour Drawing, 15¹/₂ × 15¹/₂, 10193
The Remains of a Fortified Town 12-15 Nov. 1944, Watercolour Drawing, 15¹/₂ × 22¹/₂, 12205
Canadian Troopers Guarding the Nijmegen Bridge 20-22 Nov. 1944, Watercolour Drawing, 14 × 21¹/₄, 12131
The Watch on the Dyke Nov. 1944, Watercolour Drawing, 15¹/₂ ×22¹/₂, 12220
Nijmegen Bridge — Late Afternoon 15 Nov. 1944, Watercolour Drawing, 12⁵/₈ × 18¹/₄, 13134
The Nijmegen Bridge, Holland Oil on canvas, 36 × 18¹/₄, 12187
Carriers in a Wood 2 Dec. 1944, Watercolour Drawing, 14¹/₄ × 18⁷/₈, 12132
The River Waal in Flood Dec. 1944, Watercolour Drawing, 15¹/₂ × 22³/₄, 12206
Field Guns in the Snow 9 Dec. 1944, Watercolour Drawing, 15¹/₄ × 22³/₄, 12154
Platoon Positions in an Orchard 10 Dec. 1944, Watercolour Drawing, 15¹/₄ × 22¹/₂, 12196
Derelict Gliders of an American Airborne Division 15 Dec. 1944, Watercolour Drawing, 15 × 22, 12146
A German Gun in Fog, Holland 19 Dec. 1944, Watercolour Drawing, 22³/₄ × 15⁵/₈, 12163
Anti-Aircraft Gun Near Nijmegen Bridge 20 Dec. 1944, Watercolour Drawing, 15¹/₂ × 22³/₄, 12113
The Machine Gun, Germany Dec. 1944, Watercolour Drawing, 15¹/₂ × 22³/₄, 12179
Parachutes in No-Man's-Land, Holland 17-30 Dec. 1944, Watercolour Drawing, 15¹/₂ × 22³/₈, 12193
A Machine Gun Position in Germany 21 Dec. 1944, Watercolour Drawing, 15³/₈ × 22³/₈, 12180
Frost on an Aircraft 25 Dec. 1944, Watercolour Drawing, 15⁵/₈ × 22, 12162
Frost in a Wrecked Town 27 Dec. 1944, Watercolour Drawing, 22¹/₈ × 15³/₈, 12161
A Road Block in Germany 28 Dec. 1944, Watercolour Drawing, 10 × 14, 12208
Flak Over the Nijmegen Bridge 31 Dec. 1944, Watercolour Drawing, 15¹/₂ × 22, 12158
Me. 109 In the Snow, Holland 11 Jan. 1945, Watercolour Drawing, 14 × 20, 12183
The Raider Jan. 1945, Watercolour Drawing, 13¹/₂ × 22¹/₄, 12203
A Littered Dugout, Holland 6 Jan. 1945, Watercolour Drawing, 15³/₄ × 22¹/₂, 12176
Dugout Near Nijmegen 7-9 Jan.1945, Watercolour Drawing, 15³/₈ × 22¹/₂, 12148
The Barrier, Holland 10 Jan. 1945, Watercolour Drawing, 22 × 18, 12117
The Steps — A Dugout in Germany 13 Jan. 1945, Watercolour Drawing, 22¹/₄ × 15¹/₂, 12211
Tanks in Harbour, Holland 18 Jan. 1945, Watercolour Drawing, 15 × 21, 12217
The Pine Grove, Holland 19 Jan. 1945, Watercolour Drawing, 13¹/₄ × 21¹/₂, 12195
A Canadian Medium Gun Watercolour Drawing, 15¹/₂ × 22¹/₄, 12182
The Plotting Table 22-24 Jan. 1945, Watercolour Drawing, 15¹/₂ × 22¹/₂, 12197
London Bridge 31 Jan.-2 Feb. 1945, Watercolour Drawing, 15¹/₄ × 22³/₈, 12177
Troops of the 3rd Canadian Infantry Near Nijmegen, Holland 2 Feb. 1945, Watercolour Drawing, 11¹/₄ × 15¹/₄, 12191
Tanks in a Workshop 5 Feb. 1945, Watercolour Drawing, 15¹/₂ × 22¹/₂, 12218
Armoured Cars in Nijmegen 3-4 Feb. 1945, Watercolour Drawing, 15¹/₄ × 22¹/₂, 12114
Shattered Landscape, Cleve 9 Feb. 1945, Watercolour Drawing, 22¹/₂ × 15¹/₄, 12209
Dead City 24 Feb.-2 Mar. 1945, Watercolour Drawing, 15¹/₄ × 22³/₄, 12139
A Street on the Forward Defence Line in Germany 3 Feb. 1945, Watercolour Drawing, 14 × 20, 12212
Wrecked German Self-Propelled Gun Watercolour Drawing, 15 ³/₈ × 22³/₈, 12222
Abandoned Munitions 6-7 Feb. 1945, Watercolour Drawing, 12³/₄ × 19, 12112
Before Zero Hour 8 Feb. 1945, Watercolour Drawing, 14³/₄ × 21, 12120
A Flooded German Road 9 Feb. 1945, Watercolour Drawing, 10 × 14, 12159
The Broken Dam 10-13 Feb. 1945, Watercolour Drawing, 15¹/₂ × 22³/₄, 12127
The Beach Area, Holland 10-11 Feb. 1945, Watercolour Drawing, 14 × 20, 12118
The Church in Wyler, Germany 12-13 Feb. 1945, Watercolour Drawing, 10 × 14, 12135
Wrecked Artillery Bug 14 Feb. 1945, Watercolour Drawing, 9¹/₂ × 13⁷/₈, 12221
A Dead Civilian in a Prison Yard at Cleve, Germany 15 Feb. 1945, Watercolour Drawing, 14 × 20, 12140

A Gun of the 3rd Canadian Division by a Hedge in Bedburg 23 Feb. 1945, Watercolour Drawing, 10 × 14, 12165
Bodies on a Road 23 Feb. 1945, Watercolour Drawing, 10¹/₄ × 14, 12124
Before an Attack 2-3 Mar. 1945, Watercolour Drawing, 12 × 19, 12119
Panther Tank Near Sonsbeck, Germany 7 Mar. 1945, Watercolour Drawing, 10 × 14¹/₄, 12192
Farmyard, Germany 9 Mar. 1945, Watercolour Drawing, 15³/₈ × 22¹/₄, 12153
Destroyed Vehicles Near Xanten, Germany 10 Mar. 1945, Watercolour Drawing, 15¹/₂ × 22³/₈, 12147
Church in Cleve, Germany 21 Mar. 1945, Watercolour Drawing, 15³/₈ × 22¹/₂, 12134
Grave of a Canadian Trooper 22 Mar. 1945, Watercolour Drawing, 14¹/₂ × 20⁵/₈, 12164
Railway Station at Labbeck, Germany 23 Mar. 1945, Watercolour Drawing, 15¹/₂ × 22¹/₂, 12204
Buffaloes Beside the Rhine 24 Mar. 1945, Watercolour Drawing, 13¹/₄ × 21, 12128
On the Rhine — Germany 25 Mar. 1945, Watercolour Drawing, 14 × 22¹/₄, 12191
Scotia Highlanders Resting, Near Emmerich, Germany 30 Mar. 1945, Watercolour Drawing, 10 × 14¹/₄, 12173
Demolished Bridge, Germany 30 Mar. 1945, Watercolour Drawing 14 × 20, 12144
Prisoner of War Cage 31 Mar. 1945, Watercolour Drawing, 15¹/₂ × 22¹/₂, 12200
A Newly Liberated Street at Zutphen, Holland 7 Apr. 1945, Watercolour Drawing, 11¹/₂ × 15⁵/₈, 12175
Dead Paratrooper Near Deventer, Holland 11 Apr. 1945, Watercolour Drawing, 14 × 20, 12142
The Highland Light Infantry of Canada Advancing Toward Wesel Watercolour Drawing, 15³/₈ × 22¹/₂, 12171
Prisoners Taken by "B" Company of the Queen's Own Rifles of Canada 18 Apr. 1945, Watercolour Drawing, 12¹/₄ × 20⁵/₈, 12199
Germans at a Telephone Station, Holland 20 Apr. 1945, Watercolour Drawing, 15¹/₂ × 22⁷/₈, 12210
Belsen Concentration Camp 30 Apr. 1945, Watercolour Drawing, 15³/₈ × 22¹/₂, 12121
At a Captured Airport 4 May 1945, Watercolour Drawing, 15¹/₂ × 22³/₈, 12115
Breakfast in Germany May 1945, Watercolour Drawing, 14 × 20, 12125
Casualty Clearing Post 27 May 1945, Watercolour Drawing, 12⁵/₈ × 20, 12133
Prisoners Taken by the 3rd Canadian Infantry Division 21-23 Feb. 1945, ink and pencil on paper, 15 × 22, 12201
Young Prisoner Near Udem, Germany 5 Mar. 1945, pen and ink and watercolour on paper, 20¹/₂ × 13, 12223
Dead Horse 7 Mar. 1945, coloured pencil, 10 × 14, 12141
Cross Roads in Udem, Germany 8 Mar. 1945, coloured pencil, 15 × 22¹/₂, 12138
Burned Vehicles 9 Mar. 1945, coloured pencil, 10 × 14, 12130
Awaiting Orders 23 April 1945, Pencil, 12³/₄ × 19¹/₂, 12116
Road Accident 4 June 1945, Ink and Coloured Pencil, 10¹/₄ × 14¹/₈, 12207
Dead Women — Belsen 29 Apr. 1945, pencil on paper, 12 × 19, 12143
Sketch — Bodies in a Grave Belsen, Germany 1 May 1945, pencil on paper, 12 × 19¹/₂, 12123
Street in Utrecht, Holland pen and ink and wash on paper, 15 × 22, 12213

WORKS FROM THE COLLECTION OF ALEX COLVILLE

Self Portrait 1944, pencil on watercolour paper, 12 × 14, Coll. Alex Colville
Portrait pencil on paper, 10 × 7¹/₂, Coll. Alex Colville
Portrait pencil on paper, 10 × 7¹/₂, Coll. Alex Colville
The Artist's Hand 1945, pencil on buff paper, 10 × 8, Coll. Alex Colville
Sketch for Nijmegen Bridge pencil & inkwash on paper, 9 × 12, Coll. Alex Colville
Mechanic Repairing Underside of Truck 20 June 1944, pencil on paper, 13 × 10, Coll. Alex Colville
Two Lorries 10 June 1944, pencil on paper, 10 × 13, Coll. Alex Colville
Sketches at Levin, Yorkshire 6 June 1944, pencil on paper, 10 × 7¹/₂, Coll. Alex Colville
Landscape, Yorkshire 9 June 1944, pencil on paper, 10 × 7¹/₂, Coll. Alex Colville
Sketch for "Parked Convoy" 9 June 1944, pencil on paper, 7¹/₂ × 10, Coll. Alex Colville
Tank Transporter 3 June 1944, pencil on paper, 10 × 13¹/₂, Coll. Alex Colville
Motorcycle Instructor 12 June 1944, pencil heightened with white on paper, 20¹/₂ × 15, 12185
Wet Morning Watercolour Drawing, 15 × 16¹/₂, Coll. Alex Colville
Men Resting Watercolour Drawing, 14 × 20, Coll. Alex Colville
43rd Battery "E" Troop #1 Gun 12th Field Regiment 4 Dec. 1945, Watercolour Drawing, 9 × 11, Coll. Alex Colville
Commandoes in L.C.M. 9 Aug. 1944, Watercolour Drawing, 19 × 12, (A watercolour nocturne) Coll. Alex Colville
Sketch of Gun 24 July 1944, pen and pencil, 10 × 8¹/₂, Coll. Alex Colville
Sailor Sunbathing on Deck of PRINCE DAVID in Gibraltar 28 July 1944, pencil on paper, 8 × 5¹/₂, Coll. Alex Colville
Sailor Reading a Newspaper on Foc'sl. 30 July 1944, pen and ink on paper, 7¹/₂ × 8¹/₂, Coll. Alex Colville
Commandoes in Dinghies 3 Aug. 1944, pencil on paper, 10 × 8¹/₂, Coll. Alex Colville
Sailors Aug. 1944, pencil on paper, 10 × 8¹/₂, Coll. Alex Colville
Sketch for "Night Exercise" Aug. 1944, pencil on paper, 8¹/₂ × 10, Coll. Alex Colville
Preparing to Go Aug. 1944, pencil on paper, 8¹/₂ × 10, Coll. Alex Colville
Sketch of L.C.A. 4 Aug. 1944, pen and sepia ink on paper, 14 × 10, Coll. Alex Colville
Sketches of Commandoes & Ships 7 Aug. 1944, pencil on paper, 14 × 10, Coll. Alex Colville
H.M.S. DIDO 13 Aug. 1944, pen and ink wash on paper, 10 × 12¹/₂, Coll. Alex Colville
Sketch of Harbour, Ajaccio 26 Aug. 1944, pencil (2 sheets) on paper, 2 × 5¹/₂ × 8, Coll. Alex Colville
Survey Beacon pencil, 9 × 11¹/₂, Coll. Alex Colville
Sketch for Nijmegen Bridge 15 Nov. 1944, pen and ink on paper, 9 × 11, Coll. Alex Colville
Costburg 3 Nov. 1944, pen and ink on paper, 9 × 11, Coll. Alex Colville
Nijmegen-A Sqn. 7 Recce Regt. Daimler 16 Nov. 1944, pencil on paper, 9 × 11, Coll. Alex Colville
Sketch for Parachutes in No-Man's-Land pencil on paper, 9 × 11, Coll. Alex Colville
Portrait Study (Dugout Near Nijmegen) Jan. 1945, pencil on paper, 9 × 11, Coll. Alex Colville
Sketch of Soldier 8 Nov. 1944, Pencil, 10 × 7
Sketch of Motorcyclist Pencil, 11³/₈ × 8³/₄
Heavy Regt. R.A. AGRA 12 April 1945, Pen and Ink, 11³/₈ × 8³/₄
Sketch of Tanks and Landscape Pen and Ink, 11³/₈ × 8³/₄
Sketch of Soldiers 25 April 1945, Pencil, 11³/₈ × 8³/₄
Ink Sketches of Couples April 1945, Pen and Ink, 11³/₈ × 8³/₄
Utrecht 23 May 1945, Pen and Ink, 11³/₈ × 8³/₄
Landscape with Nijmegen Bridge 30 May 1945, Pen and Ink, 11³/₈ × 8³/₄
Sketch of Canal Boat 31 May 1945, Pen and Ink, 11³/₈ × 8³/₄
Sketch of Barges 30 May 1945, Pen and Ink, 11³/₈ × 8³/₄

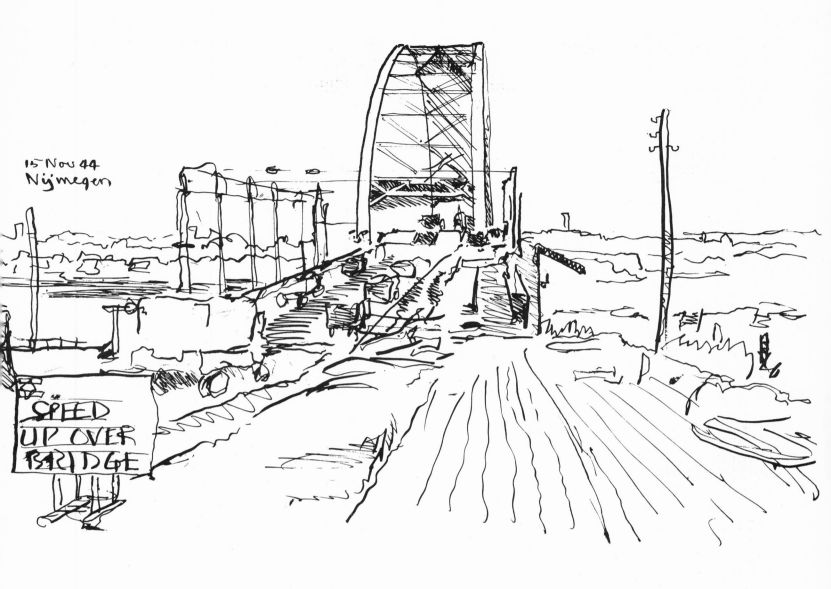

15 Nov 44
Nijmegen

SPEED
UP OVER
BRIDGE

CONTENTS

Catalogue of works

FOREWORD

by Moncrieff Williamson C.M.LI.D., F.R.S.A., F.C.M.A.
Director, Confederation Art Gallery and Museum,
Charlottetown, Prince Edward Island

War, the most crippling of mankind's negative endeavours, has its own macabre imagery captured for perpetuity by official war artists, surely now an endangered species. Tomorrow we face nuclear holocaust. There will be no opportunity for a careful selection of pencils, choice of brushes, or search for watercolour paper and oil sketching materials. Personal decision as to selection of subject matter, impossible.

It was Lord Beaverbrook who arranged, in 1917, through the establishment of the Canadian War Memorials Committee, the commissioning of Canadian artists to record Canadian participation in battle. In Britain there was already established a war artists' group comprising such artists as Orpen, Wilkinson, Nevinson and Lavery, to be followed in World War II by other distinguished painters like Paul Nash, Graham Sutherland and John Piper. These works were deposited eventually in the old Imperial War Museum, London, and in Canada, first in the National Gallery, but later, transferred to the curatorial custody of the Canadian War Museum in Ottawa. It is there that we find the magnificent range of drawings and paintings by Alex Colville. It is a rich inheritance, a kaleidoscopic record of historical incidents, a panorama of individual response and interpretation.

What matters, of course, is the final image. To read Alex Colville's notes, diary jottings and war report is to learn, at first-hand, the problems encountered, in the awesome responsibility thus placed upon a sensitive individual. He is a man indifferent to personal danger. His writings are clear-cut, sharp, almost impersonal. His war sketches, like his writings, reflect neither sentimentality nor histrionics. His amazing technical control and skill enable him to transport us and immediately we understand what he is showing us: endurance, comradeship, individuality, bewilderment, waste, loss and abiding courage.

What we value in Alex Colville is the immensity of the man's vision, which pervades the mysticism. His cool, supra-realism, with its sensual undercurrents, guides us beyond fearsome boundaries.

In these war drawings and paintings, we can see a man of integrity deeply moved by the shattered world, his awareness of apocalyptic shadows, and the necessity of countering evil by true Faith.

9

INTRODUCTION

by Hugh A. Halliday
Curator of War Art
Canadian War Museum
National Museum of Man
National Museums of Canada

The works by David Alexander Colville that are included in the War Art Collections of the Canadian War Museum are a record of that painter's wartime work as an Official War Artist. As such, they are also part of the general history of Canadian art insofar as it has influenced or been affected by Colville. They form part of another record as well — that of Canadian military activity in the Second World War. Such, indeed, are the War Art Collections as a whole, being records of historical events (the military subjects portrayed) and of cultural developments (the trends and developments in art during the period of their execution).

Colville was one of many artists who have contributed to this collection; as an Official War Artist he was also part of a tradition extending back to the beginnings of recorded history. War and art have accompanied one another for centuries. This may surprise those who consider the two as being mutually exclusive. War, we often presume, is purely destructive, sweeping away lives, societies, and art itself. Art, on the other hand, is generally considered to be an expression of man's creative impulses, the very antithesis of military sentiments.

Paradoxically, warfare can give rein to creative as well as destructive tendencies. Technological advances have been accelerated by armed conflicts, in fields as diverse as medicine and explosives. Some societies have collapsed under the strains of warfare; others have been tempered and strengthened. Amid the horror and mutual murder campaigns that constitute Northern Ireland's "troubles", we find the suicide rate declining in that unhappy province. None of this justifies the institutional violence that constitutes war, but it does indicate that war is more complex than is often assumed, and the complications extend to art in war.

War has been a subject for artists of many civilizations. Ancient Egyptian tombs and temples contained elaborate paintings memorializing the military triumphs of various pharaohs. Assyrian temples and public buildings were rich with art work, painted and sculpted, that illustrated in detail the brutality of warfare in the area of Mesopotamia. Greek and Roman feats of arms were commemorated by their artists. Indeed, some works inspired modern imitations; the Arc de Triomphe (Paris, 1806-1836) and the Wellington Arch (London, 1846) were based upon Roman triumphal arches, while the Emperor Trajan's victory column in Rome became the basis for a column in the Place Vendôme, Paris, commemorating Napoleon Bonaparte's martial successes. Although religious subjects dominated mediaeval art, the Bayeux Tapestry is but one example (albeit the most famous) of war art in that period, presenting the Norman conquest of England in roughly seventy metres of embroidery.

The Renaissance was a revolutionary era. Not only did it revive Europe's interest in art, but it led to greater emphasis upon secular activities, including warfare. The

increased interest in military paintings did not necessarily mean accuracy or realism in those paintings. To satisfy their patrons, artists frequently depicted military leaders in classical rather than contemporary dress. Even when period costumes were shown, "battle" paintings often featured groups of senior officers mounted on horseback in the foreground, with the battle itself relegated to the distant background, like a theatre spectacle arranged for the aristocratic equestrians. Benjamin West's *The Death of Wolfe* was considered to be a radical work because the artist depicted all the principals in the uniforms in 1759, although it was historically inaccurate in other respects, notably by including officers who were not present when Wolfe died, and placing an Indian in the British camp. These shortcomings were minor, however, compared with a work by Louis-Joseph Watteau, depicting the death of Montcalm in a setting that in no way resembled either the place or circumstances in which that officer expired.

Not all artistic renderings of military subjects were so detached or unrealistic. Diego Velazquez, Jacques Callot, Francisco Goya, and Vasili Vereshchagin were examples of famous artists who captured the drama and terror of warfare. In part this was due to more direct military experiences by the painters; Vereshchagin, for example, had been wounded and his brother had been killed during the Russo-Turkish war of 1877-78.

War art was not monopolized by the painters of the day. During the 18th and 19th centuries many professional officers of European armies were trained in sketching. Such skills enabled them to access and record the military aspects and potential of various areas. Their work dealt mainly with landscapes, camps, and fortifications, rather than with combat. Occasionally, however, they turned their attention to battle scenes, although the results seldom captured the drama of bombardments and action at close quarters. Major Thomas Davies, for example, turned out hundreds of drawings and watercolours based on his service in Canada at intervals from 1757 through to 1790. Most could be classified as landscapes, but he also produced a few bloodless views of events — the siege of Louisbourg, the burning of an Acadian village, a naval skirmish on the St. Lawrence River, and the descent of that river by troops under General Amherst in 1760. Captain Lord Charles Beauclerk participated in the campaign to suppress the *Patriote* rebellion in Lower Canada in 1837; he subsequently produced six dramatic views of troop movements, the Battle of St. Charles, and the Battle of St. Eustache.

Another form of war art developed during the 19th century in response to the appearance of mass-circulation newspapers. These hired "special artists" to provide illustrations for the news stories. Warfare was always "good copy", and the age was filled with major and minor European wars, revolutions, and colonial campaigns to be

followed, described, and depicted. The "special artists" were a remarkable group of specialists. Sometimes they travelled in great luxury; at other times they shared the hardships of the fighting men. Canadian history provided little scope for their skills, although the North West Rebellion of 1885 gave birth to the short-lived *Canadian Pictorial and Illustrated War News* which provided lavish coverage of events in Western Canada.

Art and warfare became more intimately related in the 20th century. The First World War — a conflict so massive that some described it as "a war to end wars" — was the first example of "total war", in which the belligerents harnessed all their resources to the sole end of pursuing victory. Manpower was mobilized to an unprecedented degree through recruiting drives and national conscription. Women poured into industry and agriculture, performing tasks that hitherto had been assigned to men. Consumer goods were rationed while production centred upon military supplies. National finances were harnessed to the war effort through bond sales, government borrowing, and taxation. In Canada the income tax was introduced in 1916, as a "temporary wartime measure".

Given the totality of modern warfare, it was not surprising that art itself would be mobilized as part of the national effort. In both the First and Second World Wars artists and their work became as much a part of military activity as medicine, science, or industry. The most obvious field in which artists could operate was that of propaganda. Posters in every warring country urged people to do things (enlist, buy bonds, save scrap metal) or refrain from certain acts (gossiping, unnecessary travel), all in aid of the war effort. Other posters supported the national cause, or attacked the moral basis of the opposing cause. Some were crudely designed; others demonstrated imagination and artistry.

Propaganda aside, the potential employment of artists was not generally recognized by authorities. In 1916, however, British officials assigned Muirhead Bone to sketch and paint scenes in France. His drawings accurately recorded conditions as he saw them. They were admired not only in Britain but also on the enemy side. Bone became the first Official War Artist; his works were reproduced widely through service newspapers and books. Others followed, while Canada and Australia organized their own schemes for employing artists.

Sir Max Aitken (later Lord Beaverbrook) was the moving force behind the establishment of a Canadian war art programme. An ardent Imperialist and a Canadian nationalist, Aitken sought to publicize the achievements of the Canadian Expeditionary Force, to be appreciated in Canada itself and among the Allies. He founded a newspaper for the troops, published a three-volume account of the CEF, instituted a still-photography programme, and sent ciné-photographers to the front.

Officially he was in charge of the Canadian War Records Office, responsible for unit diaries, historical documents, and narratives. From this grew his War Memorials Fund, simultaneously advertising Canadian achievements and collecting monies to establish a memorial commemorating the national effort. In 1917 the Fund undertook promotion of an art scheme, relying first on British painters, but soon joined by Canadian artists. An energetic organizer, Aitken knew little about art, but this deficiency was made good by advice from Paul Konody (art critic for the *Observer*), Ernest Fosbery (who brought several Canadian artists to Aitken's attention), and Sir Edmund Walker (Chairman of the Board of Trustees, National Gallery of Canada, who virtually ran the programme in Canada). The result was the Canadian War Memorials Collection — some 850 works ranging from pencil sketches to massive oils on canvas. These were brought to Canada in 1919-20 and turned over to the National Gallery.

Aitken had intended that a special gallery be built to house the collection and serve as a war memorial, an idea not unlike the concepts behind the Australian War Memorial and the Imperial War Museum. Yet the gallery was never begun, probably because construction funds were being directed to rebuilding the Centre Block of the Parliament Buildings which had burned in 1916; the new Centre Block would incorporate a war memorial in the form of the Peace Tower. The National Gallery, as custodian of the collection, preserved and occasionally exhibited the war paintings while hoping for a new building of its own — again, a wish that went unfulfilled.

With the outbreak of the Second World War, Britain launched another war art programme, the first fruits of which were shown at the Museum of Modern Art, New York, in 1941. On that occasion the exhibition, *Britain at War,* included fifteen major works on loan from the Canadian War Memorials Collection. The National Gallery of Canada directed several artists towards war-related subjects, while the art community pressed for the establishment of a war art programme similar to that undertaken in 1917; newspapers and military historians supported these requests. Nevertheless, it was not until January 1943 that the Dominion government authorized a scheme for the employment of Official War Artists. The efforts of the National Gallery, combined with that of the military painters, resulted in the assembly of the Canadian War Records Collection, some 5,000 works in all, which subsequently joined the War Memorials Collection as part of the nation's artistic and military heritage. Among those eventually contributing to the collection was David Alexander Colville.

Two committees — one in Canada and one in the United Kingdom — administered the Canadian War Records programme. Representatives of the RCAF, Canadian Army, and RCN Historical Sections sat on both. Civilian

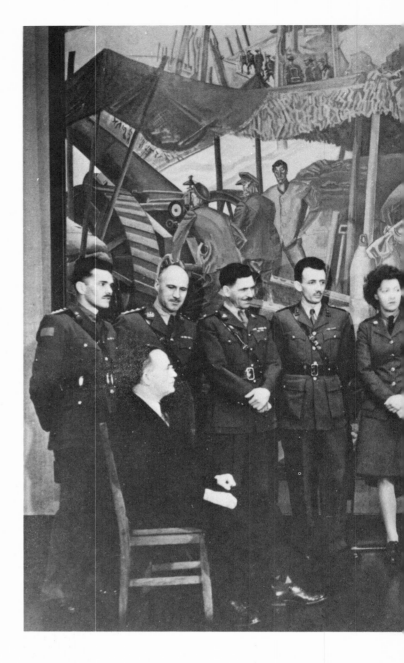

advice was provided by H.O. McCurry (Director, National Gallery of Canada), A. Y. Jackson (formerly a contributor to the War Memorials Collection), Charles Comfort (a professor of art at the University of Toronto, and one of the first war artists selected by the army), and the Honourable Vincent Massey (Canadian High Commissioner to Great Britain). Official War Artists held commissions as officers; they wore the same uniforms as their counterparts in other trades and drew the same pay. Although not combatants, they shared many hazards with other servicemen — torpedos at sea, German air raids, V-1 buzz bombs, V-2 rockets, artillery shells in rear areas — together with the routine discomforts of service life in wartime.

The artists themselves represented a cross section of the Canadian art community. Some had been well established

Canadian War Artists, 1946, with the Director of the National Gallery, H. O. McCurry, and the painter A. Y. Jackson sitting in front of a row of artists: from left to right: Orville Fisher, George Pepper, Will Ogilvie, Edward J. Hughes, Molly Lamb Bobak, Charles Comfort (later Director of the National Gallery), George F. G. Stanley (the historian), Alex Colville, Campbell Tinning and Bruno Bobak. Behind them is *A Canadian Gun Pit* painted by Wyndham Lewis in the First World War (and a part of the War Collections that has not been transferred from the National Gallery).
 Original belongs to Dr. R.H. Hubbard.
 Copy-negative by the National Gallery of Canada, Ottawa.

before the war; others had shown promise and were chosen on that account; a few were virtually discovered by the armed forces. Among those whose pre-war background included notable artistic credentials were Charles Comfort, Donald MacKay (a naval reserve officer and Vice Principal

of the Nova Scotia College of Art in 1939), Carl Schaefer (winner of a 1940 Guggenheim fellowship), and Will Ogilvie (Director of the School of Art, Art Association of Montreal). They came to their duties by different ways. Some were plucked directly from civilian life to be Official War Artists; such was the case with Comfort, Schaefer, and others. A few had enlisted or gained commissions in the forces with a view to seeing action. Robert Hyndman and Miller Gore Brittain flew operational tours as a fighter pilot and bomb aimer respectively before being selected as Official War Artists for the RCAF; Charles Anthony Law alternated between painting duties and action at sea aboard motor torpedo boats; Bruno Jacob Bobak had been trained as a sapper with the Royal Canadian Engineers and was switched to painting only weeks before the Allied invasion of Normandy. Still others, having enlisted in the forces, came indirectly to their final tasks. Eric Aldwinckle, who started as a poster designer, enlisted in the RCAF and was assigned camouflage duties before being selected as an Official War Artist. Rowley Murphy had been a camouflage officer with the RCN before the establishment of the War Records programme. As a non-commissioned officer in the RCAF, Paul Goranson worked as a service artist in Canada; when the official art scheme was launched he accepted a commission and went overseas. The experiences of these and other artists varied as much as their selection of subjects and professional techniques.

Functioning as part of the services' historical programmes, the artists operated with considerable freedom. Normally they were sent to a particular school, unit, or operational area to obtain coverage of whatever activity was in progress. Having arrived, they chose their subjects and the approach to be taken in depicting the activity. Formal guidelines had been considered by authorities when the scheme was inaugurated, but these were never applied. Lawren Phillips Harris, feeling that he was painting for the paymaster, adopted a highly realistic technique that differed markedly from his prewar and postwar work. Nevertheless, "high realism" was not dictated by senior officers, and some artists (notably Jack Nichols) employed very distinctive impressionist methods.

Some works were vivid, dramatic renderings of battle scenes — Charles Comfort's *Dieppe Raid* and *Casa Berardi* (the latter depicting the action in which Captain Paul Triquet won the Victoria Cross), Miller Brittain's *Night Target, Germany,* Orville Fisher's *D Day — The Assault* and *Stormont, Dundas, and Glengarry Highlanders,* Jack Nichols' *Infantry in LSI Under Bombing Attack,* Harold Beament's *HMCS ASSINIBOINE* vs. *U-Boat U-210,* to list but a few. Many more were simply the scenes of war — of men training, or moving towards battle, or performing routine tasks, or simply killing time, proof of the statement that war is "a period of great boredom, interspersed with moments of great excitement". Still others showed the aftermath of

war, from rotting corpses (Comfort's *Dead German on the Hitler Line),* to mutilated faces (a whole series of sketches executed by Charles Goldhamer at the Queen Victoria Hospital, East Grinstead, which dealt with plastic surgery cases), to shattered buildings, and ultimately the horror of the concentration camps (these last being handled by Donald Kenneth Anderson, Aba Bayefsky, and Colville himself). Back in Canada other artists captured the lonely isolation of radar posts (Albert Cloutier), the intensity of training (Fisher's extensive treatment of infantry exercises on the Pacific coast), the occasional dramatic moment (*German Prisoners Leaving Their U-Boat, Bay Bulls, Newfoundland* by Tom Wood), and the final winding down on Canada's war machine (C. A. Law's series of paintings dealing with the decommissioning of corvettes). Mixed through the works were portraits of generals, junior officers, private soldiers, nursing sisters, clerks, technicians, and even fellow-artists.

As a collection these works showed a remarkable lack of rhetoric; they neither glorified nor denigrated the war and Canadian participation in it. They achieved great impact by their honest approach to the subject. Colville's work would be only one example of this — *Painting the Ship, Infantry Near Nijmegen, Dugout Near Nijmegen, The Watch on the Dyke* dealt frankly with tasks that mixed boredom with occasional dangers. His *Tragic Landscape* — death in a pastoral setting — would show the paradox of war, and would be no less moving for the fact that the corpse was that of a German paratrooper. *Bodies in a Grave,* one of his Belsen works, would demonstrate the justification of this war, to eradicate such a perverted tyranny.

The reception of war artists by other servicemen was marked by interest, warmth, and co-operation. Colville has stated that troops who had difficulty in articulating their experiences and emotions through letters home seemed to regard him as someone who would, through his paintings, convey much on their behalf to those in Canada, and to succeeding generations. Diaries of operational units frequently mentioned the visits by artists in tones reflecting this feeling. Albert Cloutier spent two months in a remote radar station on the Labrador coast; when he left the unit diarist wrote, "Flying Officer Cloutier has done a fine job here and has taken away a very thorough record both in paintings and photographs. He has proved very good

company for the officers and men here." In 1943 Charles Comfort and Will Ogilvie exhibited fifty-four works at Campobasso, Italy, the site of an army rest centre; in two days their show attracted 3,137 visitors.

The works comprising the War Records Collection were transferred from the services to the National Gallery of Canada in 1946-47, where they joined the Canadian War Memorials Collection. A permanent Curator of War Art was appointed to supervise these collections in 1962. Nine years later the bulk of the paintings were transferred to the Canadian War Museum, which now holds them in trust for the people of Canada. Over the years the two collections have been augmented by other works gathered through donation and purchase. Since 1968 a programme known as the Canadian Armed Forces Civilian Artists Programme has brought in more than 170 paintings covering current military activities.

Apart from the acquisition of new works, much has been done to make the collections more accessible to the public. In 1968 the National Gallery published a *Checklist of the War Art Collections,* prepared by Major Robert Wodehouse and listing the paintings and sculpted items as of that time. Major Wodehouse, whose service as Curator of War Art extended from 1962 until his death a decade later, also undertook research into the collections and devised cross-references to enable interested parties to locate paintings of specific people, places, or units. For several years the National Gallery devoted an entire floor to the display of war art, and works were regularly loaned to galleries and museums requesting them. Since 1972 the Canadian War Museum has mounted successive exhibitions of war art, many of which have travelled extensively in Canada and abroad, while continuing the policy of loans to other institutions. Today some 500 works (roughly eight percent of the collections) are on public view at any time, either in Ottawa or elsewhere in Canada.

The war art of Alex Colville is but one aspect in the career of this most distinguished painter, but it is important in any overview of his total creative record. It is an equally valued portion of the war art collections, which overall constitute a national treasure, recording a significant portion of our artistic development and military heritage. The Canadian War Museum is proud to be the trustee of such a body of paintings, and proud that Colville should be so generously represented among them.

Tank Transporter 3 June 1944, pencil on paper, 10 × 13¹/₂, Coll. Alex Colville

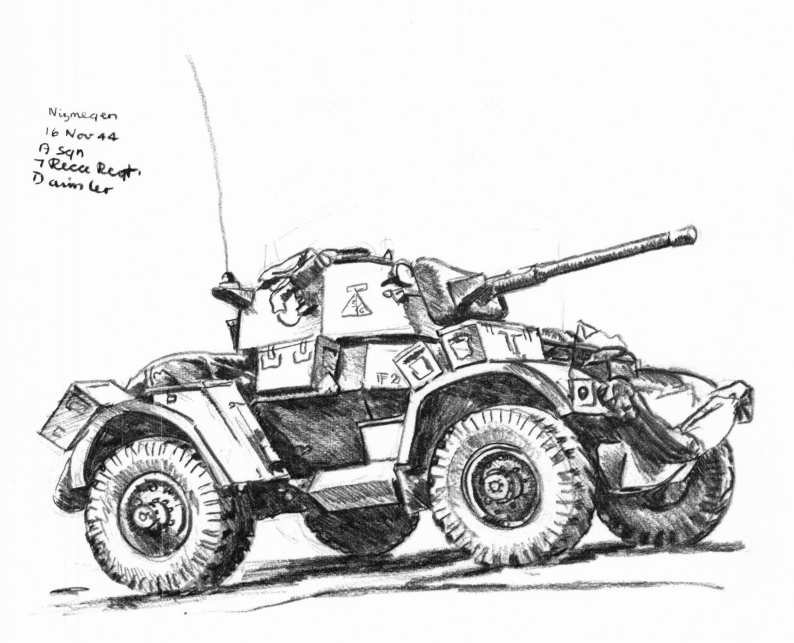

Nijmegen
16 Nov 44
A Sqn
7 Recce Regt.
Daimler

Nijmegen-A Sqn. 7 Recce Regt. Daimler 16 Nov. 1944, pencil on paper,
9 × 11, Coll. Alex Colville

A PERSONAL REALIST

by Graham Metson

Alex Colville showed a fascination for drawing and painting during his childhood. It was no surprise to his family when he decided to become an artist, and they encouraged him in this direction. From high school in Amherst, Nova Scotia he entered Mount Allison University in Sackville, New Brunswick to study Fine Art.

His teacher at Mount Allison was Stanley Royle ARCA who had watched over the development of Colville's skills while he was still at high school. It was Royle who had arranged a scholarship for Colville at the university.

Stanley Royle was a good teacher, more importantly he was a sensitive and skilled practising painter. Royle was from Lancashire, England. He had attended Sheffield School of Art where he was awarded the King's Prize and a Silver Medal. As a student three of his works were accepted to the Royal Academy's prestigious annual summer exhibition. He became an Associate of the Royal West of England Academy, Associate of the Royal Society of Arts and Associate of the Royal Canadian Academy. He was an enthusiastic and serious landscape painter believing that a landscape painter was the most fortunate of painters.

> *"He goes where he likes, paints what he likes and how he likes."* [2]

Looking for new landscapes to paint and the opportunity of employment, he came to Canada in 1930 to take a teaching post at the Nova Scotia College of Art in Halifax. Later he became Professor of Drawing and Painting at Mount Allison University.

The Maritimes afforded him the subjects he loved to paint. His paintings have a rich mellow quality.

> *"He painted with broken colour, something I picked up from him and still do really, a modified pointillist, individual brushstrokes. A green sunlit lawn in a painting by him would have dots of pure yellow and perhaps dots of blue; these mix optically of course."* [3]

Stanley Royle's first concern was for structure and composition in his painting:

> *"My first consideration in painting the finished picture is design. Everything really depends on this first planning of the basic rhythms. Referring to my colour sketch, I then introduce subordinate rhythms, making a more or less abstract pattern of colour. In introducing the details which I consider necessary, and working out the planes to solidify the forms, I endeavour to echo the big rhythms, and thus keep my canvas a unified whole."* [2]

This stress on structure and composition suited Colville.

16

Alex Colville shortly before entering university.

Here he could relate his early fascination in machines, model building and blue prints, to the construction of his paintings. Colville sought this structure intuitively. From his earliest works with the support and understanding of Royle he was able to explore this fully.

At first he worked with landscape and this helped him to absorb and appreciate his teacher's work. However, he realized that he was a figure painter. It was people who interested him and their relationship with their environment.

A powerful early oil, *Wounded Soldier in North Africa,* shows his preoccupation with rhythm and representation. A group of figures carry a wounded man on a stretcher. There is a chain link flow to this vertical composition which is repeated humourously, yet incongruently by the movement of an admirably observed dog, the shadow of its tail linking the composition to the edge.

Stanley Royle believed in the necessity of acute observation, the need to return to the subject, repeatedly learning its forms, towards accurate representation.

> *"I make a first study, this in the form of a colour sketch which should contain all the vital aesthetic qualities, stressing rhythmic flow of contour and shape, colour pattern, values of planes, and the more important accents"* . . .

> *"I return to the subject a number of times, make pencil drawings of all the material I may possibly require."* [2]

These were disciplines and ways of working that were natural to the young Colville and have remained with him.

In 1942, Colville left college and joined the Canadian Infantry, rising through the ranks to a commission. For two years he was denied his art and perhaps denied it to himself. Then suddenly in 1944, without warning, he was flown to London to take an appointment as a War Artist.

He spent two weeks familiarizing himself with his new role working with the RASC in Yorkshire. He brushed up his techniques, experimenting with watercolour, a medium that was new to him, and combining watercolour with pen and ink.

> *"The conditions of work were extraordinarily civilized and humane. We all had a completely free hand. I used to sometimes wonder what I*

Student self-portrait in oils.

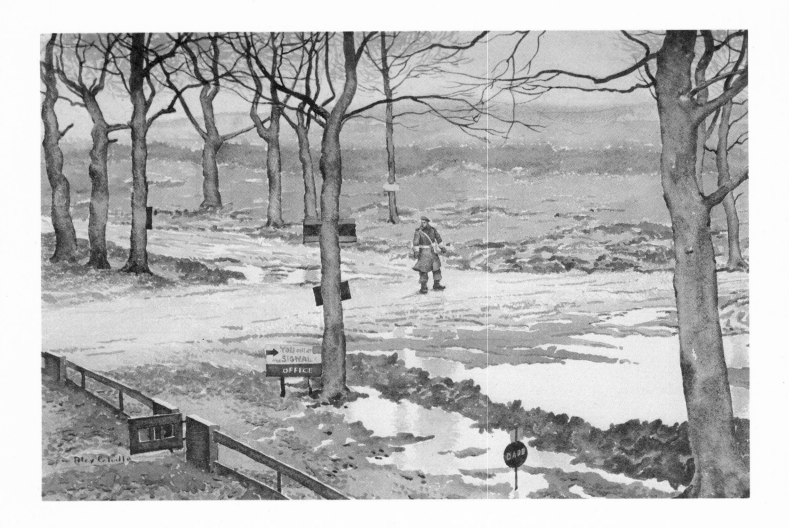

The Provost 24 Nov. 1944, Watercolour Drawing, 15 × 22, 12202

should be doing and I soon settled into a kind of routine. Everyday I would go out with this jeep and driver, and anything I saw that was interesting I would make a drawing or watercolour of it. So it was a kind of genre painting. Everyday life in the army.'' [4]

In July 1944, he was told to return to London and was seconded to the Navy for a special exercise involving assault landing infantry.

At this time, he kept a personal diary which is excerpted later in this book. In addition, he made annotated sketches and watercolours, some of which were later formed into larger oil paintings.

The period in the Mediterranean with the Navy was followed by the winter months of 1944-45 in Holland. He continued to work daily covering a wide variety of subjects. In his own words,

> *"The parallel I would make would be for a novelist to be a police reporter doing factual reporting, physical, sordid, concrete rather than philosophical or abstract.''* [1]

The machinery of war, the vehicles, the guns, the bridges, the airplanes, and all the paraphernalia that man imposed on the landscape in this theatre of war, were unavoidably his subjects. Here he picked up the thread of his childhood fascination in machinery and transposed it to this service he now rendered for the Allies, in the open fields of the Second World War. He portrayed these inanimate creatures with meticulous detail. Hard pressed, damaged, often destroyed, the machines like the troops and the refugees, were victims.

Everyday he worked, recording what he saw, the men, the machines and the landscape. Rarely did he select an individual for portraiture or special study, although some of the finest works in this collection are of soldiers, sometimes unnamed, often from an impersonal distance, always rendered with precision and detail.

> *"I felt in a certain sense I was writing letters home for these people, depicting their lives, the dugouts, tanks, where they lived.''* [4]

Towards the end of this period in Holland he was sent to the concentration camp at Belsen. In the few days he was there, he observed and recorded the huts and the pits full of corpses. In these drawings the naked, starved skeletal forms extended horizontally. The emaciated limbs, the lumpiness of the joints, they are the colour of the earth; the forms, angled and insubstantial, lie above the ground.

> *"One felt badly because one didn't feel worse. That is, you see one dead person and it is bad: 500 is not 500 times worse. There is a certain point at which you begin to feel nothing. There must have been 35,000 bodies in the place and there were people dying all the time."* [4]

Colville returned to Canada at the end of the hostilities in Europe. In Ottawa, he spent time completing the series of oil paintings, in particular the final work *Artillery* which depicts a group of weary infantry advancing in single file curving from the horizon. There is no communication. Each man is withdrawn into his own thoughts. The hands of the leading man, carefully rendered, are the most focussed objects in the painting. The line of a casually carried bren gun slung across a shoulder emphasizes the flatness. The only hint of colour comes from the wintry sky.

Among all the young men whose lives were interrupted by war, Colville was one who was selected to apply himself in active service with his own artistic gifts. He was permitted to put aside the tools of aggression and replace them with those of the artist. He was called upon to leave a record of how these men, their machines and this landscape were perceived by him, going beyond merely graphic rendition into a realm where the expression of inner emotion touches the viewer. It is Colville's own quality of introspection that is evident here as in all his work.

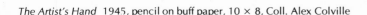

The Artist's Hand 1945, pencil on buff paper, 10 × 8, Coll. Alex Colville

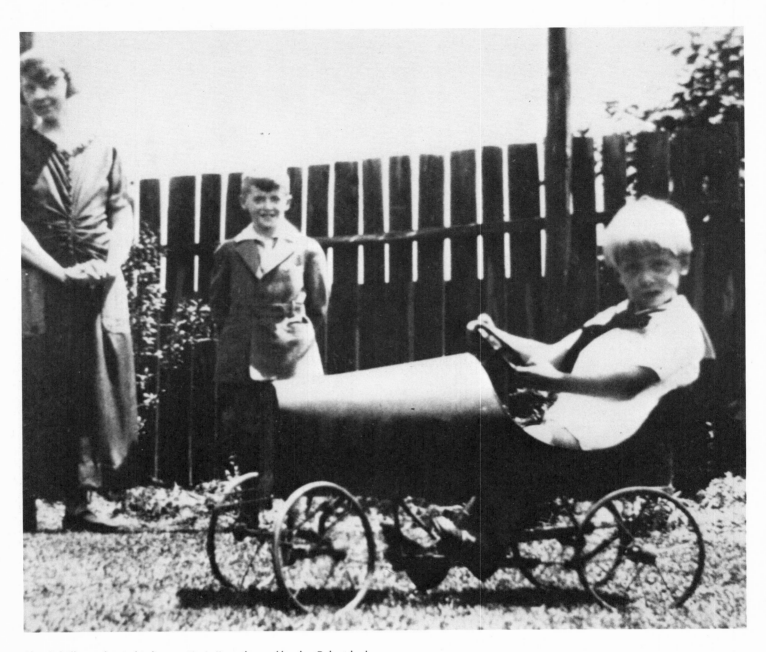

Alex Colville age four in his first car "La La", mother and brother Robert look on.

ALEX COLVILLE ON ALEX COLVILLE

Transcription of an interview with Graham Metson, November 1980.

I was born in Toronto and grew up there until the age of seven. In 1927 when my father got a job on the steel gates for the Welland ship canal we moved to St. Catharines. When the steel gates job was finished, Dominion Bridge, who my father had been working for, moved him to Amherst to be a plant superintendent, a kind of foreman, in the ROBB Engineering Works.

To me, as a child, Amherst, Nova Scotia seemed like a new world. People spoke with a different accent, school seemed different. The thing I remember about Amherst was the steel plant where my father worked. I used to go down there after school. I became familiar with the steel works, the drilling and punching of steel plates and rivetting of "I" beams, as well as blue prints which my father worked with. I think this mechanical and construction background had an important effect on me.

Alex with Mother, Robert and Skippy.

Alex with his parents and Skippy.

When I was nine, only months after we had moved to Amherst, I got pneumonia. I was delirious for many days and in fact I nearly died. Convalescence was very long and I was in bed for several months. I stress this business of having pneumonia and almost dying because I think it had an effect on me. In addition I was lifted out of association with my friends and schoolmates. All through that spring

and summer I led an almost solitary life. In this period I became what we usually call an introvert, one whose life is essentially a kind of inner life. I began to read, really for the first time, and I did quite a few drawings, simply because I was alone and had to find something to do. The drawings I made were all of machines, without exception. I drew cars, boats, airplanes, things like that.

The doctor who attended me was a man named Dr. Goodwin, an Amherst man who had studied at the

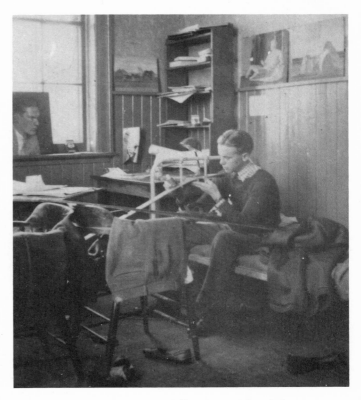

Working in the dormitory at Mount Allison; note early paintings.

University of Edinburgh. Years later he'd talk to me seriously about all kinds of things, about communism, about the biological idea of the survival of the fittest. He was a person who admired musicians and painters. I am sure that knowing him was one of the things that made the idea of becoming an artist legitimate to me much later. Dr. Goodwin recommended that that summer we go to someplace near the beach where I'd be in the sun all the time. I remember that summer very vividly as a kind of idyllic one. It was the summer that I turned ten.

When I was twelve I had a friend whose older brothers had a woodworking shop. These brothers made models of ships and airplanes, not the way this thing is done now with balsa wood, but with pine. These were solid models. I became very interested in this and through my childhood and adolescence, until the time I was sixteen, I spent a lot of time making models. I did both drawings, scale drawings

David Harrower Colville and Florence (Gault) Colville with their youngest son David Alexander.

and engineering drawings, which I got out of flying magazines. I would enlarge these scale drawings which were plans, elevations and cross sections and from these I would make pine models, put them together and paint them. The relationship between a schematic two-dimensional diagram and an actual three-dimensional object has always been important to me. I am sure this model building was an important part of my formative influences. I used to sell them as soon as I got bored with them. My early instinct to sell things began then too. Once I had done it, I didn't want to see it anymore.

When I was in grade nine a woman named Mrs. Hart began to offer drawing and painting as well as lessons in woodcarving, leather work and other crafts. This was done in school, late in the afternoon or in the evenings, and one paid some minimal sum. I enrolled in this class.

Mrs. Hart was very good to me. She simply encouraged me to draw and paint. It shocks me now that I began in oils. At this time I started to draw animals and people and no longer drew airplanes and ships. I would make drawings of my brother and my dog, interiors of rooms and buildings. I remember one of my early paintings was of the factory where my father worked with steam and smoke coming out

of the chimneys. It was rather like a Russian communist painting of vital industry. It seemed a natural thing for me to do.

I continued with that class through grades nine, ten and eleven. I became quite proficient at drawing and painting. Once or perhaps twice in each year, Mrs. Hart would invite the professor of Fine Art at Mount Allison University, Stanley Royle, to come and observe the work of the classes. From the beginning, Mr. Royle gave me a lot of encouragement, he said that my stuff was good and that I should keep at it.

In my last year of high school, I won a scholarship to Dalhousie University through writing an essay and had thought that I might study law. Along with a friend, I had done quite a lot of public speaking. We used to debate and give speeches on politics, economics and public affairs. This seems incongruous to me now, but we spoke to the Rotary Club and things like that. So I had some interest in the possibility of studying law, and I suppose I probably thought of going into politics. Curiously enough, winning the scholarship at Dalhousie made me begin to focus my attention on what I could do and I realized I had to make up my mind fairly soon about this.

When Mr. Royle came over during the winter of my last year of high school, I asked him if he thought I was quite good at drawing and painting and he said "Yes," adding that he thought it was more than just a little talent. I then asked him if he thought that if I became an artist I would be poor and have a terrible time. Fortunately, he said that he didn't think that would happen. I think I decided virtually that same day that I would be an artist. I told him about having a scholarship to Dalhousie and he said he would try to get me a scholarship to Mount Allison to study Fine Art. He did this.

I'm a bit surprised at the ease with which I decided to do this. The other thing which is surprising is that my parents were in full agreement with this. One must remember that a small town in Nova Scotia in 1938 was a very different thing from say the same small town today. The depression wasn't really over, although it had abated somewhat. The whole idea of working in the arts was pretty far out. It wasn't easy for them to find the money for me to

Alex with Rhoda Wright from Wolfville, Nova Scotia, also a Fine Art student.

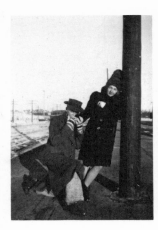
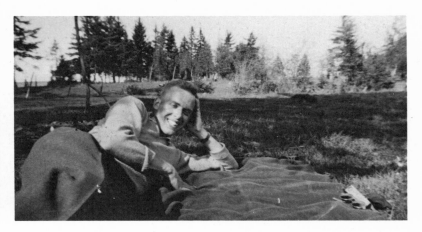

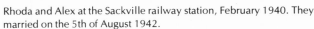
Rhoda and Alex at the Sackville railway station, February 1940. They married on the 5th of August 1942.

Colville picnicking near Camp Petawawa, Ontario, autumn 1942.

go to university to study Art, but they did find it.

As a Fine Art's student the curriculum I studied consisted of Art History, English Literature, and the rest of it was drawing, designing, and painting. I didn't do many academic things, more than ninety percent of the time was spent just drawing and painting. It was rather like being apprenticed to someone. There was a very small group of students most of whom were taking Fine Art simply because they didn't want the work of doing chemistry, biology, or Greek. Mr. Royle didn't care whether you worked or not, he didn't see that as his problem. Anytime I wanted help on some kind of technical problem, he was available. He worked in a studio right in the school, the school where I later taught and worked.

I read a lot through those years. I had friends, most of whose interest was in literature. I was a close friend of Nathan Cohen, now dead but possibly Canada's best drama critic. So there was a kind of intellectual life in a small university at that time. I entered in the fall of 1938 and went into the army just a month before graduation in the spring of 1942. My student years at university were very much affected by the war. By the time I was a third year student the real war was on. The Germans had overrun virtually the whole of the European continent and from that time on, the war was something one thought about. It

affected student life, made it more somber than it would otherwise have been. My wife and I were students together beginning in the fall of 1938, both Fine Art's students and when I went in the army in May of 1942 one of the good things about that was the knowledge that this would permit me to get married, because in effect I had a job. So we were married in August of 1942.

The two years I spent in the army as a soldier I didn't paint. First I became a corporal, a lance sergeant, then I was recommended for a commission. I went to an infantry officers' training centre. I became an infantry 2nd lieutenant and then I trained people.

Suddenly I was sent overseas in a very dramatic way. My wife and I were living in a little place near a camp in Yarmouth, Nova Scotia. The assistant adjutant arrived at our home in a jeep, and said the Colonel wanted to see me. I got into the jeep, and as soon as I got there the Colonel said, "You're leaving at 3:45 on a Canso aircraft and you're being flown to Halifax and Montreal and England", then he said "Mr. Churchill wants you." I didn't know what it was all about. When I got to London, I was told to report to Canadian Military H.Q., to a Colonel C. P. Stacey, I reported to Stacey and he said, "You've been made a war artist." That was it, just like that. I was a war artist.

Colville in his studio in London, England, 1944.

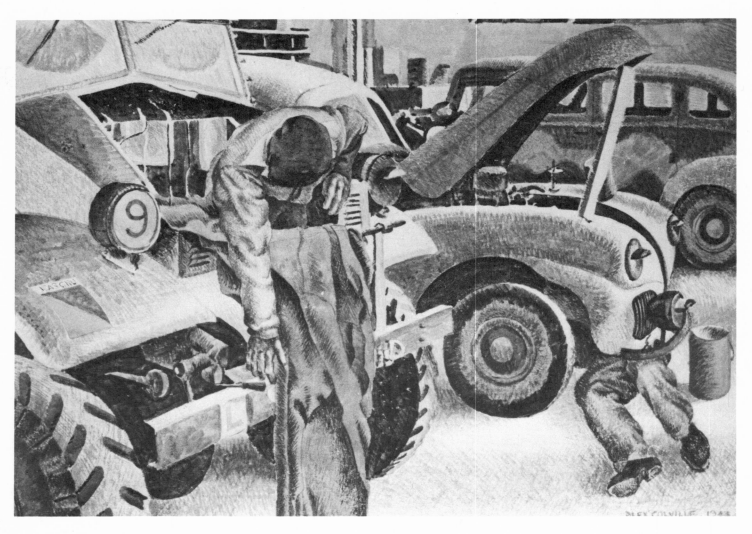

MT Workshop Watercolour Drawing, 21¹/₈ × 27³/₄, 12186

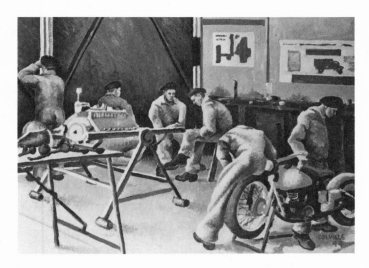

Fitters 'Break' Period Oil on canvas, 24 × 29³/₄, 12156

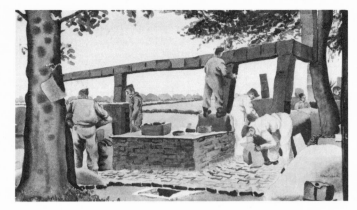

Field Kitchens 8 June 1944, Watercolour Drawing, 13⁷/₈ × 22, 12155

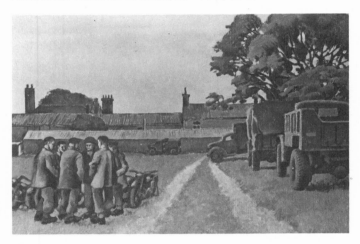

Mechanical Transport Park June 1944, Oils on canvas, 23 × 29, 12181

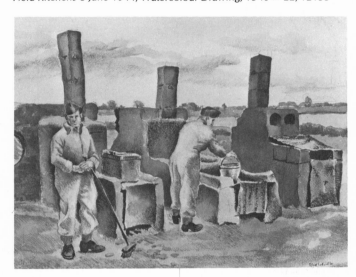

Improvised Stoves 2 June 1944, Watercolour Drawing, 15 × 18, 12169

Colonel Stacey said to me, "You must remember you are no longer an infantry officer, I don't want you getting killed." I spent the next two years as a war artist. I hadn't been painting or drawing for two years. In the army you have no time, you're doing things all the time, no place to work or anything, even if I had wanted to. Being an artist while being a soldier is just impossible. In order to get my hand in I was sent to a reinforcement unit in Yorkshire for about two weeks. I was given watercolours, and five pens and I went up there. It was a Royal Army Service Corps place. They are the people who do supplies with trucks. I did a lot of drawings and watercolours, it seemed wonderful to be painting again.³

It was like postgraduate work for him. A great discipline to work in the field. It was like a reward for having given it all up. RHODA COLVILLE⁵

YORKSHIRE

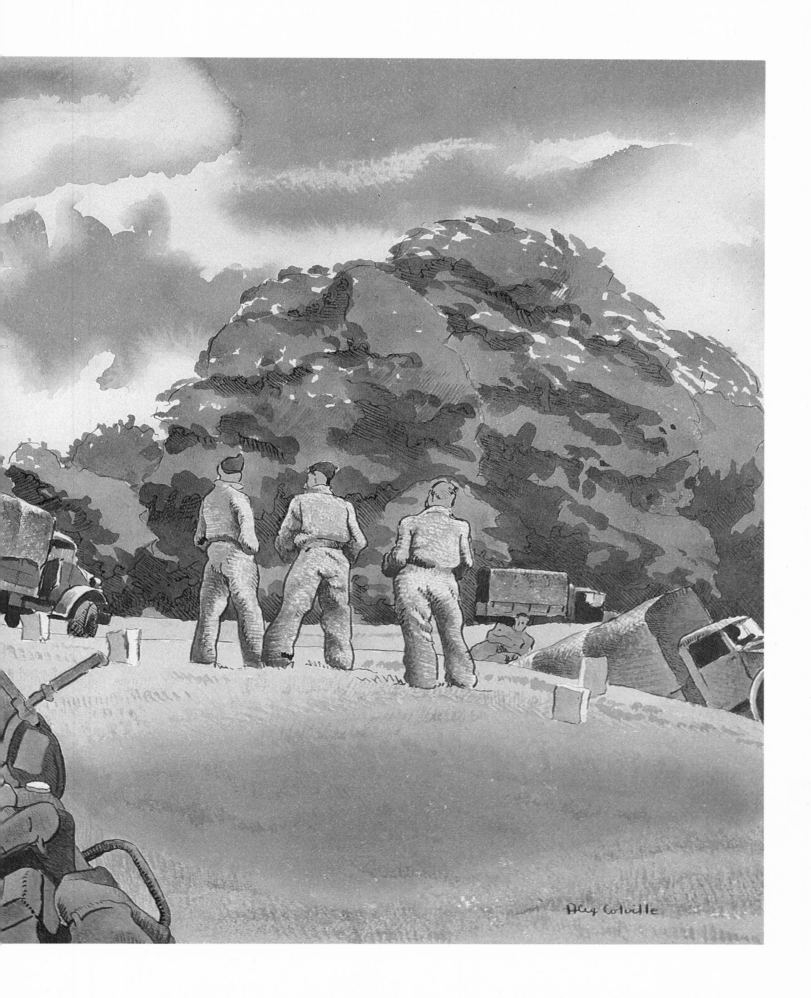

The "Bullpen" 6 June 1944, Watercolour Drawing, 13 × 19, 12129

Sketch for "Parked Convoy" 9 June 1944, pencil on paper, 7½ × 10, Coll. Alex Colville

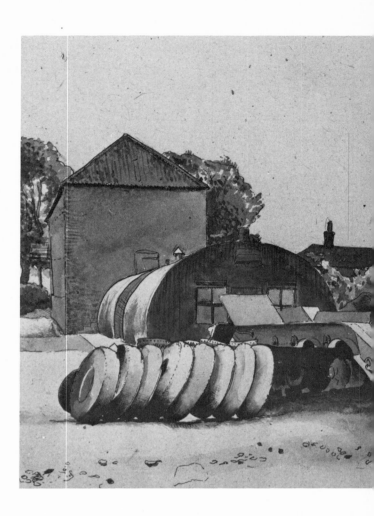

Convoy in Yorkshire No. 2 June 1944, Oils on canvas, 30 × 40, 12137

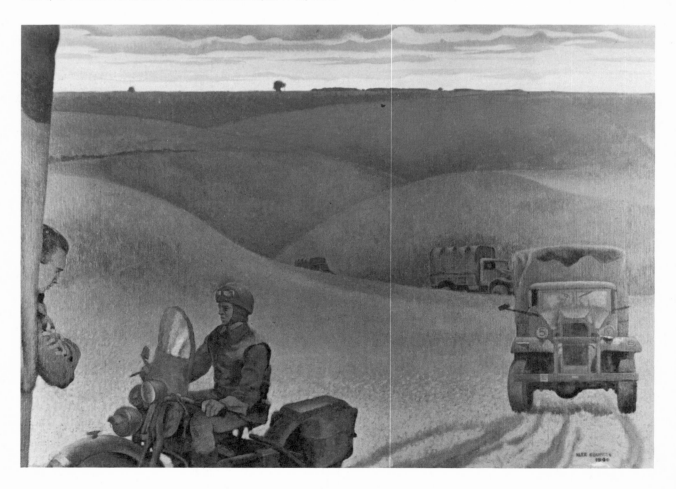

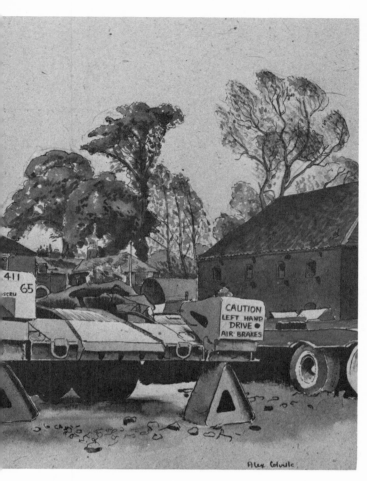

Tank Transporters in Park 4 June 1944, Watercolour Drawing,
12⁷/₈ ×19³/₄, 12216

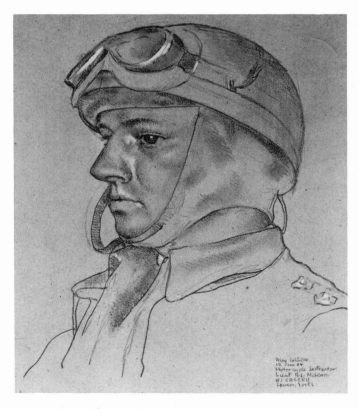

Motorcycle Instructor 12 June 1944, pencil heightened with white on
paper, 20¹/₂ × 15, 12185

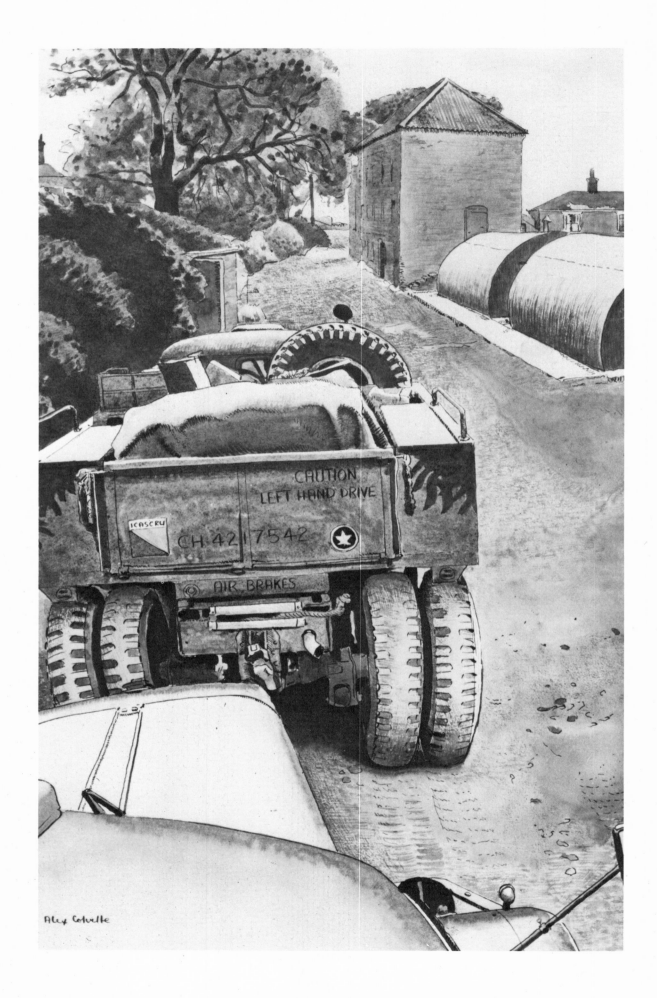

Tank Transporters Tractors 5 June 1944, Watercolour Drawing,
19³/4 × 12³/4, 12215

Parked Convoy 10 June 1944, Watercolour Drawing, 13 × 19½, 12194

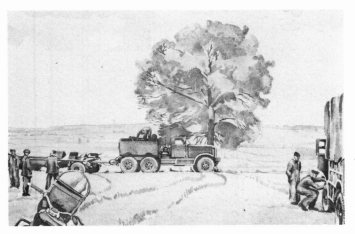

Noon Hour Break June 1944, Watercolour Drawing, 15¼ × 22½, 12190

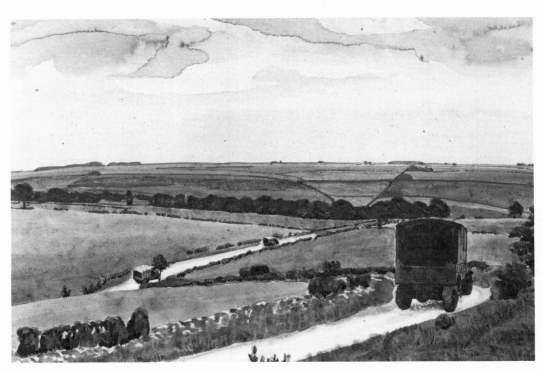

Convoy in Yorkshire 9 June 1944, Watercolour Drawing, 13¾ × 20¾, 12136

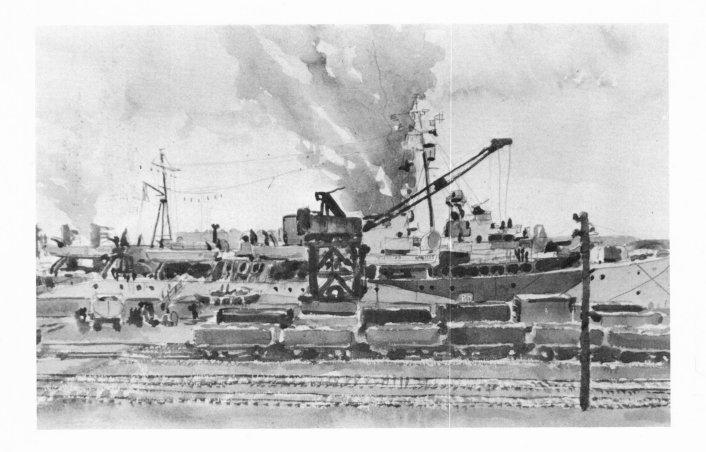

MEDITERRANEAN

21 Jul 44.
 Have £12-4
 In bank £ 1-9
 Have cheque for £ 20-0.
Went to see Lt. Comd. Todd at
R.C.N. office on Haymarket
about attachment to Navy. Very
cool & aloof. Col. Stacey provoked
by their attitude. Doing no
painting today. Cashed cheque
at Lloyds East of St Pauls —
saw the latter for first time.
Very impressive, but dirty
and crowded by shabby
buildings. Wrote mother at
noon. Very hot and grey today,
numerous doodlebugs. I am
two-thirds packed for a quick
departure. I've resolved to
keep this diary so that I can
tell Rhoda in some detail of
my experiences, when I go back
home. I want to get back to work at
"Stuck in Gravel Pit", but am too upset.
Saw Lt. George at 1600 hrs—trips is
on. Great rushing around,
packing. Botsik and I supped
at Cross Keys & talked to Miss
Foster. Heard BBC news of
internal strife in Germany —

cheering. Writing last letter
to Rabbit tonight, for maybe
six weeks, anyway. Thinking of
her all evening and wondering
what she'd think of this mad
life. Had one lager. Miss Foster
thinks all Canadians musical

22 Jul 44 - Sat.
Bring necessaries to Fairfax.
See George 1000 hrs.
Take cheque to bank
Buy clothes
Station (Paddington) by 1230hrs
Phone station, confirm 1·55 ·
Turn in C.M.H.Q. Pass.
Buy cigarettes.
Ask Col. Stacey about ration
 & clothing coupons.
Leave note for Eric.

 Take - art supplies.
besides pistol, helmet, respirator
what wearing trench coat.
 1 pr. boots
 summer stuff
 brushes, etc.
 shaving kit.
 shirts, shorts, socks, hankies
 pyjamas.
 sweater

Met Capt. Houghton R.C.N.
 C.N.M.O. Deputy Head.
Clothes cost £ 8-7-0.
1120 hrs - have £12 cash
 £ 11-19-0 in bank

Left Paddington 1555 - stood up
most of way in 3rd cl. carriage
arrived Cardiff 1800 - by
chance met Comd. Kelly and
Admiralty Courier who drove
me to ship. Headache and
starved. Com. Kelly is Capt. of
Prince David - Irish - charming,
impulsive - man of action.
Had a drink, stood and talked
to 2100 - thought I would
faint. Had good meal but
couldn't enjoy it. Went to
room and slept for 30 mins.
Lt. Comd. Matteson. Engineer
Brooklyn near Liverpool N.S.,
my cabin-mate, came in and
woke me. Had drink ward room
went to Barry and rode
crash-buggies. Felt good.
Too tired to write Rhoda.
Went to bed. The Ex. O. Lt. —

HMCS PRINCE DAVID in Barry, Wales 23 July 1944, Watercolour Drawing, 15¼ × 22½, 10191

Soon after I got back to London I was called to Colonel Stacey. The Navy wanted an officer to go with a Landing Ship Assault, Infantry on an operation unspecified which was to take place in the near future. The Navy artists had all been involved in the D-Day Invasion of Normandy, on the 6th of June. They were all back doing studio things in London. They had asked if they could borrow an army person, so I was the person.[3]

DIARY

22 July, 1944, Saturday

Left Paddington 1355. Stood up most of way in 3rd class carriage. Arrived Cardiff 1800. By chance met Comd. Kelly an Admiralty Courier, who drove me to ship. Headache and starved. Comd. Kelly is Captain of PRINCE DAVID — charming, impulsive, man of action. Had a drink, stood and talked to 2100 — thought I would faint. Had a good meal but couldn't enjoy it. Went to room and slept for 30 minutes — Lt. Comd. Matheson, Engineer, my cabin-mate, came in and woke. Had a drink in the wardroom. Felt good. Too tired to write Rhoda. Went to bed.

23 July, 1944, Sunday

Got up at 0800 — excellent breakfast — grapefruit juice (my first since leaving Canada) fried egg, bacon. Capt.'s Sec. Lt. Goodchild showed me over the ship. Marvellous messing facilities. Went ashore to bank and did watercolour of ship with goods, cars in foreground. Lt. Comd. Carter came over and we talked. Put pips and Canadas on bush jacket. Made pencil, pen and watercolour drawing of part of ship. Listened to Jack Benny, which was funny. Paul and I walked to Barry's amusement park — threw balls, went on roller coaster and other devices. Paul wouldn't go on worst one. I went alone and was scared. We came back and talked about Lt. Gus Osberg who was torpedoed 400 miles off Newfoundland and sailed with others in a 22 ft. boat to the Azores, following favorable winds and tides. I wrote Rhoda rather a halting letter trying to explain that she wouldn't get much mail, that I wouldn't receive any of her mail until sometime in September. Of course I couldn't make it clear without violating security regulations. So I didn't make it clear. Don't know when it will be mailed. Can buy 20 State Express for sixpence aboard.

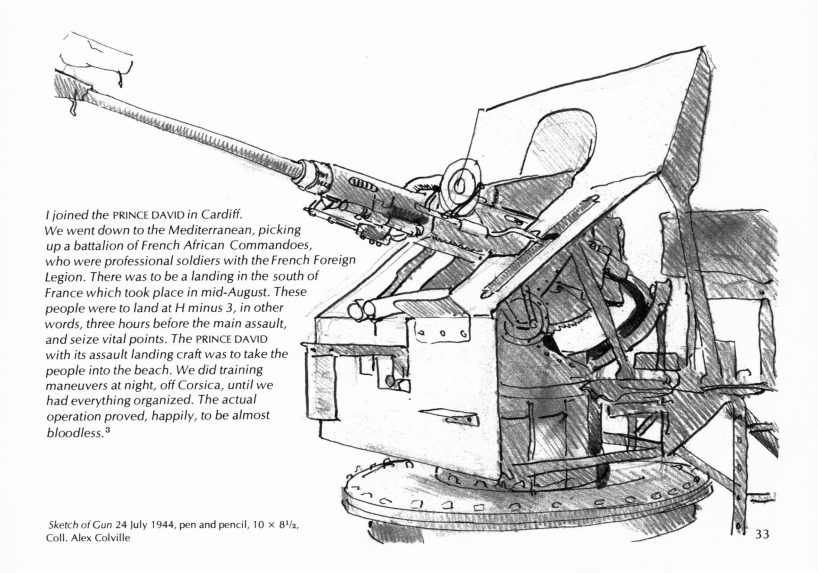

I joined the PRINCE DAVID in Cardiff. We went down to the Mediterranean, picking up a battalion of French African Commandoes, who were professional soldiers with the French Foreign Legion. There was to be a landing in the south of France which took place in mid-August. These people were to land at H minus 3, in other words, three hours before the main assault, and seize vital points. The PRINCE DAVID with its assault landing craft was to take the people into the beach. We did training maneuvers at night, off Corsica, until we had everything organized. The actual operation proved, happily, to be almost bloodless.[3]

Sketch of Gun 24 July 1944, pen and pencil, 10 × 8½, Coll. Alex Colville

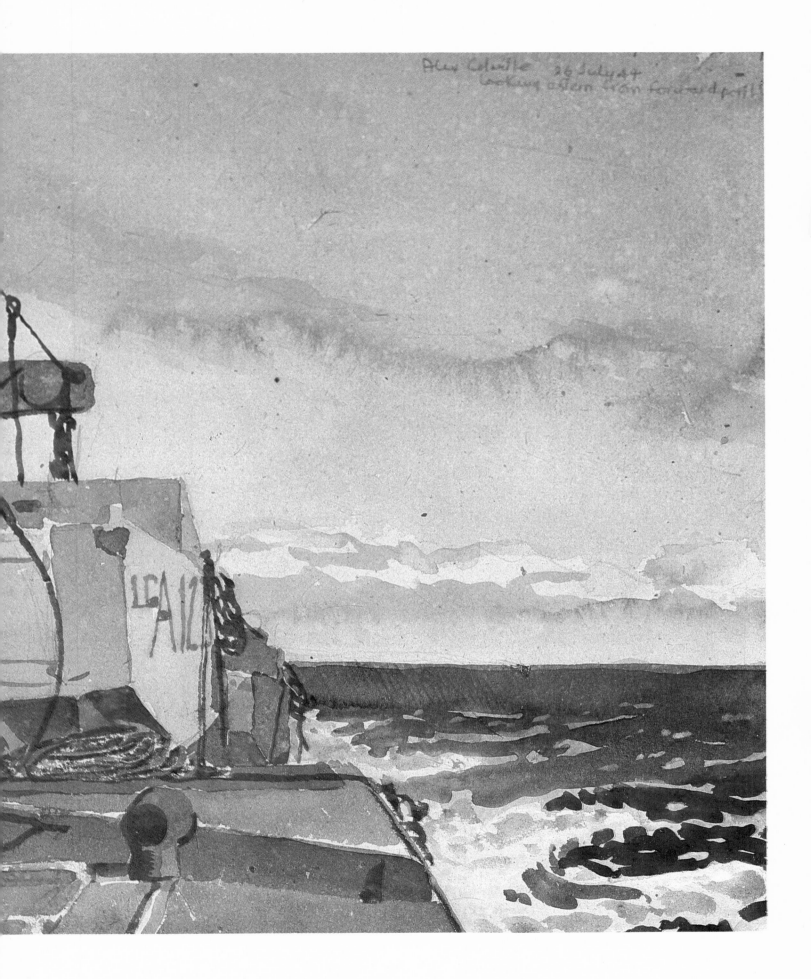

In the Bay of Biscay 26 July 1944, Watercolour Drawing, 12⁷/₈ × 20⁵/₈, 10191

25 July, 1944, Tuesday

Felt a bit squeamish all day — stayed outside. Ship rolling considerably. Quite a number of officers seasick. Visited engine room, very hot and not very interesting pictorially. Having trouble drawing and painting because of movement of ship which joggles my hand, high wind, flying spray and soot.

26 July, 1944, Wednesday

Got up for Action Stations at 0550 — seasickness (or traces of it) all gone. Did watercolour from forward L.C.A. in morning, drawing of winch and bow in afternoon. Chased away by spray flying right up to the shield from the 4 inch gun blast, on which I was sitting. Did another watercolour of wake before supper. Lovely peaceful evening with calm sea, sun set like a Chinese red jewel in mauve clouds over a warmish blue-gray sea. Cumulus clouds above — mauve against turquoise sky.

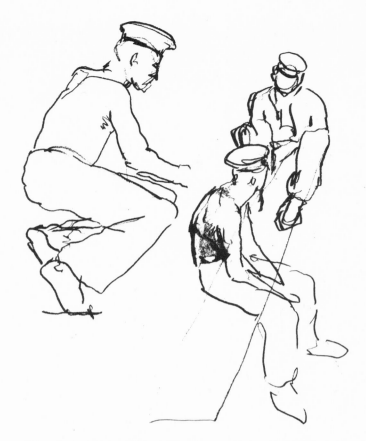

Sailors Aug. 1944, pencil on paper, 10 × 8¹/₂, Coll. Alex Colville

Sailor Reading a Newspaper on Foc'sl. 30 July 1944, pen and ink on paper, 7¹/₂ × 8¹/₂, Coll. Alex Colville

29 July, 1944, Saturday

Grey misty day in morning. Anchor up around 1100 and left Gibraltar. Water like a mill pond and incredibly blue, with porpoise around bow. Worked in morning and early afternoon on water of Friday's watercolours and improved it. A gin and lime cost only 8 cents aboard, of which only 3 cents is for the lime. Beautiful calm evening, talked to Lt. Coates until stars came out and he left to photograph them. Wrote a 900-word letter to Rhoda — felt very lonesome. I have now been painting on PRINCE DAVID for a week — hard to produce finished works here.

28 July, 1944, Friday

Up to wardroom at 0515, slept curled up in a chair until secure at 0545 — back to bed as usual until 0800. Saw coast of Africa around 0730 and Spain. Saw Gibraltar around 1100. Anchored around 1130. Numerous Catalinas flew around on way in. Bumboat came out with basket of fruit — wanted 3. Did drawing of Gibraltar with carrier and freighter at pier in front. After dinner did watercolour of bow and coast of Spain. Went swimming off stern, then ashore in L.C.A. at 1815. Bought grapes, bananas, peanuts, oranges, melons, spanish onions. Gibraltar filled with service men and greasy civilians. Got lost (five of us by this time) and missed boat. Harbour dirty — boat picked us up around 2300 and returned to PRINCE DAVID. Very wild and beautiful crossing harbour with all the searchlights. Executive Officer gave us a calling down but was not unpleasant. Wrote Rhoda — tried to get her a souvenir of Gibraltar, but could find nothing but expensive trash so got a bullfight post card.

Sailor Sunbathing on Deck of PRINCE DAVID in Gibraltar 28 July 1944, pencil on paper, 8 × 5¹/₂, Coll. Alex Colville

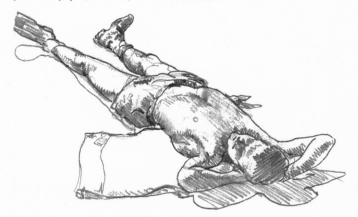

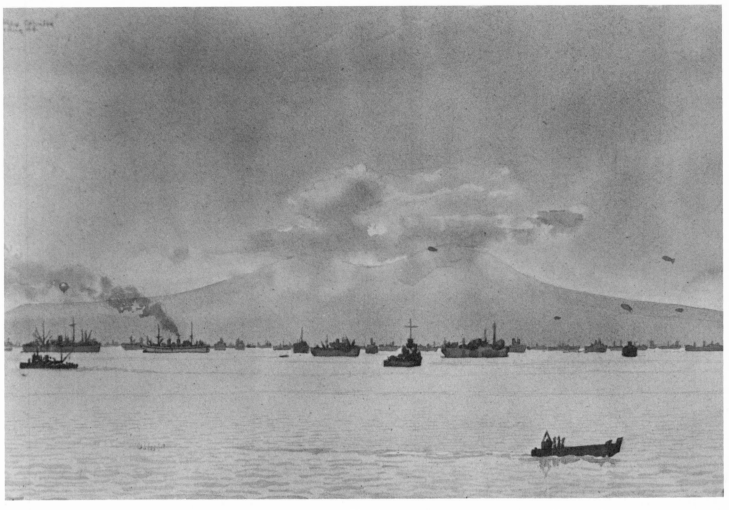

Misty Morning in Naples 1 Aug. 1944, Watercolour Drawing, 15 × 22⁵/₈, 10194

Ratings Look at Gibraltar 28 July 1944, Watercolour Drawing, 12¹/₄ × 19¹/₂, 10199

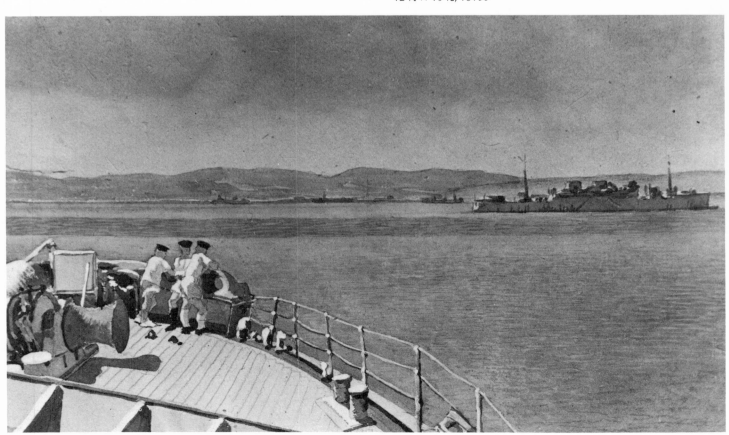

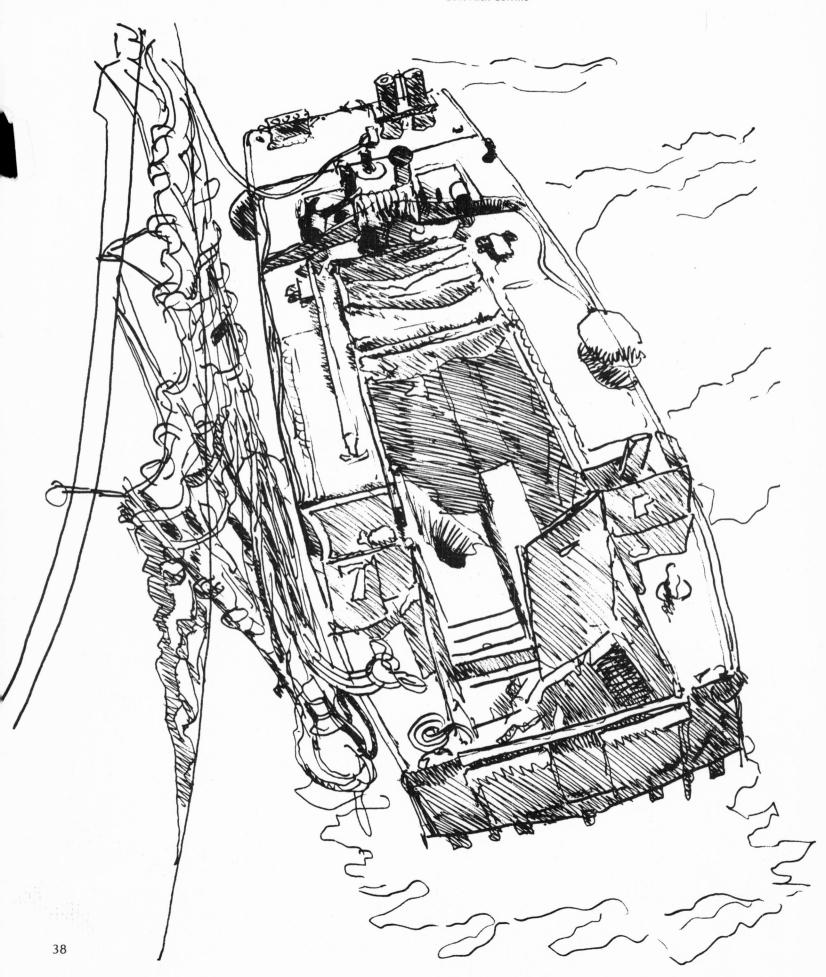

Sketch of L.C.A. 4 Aug. 1944, pen and sepia ink on paper, 14 × 10, Coll. Alex Colville

31 July, 1944, Monday
Did watercolour from port Derlikon position — worked in figures and surf after lunch — quite pleased with it. Saw Capri around 1600 and anchored in Naples before supper. Very beautiful — great quantities of ships.

1 August, 1944, Tuesday
Did painting of ships against Vesuvius. Up anchor at 1300 — arrived in Agripolo at 1630. There are two troopers with us, and an American destroyer. L.C.A.'s are going out from 2100 to 2400 on manoeuvres. L.C.A.'s left at 2145 and returned at 2400. Since it was a bright moonlight night I was able to get some rough pencil sketches. The swell was greater than it appeared to be from the PRINCE DAVID'S deck.

2 August, 1944, Wednesday
Worked all morning on a watercolour from last night's sketches. Went ashore at 1800 to Agripolo and bought a pair of wooden soled shoes for Rhoda for 350 lira. The town was painted with the communist hammer and sickle or red star on almost every house, pictures of Mussolini painted out. Little evidence of war damage except for a neatly demolished bridge. The women carry jugs on their heads, most are barefooted. The Italian soldiers wear peculiar uniforms comic opera. The town is very hilly and picturesque — buildings all stone with narrow alleyways, winding stairs, etc. and part of it overlooks (a sheer drop) a bay filled with bright blue-green water. The populace are neither friendly nor unfriendly — they have had so many different types of troops. The town is dirty, smelly and probably unhealthy. I wish Rhoda could have been with me. Today has been the hottest yet. I have heat rash on my arms — it appeared yesterday.

A Night Exercise 3 Aug. 1944, Watercolour Drawing, 11¼ × 15⅜, 10195

3 August, 1944, Thursday
Spent all morning on small nocturne that I started yesterday. Stretched some De Wint paper but the glue pulled loose and I had to do it again. This time it held, but has one bad wrinkle in it. French Commandoes came aboard around 1600. We embarked in L.C.A.'s (towing rubber boats) at about 1630. I used all my film and did some sketches.

4 August, 1944, Friday
Got up and made pen drawing of L.C.A. figure. Then started a nocturne watercolour from one of last night's sketches. Using black India ink — Finished it at 1500. Walked around deck, then got involved in a dice game for drinks. I lost once which cost me 12 gins, 4 rums, 6 lemon squashes.

The commandoes are a hard lot — many of them natives from North Africa, I believe. They have mostly American equipment and an American liaison Lieutenant from Louisiana. I had a marvellous swim around 1500 — water warm and very salty. There are also Royal Marines with this unit and U.S. Signalmen. At 2130 we went on an exercise with the three flotillas — going about 16 miles. Moonlight night, some of the soldiers were sick but most slept. Those in the rubber boats were bounced, sprayed, and must have been very cold. We made a landing on this beach at 0100 which went quite smoothly. We towed an L.C.A. off and after looking around for anyone close in trouble, returned to the PRINCE DAVID, where we had cocoa and cold roast beef sandwiches. I got in bed by 0200 hrs.

6 August, 1944, Sunday
Unable to find cap all morning, so stayed around wardroom until it was located in another cabin. In afternoon painted a watercolour of Naples with two American destroyers. We left Naples at 1500 and arrived in Agropoli around 1730. After supper I went to the quarterdeck and enjoyed singing and music from Italians in a small boat. One fellow had a marvellous voice, and looked just like Tarzan in trunks.

7 August, 1944, Monday
Got up feeling hot and cramped. The French troops came aboard in the morning. The ship is overflowing with French Army, French Naval Officers, U.S. Army and Navy Officers, Royal Marine Officers and so on. There is great activity so much so that it is difficult to do any drawing or painting. Spent afternoon making sketches of French soldiers lying around on deck. The ship left Agropoli for a point north of Naples in the afternoon. At 2130 we were in the L.C.A.'s — I was in PRINCE DAVID's L.C.A. #1 — the leader of the whole flotilla — under Lt. Buckingham. In the same L.C.A. were the Colonel and several of his officers — the U.S. Army liaison Lieutenant and several Royal Marines, plus the commandoes. We formed up and headed for the P.T. which was to lead the flotilla to the beach. There was a fair swell, we set off. One of the PRINCE ALBERT's rubber boats capsized but the nine men in it were picked up by its L.C.A. We were heading roughly 10' east of north. Presently we saw a fire ashore and a burst of flak which looked like Bofors. The men were sick, but heaving quietly. The night was dark until the moon rose around 2230. Sometime after 2300 our P.T. changed course and we

headed west of north — either the ships had started us from the wrong spot or some mistake had been made. We circled two P.T.'s while they conferred and then set off again. Shortly after the P.T. stopped and we went on, having been given our course. We passed two men with a green light in a small rubber boat — then deployed, at this time, our rubber boat broke loose, one of the lines having broken, thus causing the boat to be dragged sideways. The soldiers then released the other rope and were soon lost to our sight. We arrived at the beach at 0038 — about 8 minutes late. Everything went well, the water being very calm from an offshore wind. The commandoes got wet to their thighs and knees. We went out to the P.T. boats again, then headed towards the beach and anchored — the five L.C.A.'s in our flotilla lashed together. At 0630 we picked up the troops at the beach and returned to our ships, arriving at 0730 on 8 August 1944.

9 August, 1944, Wednesday
Wandered around ship in morning, made sketch of L.C.M. being hoisted, stretched paper. Started for Naples after lunch. Worked in the afternoon on ink and watercolour nocturne. Went ashore to Naples at 1730 — bought sketch pad. Had supper at a French Officer's Club. Red wine, soup, dark bread, peppers, lumpy meat, then lettuce with vinegar, then cheese, then peaches, then white wine.

Commandoes in Dinghies 3 Aug. 1944, pencil on paper, 10 × 8½, Coll. Alex Colville

11 August, 1944, Friday
Took troops on board in morning. Made numerous
sketches and elaborate drawing from stern of L.C.M. Made
drawings on bridge in afternoon and watercolour. There
are two British nurses on board now who are landing,
along with French doctors, with the commandoes. Saw
lovely effect from quarterdeck after dark — stern of our
ship, wake, then the PRINCE ALBERT, followed by another
ship, lit up by sheet lightning with dark clouds (big simple
ones) overhead and a few stars. We left Agropoli around
noon, heading to Corsica.

*The thing that I wondered about, both with the naval
operation and later with the Third Division, was just how
far I should stick my neck out, as far as being where the
action is. In the case of the naval operation I asked the
Executive Officer, "Could I go on one of the assault landing
craft?" and he said, "I don't want to know about it", as
long as he didn't know about it, it was no problem. So I
went and no one got killed.*

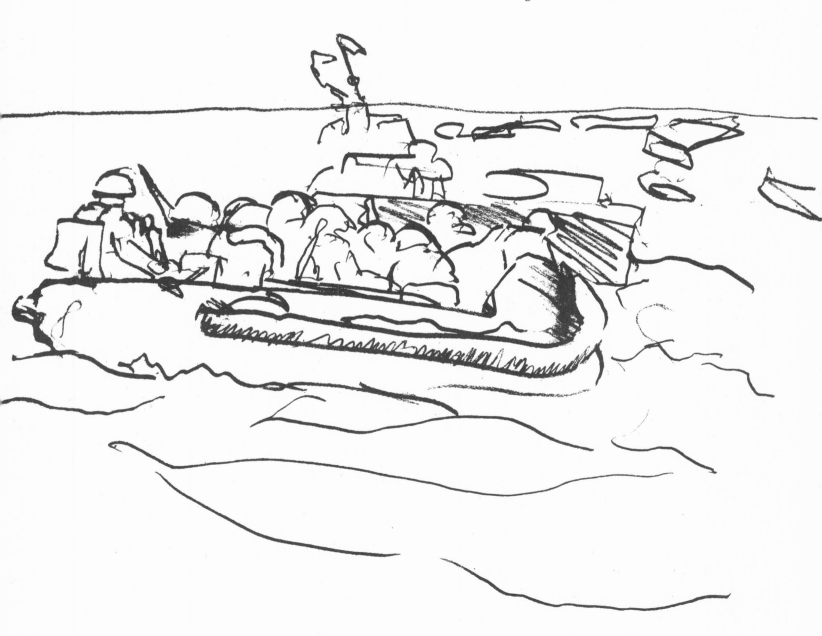

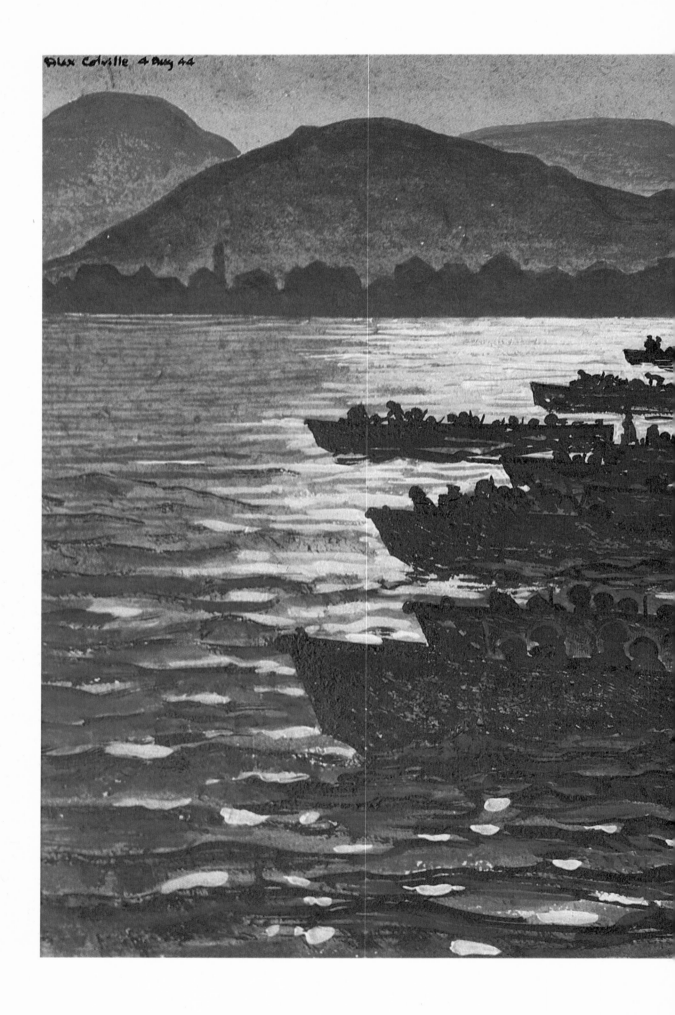

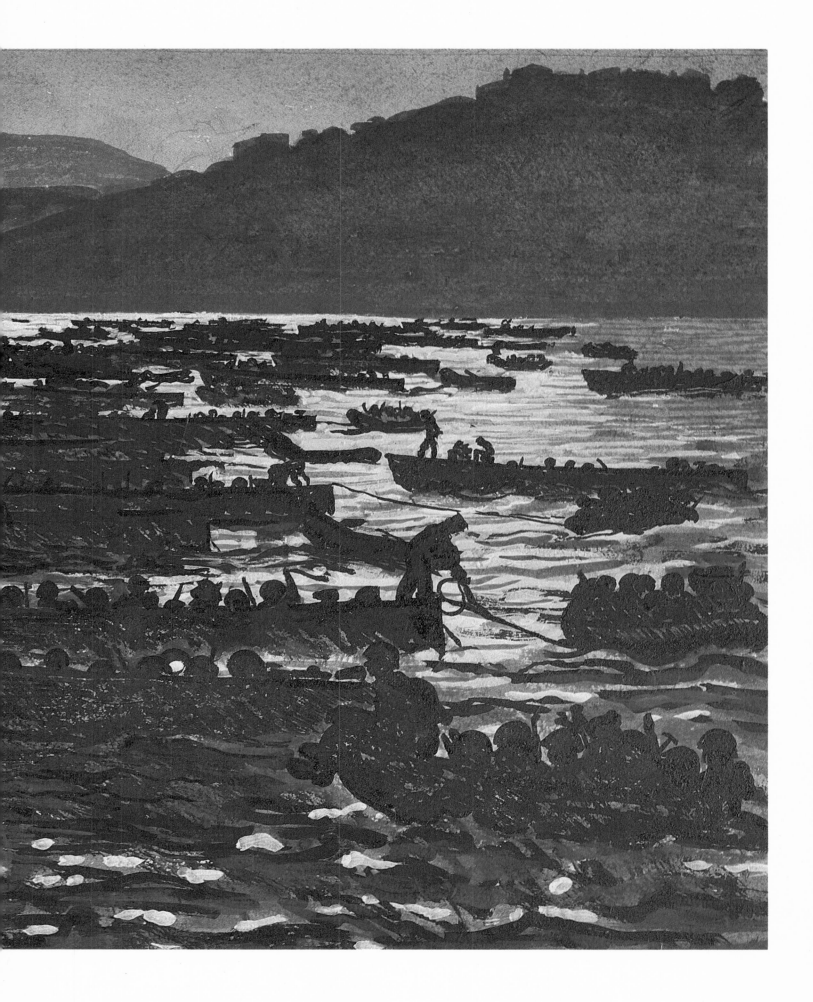

The Deploy 4 Aug. 1944, Watercolour Drawing, 12¼ × 19¾, 10188

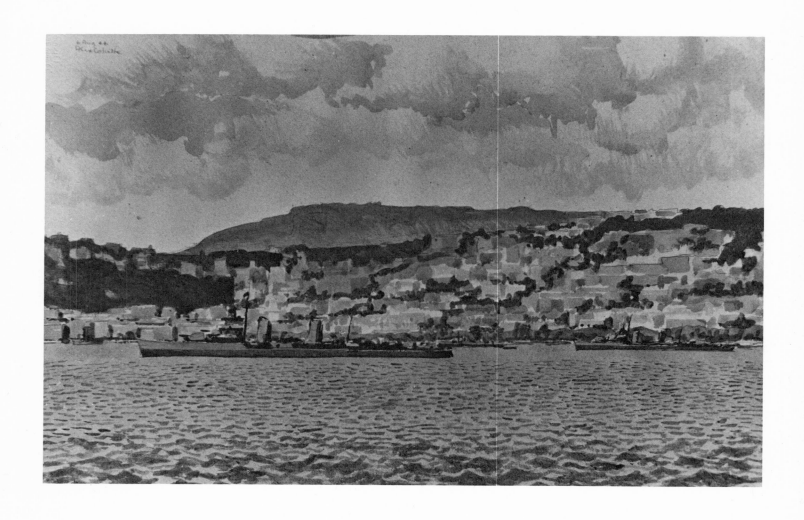

American Destroyers in Naples 6 Aug. 1944, Watercolour Drawing,
15 × 22¹/₂, 10187

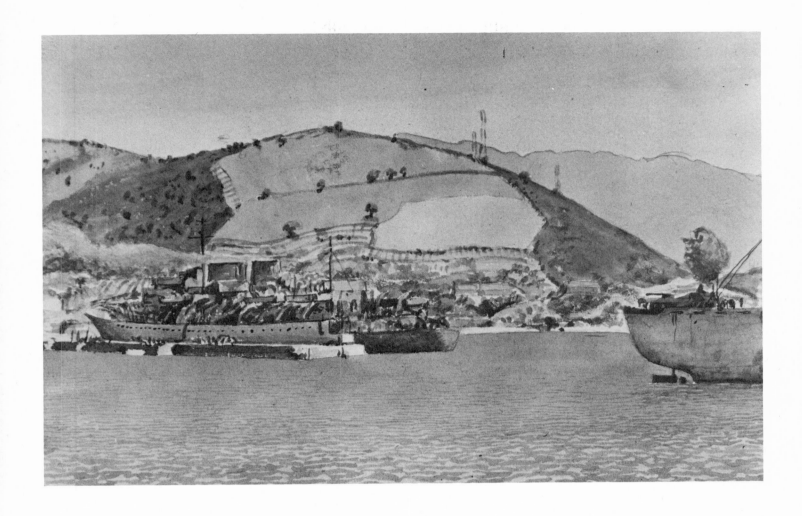

HMCS PRINCE HENRY Re-Fueling *in Corsica* 16 Aug. 1944, Watercolour
Drawing, 15 × 22, 12167

U.S. four-stacker converted
to LCH ship'

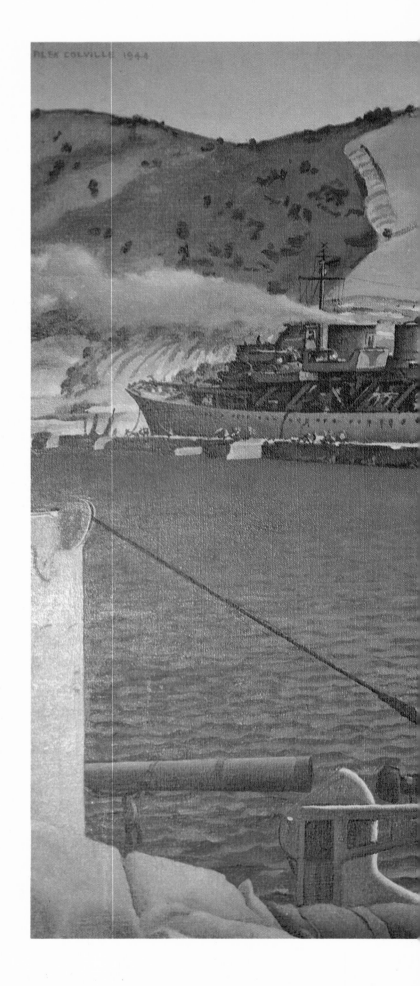

HMCS PRINCE HENRY in *Corsica* 1944, Oils on canvas, 30 × 40, 10198

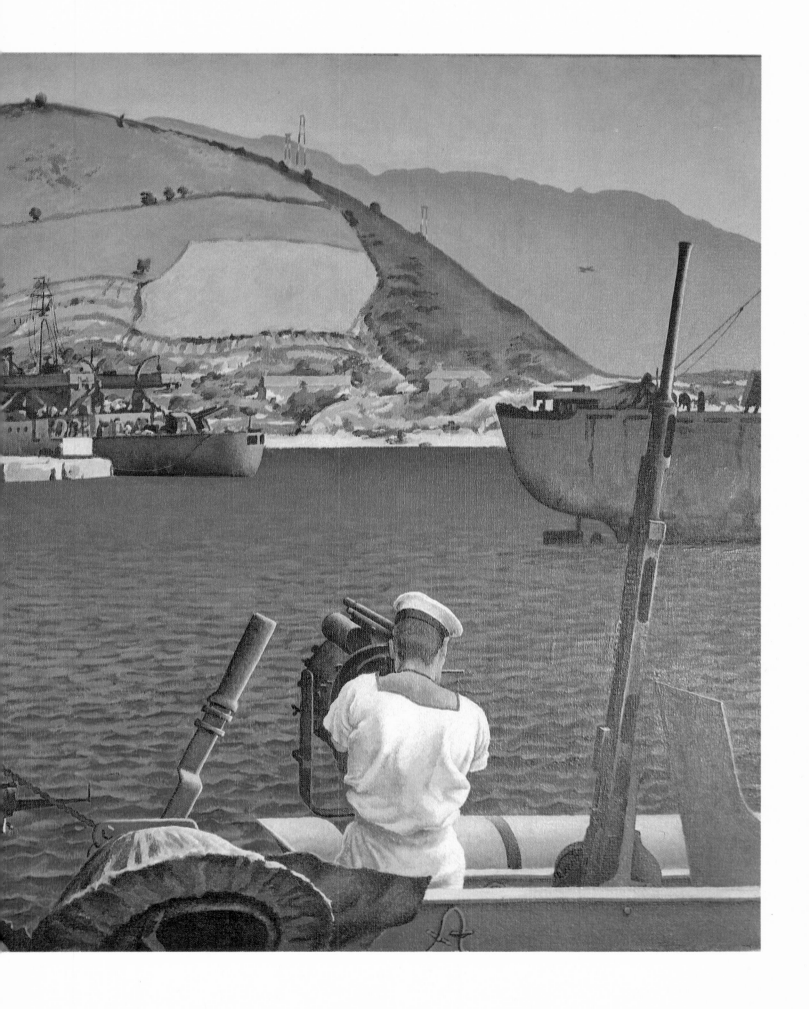

3 Aug 44

signal flags

48

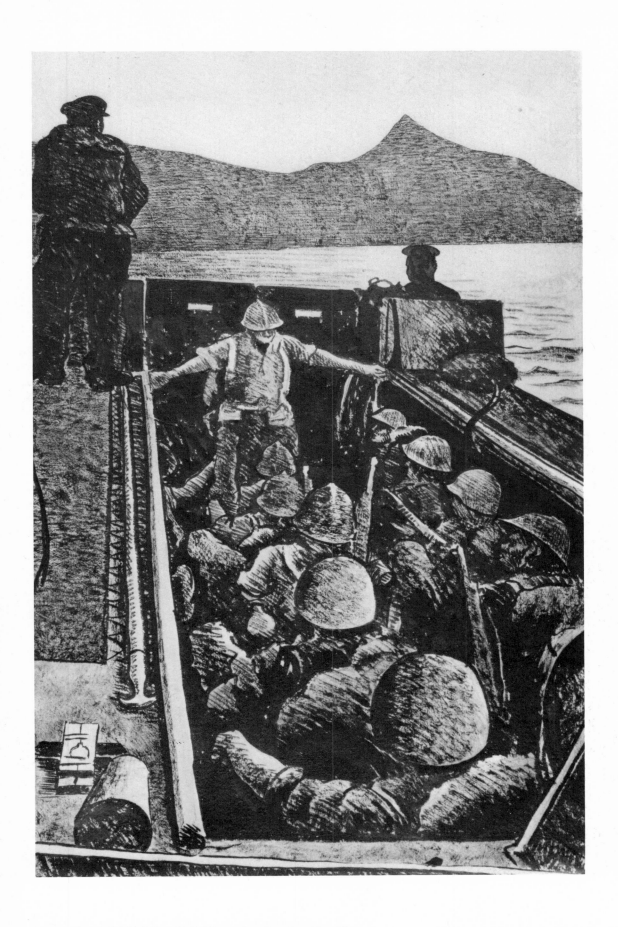

Commandoes in L.C.M. 9 Aug. 1944, Watercolour Drawing, 19 × 12,
(A watercolour nocturne) Coll. Alex Colville

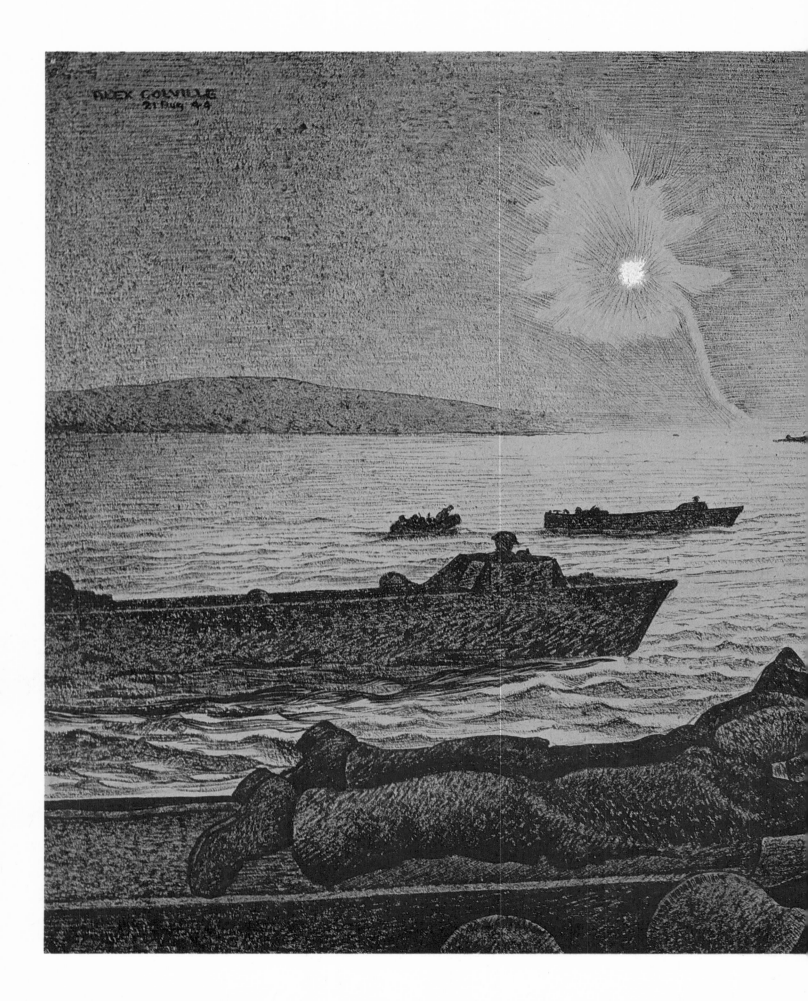

A German Flare Goes Up 21 Aug. 1944, Watercolour Drawing, 14 × 22, 10189

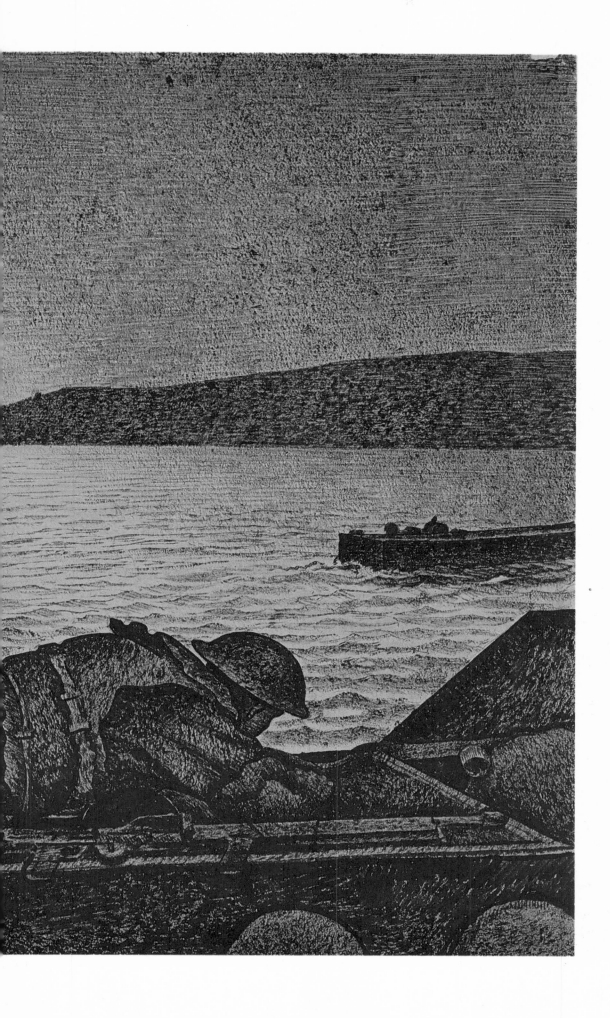

In Naples with gunnery officer, "Guns".

14 August, 1944, Monday
Left Gulfo de Valenco (village of Propriano) in Corsica around 1130 with the convoy. Did sketch and took photograph of forward gun in latter part of morning. Worked on sky and water of watercolour of Italian cruiser in Naples in afternoon. This is the big day so I didn't feel much like doing routine drawings. We took the troops aboard in the morning. We heard bombing or gun-fire around 0900 — Action Stations shortly after. It was weird in the wardroom illuminated by several red bulbs — the nurses, French Officers, etc. I still didn't know whether I was going with the L.C.A.'s or not but finally got in place in Don Graham's craft. We left the ship at 1035. I was lying on the starboard deck behind the coxswain. Water very calm, a dark night, sky half obscured by clouds, slightly misty. We sailed on. An aircraft passed over sometime around midnight. At this time, also we saw flares lighting up and heard occasional gun-fire on the left. We were heading roughly north-west. Everyone very tense. Around 0130 an L.M.G. or rifle fired at us. The bullets passing over from it. It stopped. We were now doing one knot per hour. At 0200 we touched the beach and the troops left us — there was no opposition, apparently, although we did hear

several odd shots and bursts. We left the beach and headed out to sea. We stopped and changed course several times because of the suspected presence of German E-boats or Chasseurs. Around 0315 we saw flashes of gun-fire and then something burst into flames. We thought it might be the PRINCE DAVID and later thought it was the DIDO, but it turned out to be a German frigate. Shortly after we saw an exchange of tracer west of the burning ship. We got back to the PRINCE DAVID at approximately 0700 on 15 August 1944, and had some coffee. Then action stations. Shortly after the L.C.M.'s returned.

15 August, 1944, Tuesday
A P.T. came alongside with about nine survivors, from the German ship. They were burned and looked shocked. An unpleasant sight. Some had skin hanging down from their hands. I shaved after seeing them, to restore my morale. We now moved east into the main assault fleet. I made a lot of drawings of various types of ships. There was some gun-fire ashore. Our L.C.M.'s went in to discharge their cargo. That evening we arrived in Ajaccio, Corsica.

16 August, 1944, Wednesday
I found in the morning that we were anchored very close to shore, in Ajaccio, Napoleon's birthplace and the site of his tomb. I started a watercolour but was thwarted by the ship moving around. In the afternoon I did a watercolour of the PRINCE HENRY refueling. That evening I went ashore at 1930 alone and walked through my first French town. All apartment buildings (or tenements), no houses. Public urinals in plain view of all. Some palms, very pleasant town squares and no war damage.

21 August, 1944, Monday
In Ajjacio in morning, made figure study and started a nocturne from "D" night in drybrush with black ink. Very engrossed, worked from 1130 until 1730.

23 August, 1944, Wednesday
Did no work today — still in Ajaccio. Had shower in morning, then a bunch of us hitchhiked to the beach and spent the afternoon swimming, lying in the sun. The news of the liberation of Paris reached Ajaccio just before we got ashore, tricolours were hanging out everywhere. Children surging in mobs, shouting "Vive De Gaulle", guns firing — Bofors, M.G. coastal, firecrackers. One Frenchman rushed into the street behind us and emptied a huge 45, into the air, fortunately. Had a marvellous afternoon, returned to PRINCE DAVID for supper. Robert, the French liaison officer, bought everyone a drink, someone played the piano and everyone sang the *Marseillaise*. Rumania capitulated tonight.

H.M.S. DIDO 13 Aug. 1944, pen and ink wash on paper, 10 × 12¹/₂,
Coll. Alex Colville

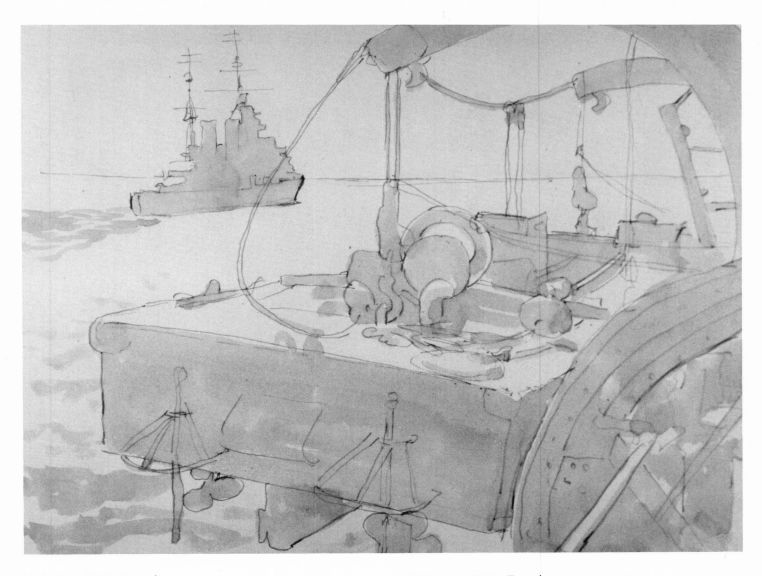

H.M.S. DIDO 13 Aug. 1944, pen and ink wash on paper, 10 × 12¹/₂,
Coll. Alex Colville

26 August, 1944, Saturday
Pressed clothes in morning went ashore at 1330 and did
some sketches of the harbour where the liberty boats land.
Went up to wardroom to party — Canadian nurses from
Casserta — Danced until 2330 when almost everyone went
ashore. Talked to John on quarter-deck until 0100. Wrote
Rhoda. Went to sleep around 0200.

27 August, 1944, Sunday
Went to Divisions in morning, started to work out drawing
from yesterday's sketches. Decided I would do it in oils, not
watercolours. Slept until 1530 after lunch. Talked to
Captain at tea about returning to U.K. He is going to try to
get me back on the PRINCE ALBERT leaving tomorrow. Went
ashore at 1630 with Buck and went to Med. Air Transport
Command on off chance of getting flight to U.K. but
discovered I needed movement order, etc. Returned at
1750 and had supper, saw film in evening — Humphrey
Bogart.

29 August, 1944, Tuesday
Spent all morning doing watercolour of painting ship. Went
ashore at 1330, called at Cdn. B.A.P.O., but there was no
message for me. Guns and I wandered around. I bought a
pair of shoes for the baby, but was unable to find any
watercolours. We went east of the Via Roma and saw the
new Post Office and a lot of modern buildings near it. They
are the most beautiful architecture I have seen, with the
exception of Peter Jones department store in Sloane Square,
London. Returned to ship at 1800 and read A. A. Milne's
Mr. Pim Passes By all evening.

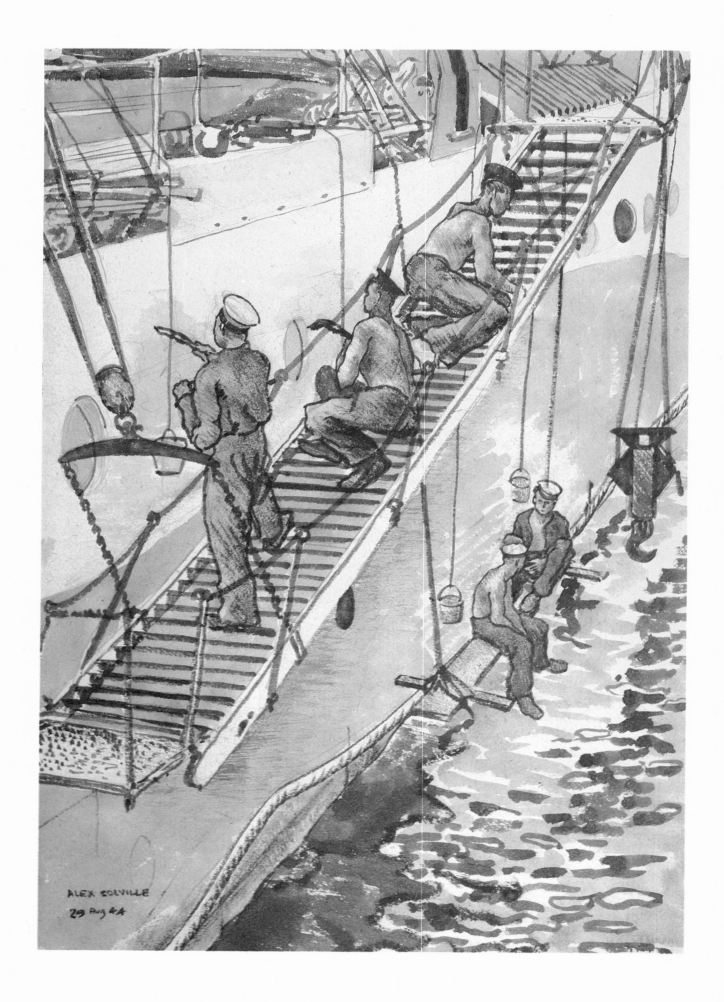

Painting the Ship 29 Aug. 1944, Watercolour Drawing, 22¹/₂ × 15¹/₄, 10196

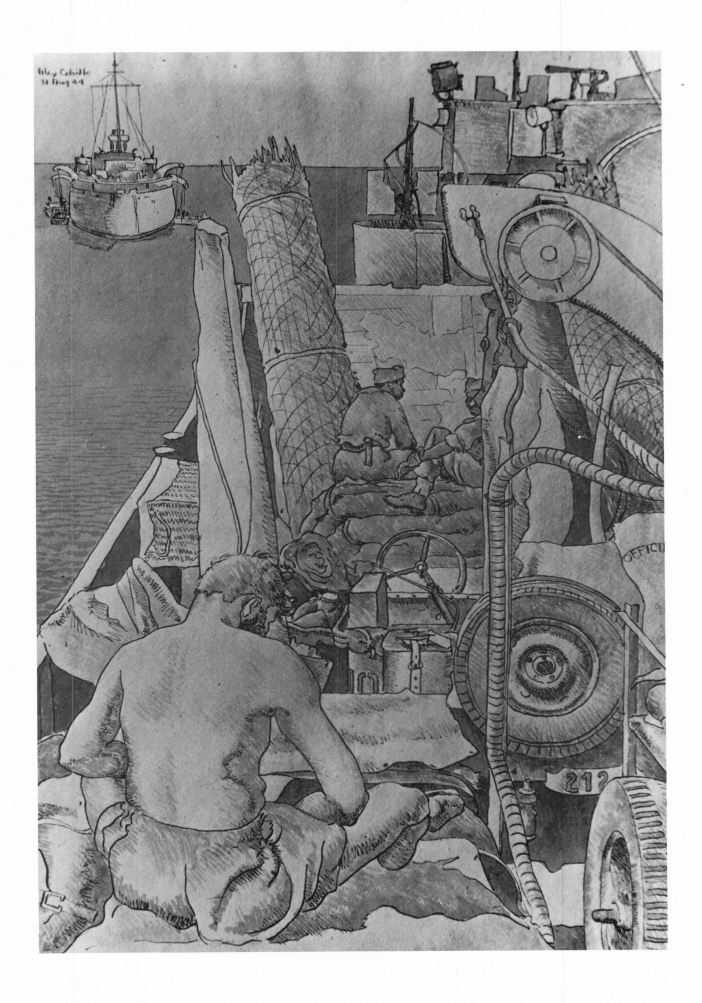

A Loaded L.C.M. 11 Aug. 1944, Watercolour Drawing, 22¹/₂ × 15¹/₂, 10193

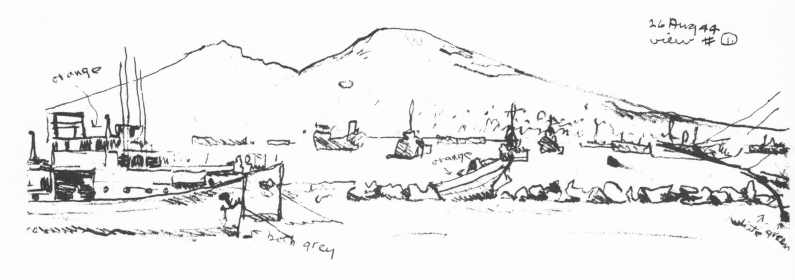

Sketch of Harbour, Ajaccio 26 Aug. 1944, pencil (2 sheets) on paper,
2 × 5¹/₂ × 8, Coll. Alex Colville

30 August, 1944, Wednesday
Went to Opera in afternoon saw "Tosca". Was ready to
leave after first act but 2nd and 3rd were better. I have no
desire to see another opera. I believe that Italians are
incapable of producing any vital art — things are
accomplished in painting and music but the impetus is
lacking. Read G. B. Shaw's *Back to Methuselah*. Preface
very thought-provoking — must read it to Rhoda — it will
show us that we agree on religion. It made me realize that
Rhoda is much wiser than I. My beard is now three days
long, and the M.O. (Paul) says I can shave it off tomorrow.

1 September, 1944, Friday
Allies in Sedan, says 0900 news. Worked all morning and
finished watercolouring yesterday's drawing. I like it but no
one knows what it is. We have now been in Naples a week,
very tedious. Went ashore at 1330 — bought a dog for
Graham* (300 lira) and a cameo for Rhoda (400 lira). I am
now broke. Had headache in evening — lay up near radar
tower until 2045 when show started. It was Betty Grable —
so I left and wrote to Rhoda.

5 September, 1944, Tuesday
Saw Capt. Mislap in morning. I am to report to him with my
luggage at 1300 so Pray God I may soon be getting out of
here.

*Graham Colville. Born to Alex and Rhoda Colville, July 15, 1944.

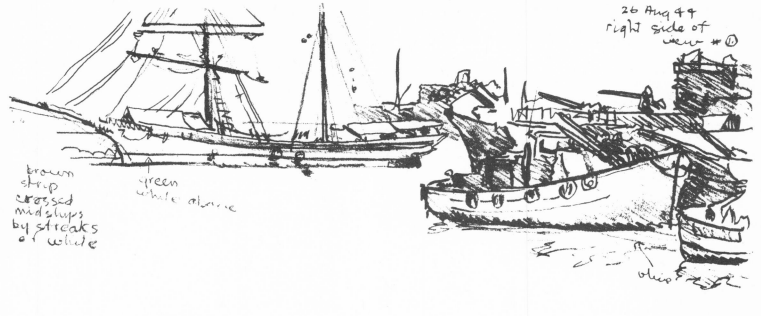

brown
strip
crossed
midships
by streaks
of white

green
white above

26 Aug 44
right side of
view # ①

*I went back to England on a troopship, as I had been told to
do. I spent about a month painting in London. I did some
big oils.*[3]

Following instructions from the Camp Commandant, I left
London on 17 October and arrived in Aldershot, on the
same day. There I was placed on draft and departed for a
transit camp on 23 October. I embarked in Southampton
24 October, disembarked in Ostend on 25 October and
arrived in Ghent on 26 October. I remained there until 29
October when I was given transportation to 2nd Command
Field History Section Headquarters 2nd Canadian Corps
and reported to Major A. T. Sesia. On 30 October Captain
O. N. Fisher called for me and I reported to Captain J. R.
Martin at Headquarters 3rd Canadian Infantry Division.
This trip from London to Headquarters 3rd Division took
much longer than I had expected; needless to say I could
do no work during these two weeks as I had always to be
packed and ready to move at short notice. The delay in
England was caused by the postponement of the draft,
while the delay in Ghent was due to an acute shortage of
transport.

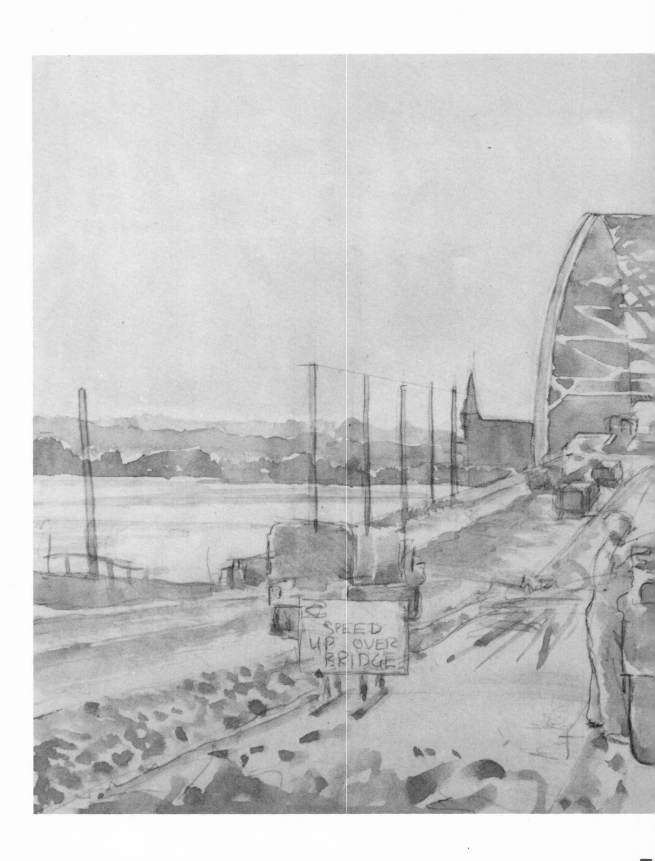

HOLLAND/

At the very end of October I was sent to the continent to join the 3rd Canadian Infantry Division. I joined them on Hallowe'en. They were then in Belgium. I lived at Divisional Headquarters which was often moving. It wasn't terribly dangerous, or a life filled with hardship. I simply did drawings and paintings every day. I stayed with the 3rd Canadian Infantry Division until the end of the war. It all passed very quickly really.

It's very difficult to describe what war is like. Much of nothing happening. The Germans are over there, about three or four hundred yards away in houses and weapon slits, and we were here. At night there would occasionally be patrols and some shooting. I would sometimes go up in these static conditions to an infantry position and make drawings and watercolours.

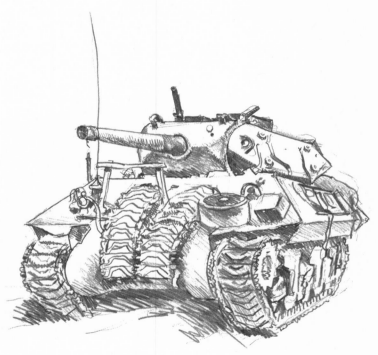

The conditions of work were extraordinarily civilized and humane. We all had a completely free hand. I used to sometimes wonder what I should be doing and I soon settled into a kind of routine. Everyday I would go out with this jeep and driver. Anything I saw that was kind of interesting I would make a drawing or watercolour of it. So it was a kind of genre painting of everyday life in the army.[4]

GERMANY

Nijmegen Bridge — Late Afternoon 15 Nov. 1944, Watercolour Drawing, 12⁵/₈ × 18¹/₄, 13134

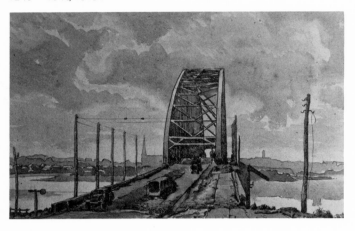

Oostburg 3 Nov 44

The Nijmegen Bridge, Holland Oil on canvas, 36 × 18¹/₄, 12187

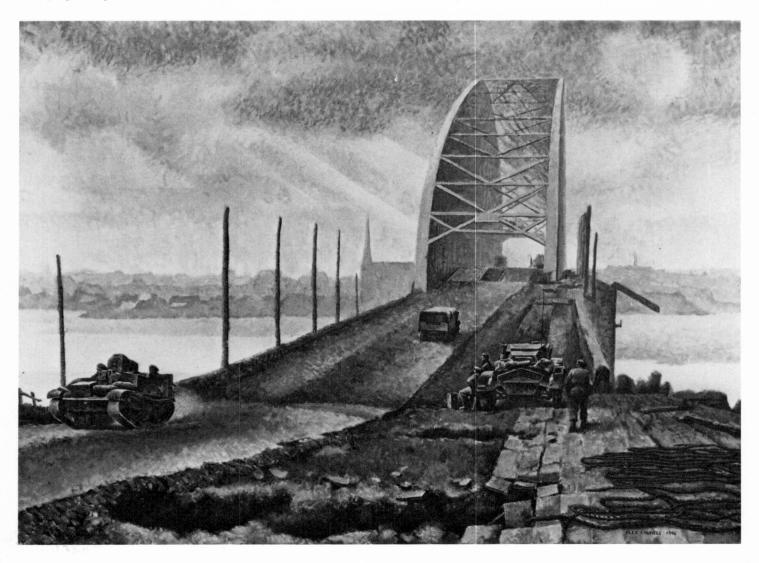

Oostburg 3 Nov. 1944, pen and ink on paper, 9 × 11, Coll. Alex Colville

I went back to Nijmegen a few years ago. I had an exhibition in Arnhem. To my amazement I couldn't remember anything about it. I remembered the bridge area very distinctly, the traffic circle I couldn't remember at all. I remember infantry positions, but the town itself, I couldn't remember. I couldn't remember where I had lived, the street, anything.[1]

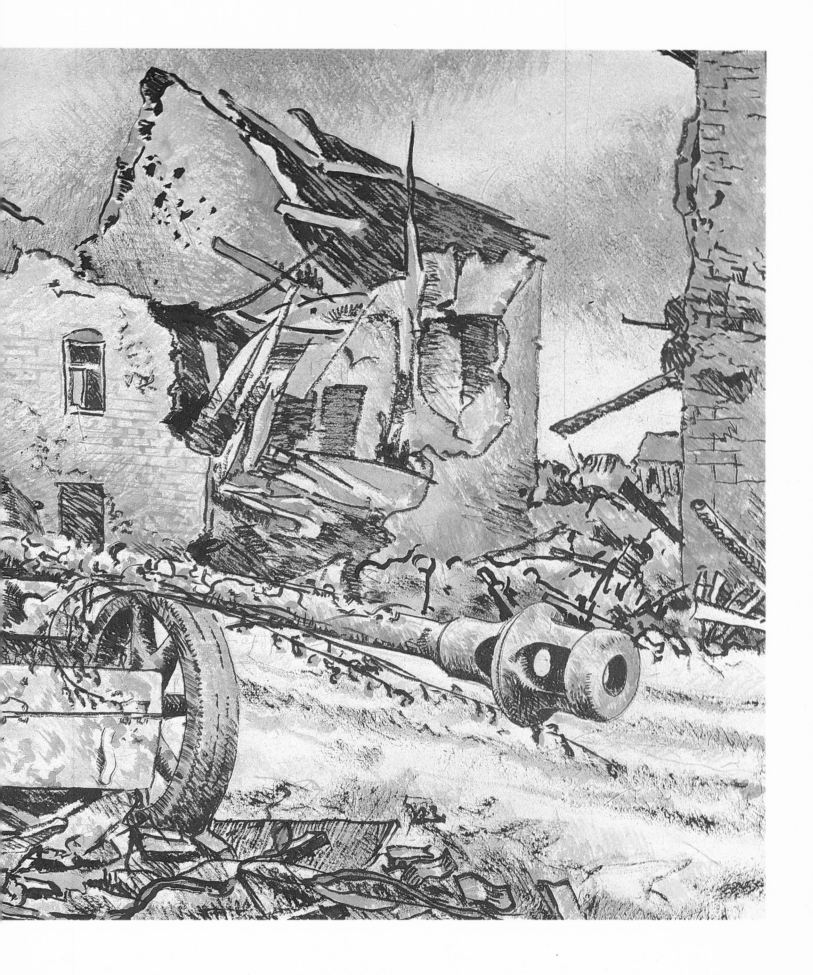

The Remains of a Fortified Town 12-15 Nov. 1944, Watercolour Drawing, 15¹/₂ × 22¹/₄, 12205

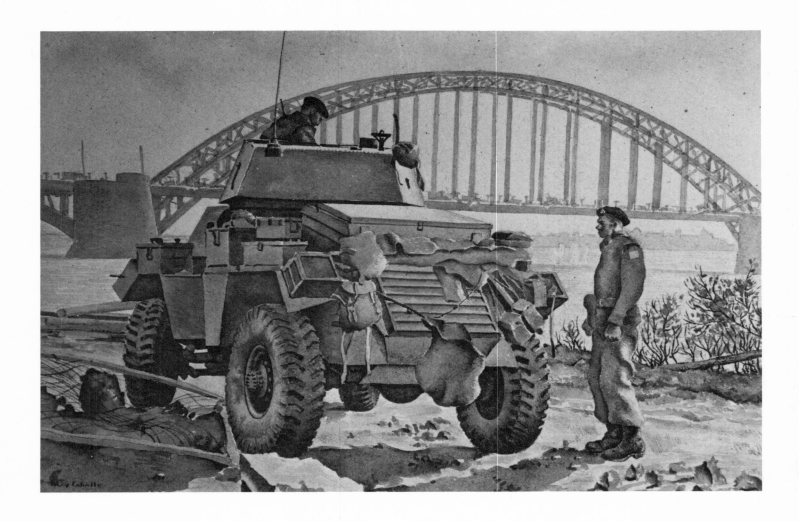

WAR ARTIST'S MONTHLY REPORT

On 30 October I went on a trip to Breskens. Although it was very cold and windy, the subject matter here was fascinating: complete devastation under a cold, blue-gray sky. We didn't stay there long as one of our aircraft dropped a stick of bombs in the area.

On 2 November went to Westkapelle dyke taken the night before and flooded by the Germans. I made a drawing and took several photographs of prisoners of war being carried in vessels through a flooded, flag-draped street. We returned to the town in the afternoon and I coloured my drawing. We both got soaked to the knees in the morning, and in the afternoon our jeep stalled on a badly flooded highway, but we were towed out by a carrier. The weather was excellent all day. The next day I made a drawing of a windmill in Maldegen, then drove to Oostburg, Holland, where I made a drawing of an abandoned enemy 75 mm anti-tank gun against wrecked buildings. This was unfortunately cut by rain. Oostburg was most interesting; I regret that I was unable to do more work there.

On 4 November Division Headquarters moved into billets in Ghent — the beginning of Exercise. I was unable to do much work due to the rather confused conditions. I bought some excellent soft drawing pencils, and some conté pencils, both unobtainable in England.

On 12 November I returned to Nijmegen (the shelling and mortaring there is not frequent enough to be a real danger) to look for subject matter. I was unable to work because of rain, but was fascinated by the possibilities of the bridge, river and wrecked town. This silver-gray atmosphere appeals to me; the natural haziness of the atmosphere is increased by the presence of smoke generators, and the effect is beautiful. That evening I started a half-sheet ink drawing of the scene I had sketched in Oostburg. I worked in my tent by lantern light, which was sufficient since I was working in black ink with dry brush. The weather stayed cold and rainy.

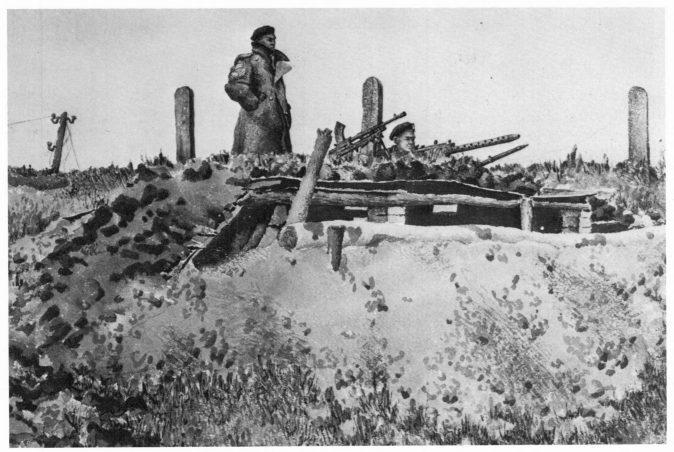

The Watch on the Dyke Nov. 1944, Watercolour Drawing, 15½ ×22½, 12220

The Machine Gun, Germany Dec. 1944, Watercolour Drawing, 15½ × 22¾, 12179

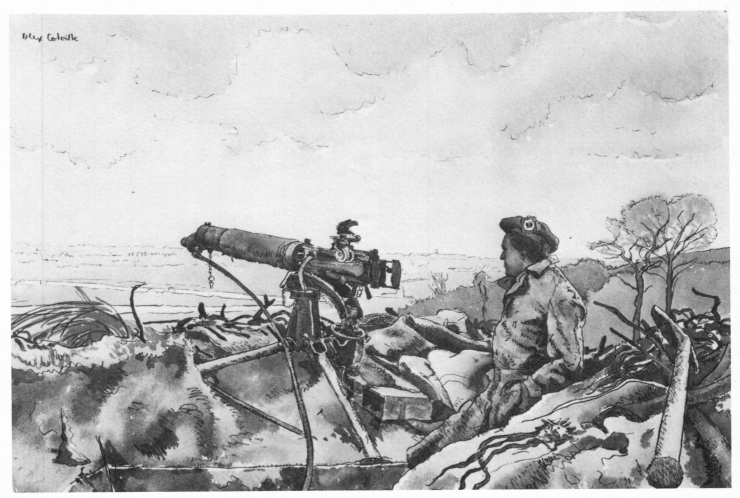

On 16 November I crossed the bridge to A Squadron 7 Reconnaissance Regiment, whose task was to protect the bridge. I met the squadron commander then did a water colour sketch of an armoured car and two troopers against the bridge. The weather was chilly but good. This day was my first experience of working with a unit, and I enjoyed it tremendously. The subject matter was good, and the people in the unit were interested, friendly and cooperative. The following day I went to B Squadron, also across the bridge, and worked on a watercolour of a machine gun emplacement in the dyke. I visited the squadron commander who almost overwhelmed me with hospitality.

The next three days I spent on a watercolour, *Troopers Guard the Nijmegen Bridge,* from my sketch made on 16 November. This is the most finished watercolour I have done, but since the weather was bad I had no transport and the subject was good. After completing this work I started another watercolour of a provost standing at a half-flooded crossroads — seen from my window. I worked on this the following day and completed it on the next day, 24 November.

On 27 November I visited Major Sesia at Headquarters 2nd Canadian Corps to receive instructions concerning my duties at the Canadian War Artists' exhibition in Brussels. I was greatly impressed with the quality and the hanging of the work, and with the art gallery itself, so I took several photographs of the three rooms which contained the exhibition. These, I feel, may provide some record of a most successful undertaking.

On 4 December drove into Nijmegen looking for engineer subjects. I was unable to find anything interesting, so I decided to try the artillery. Drove to 12th Canadian Field Regiment. I made a sketch of a detachment laying its gun on the zero line. I found a good subject at another battery and made a watercolour sketch of it.

On 6 December I remained indoors and worked on a large watercolour, driving in the late afternoon into Nijmegen. Here I made a sketch of the flooded land south of the River Waal. The next day I painted *The River Waal in Flood,* from my sketch.

On 8 December I visited 11 Battalion which was in a beautiful semi-wooded valley. It was quite cold but sunny, so I did my first large outdoor watercolour — *B-1 Gun.* The rest of the day I spent on *Laying on Zero Line.*

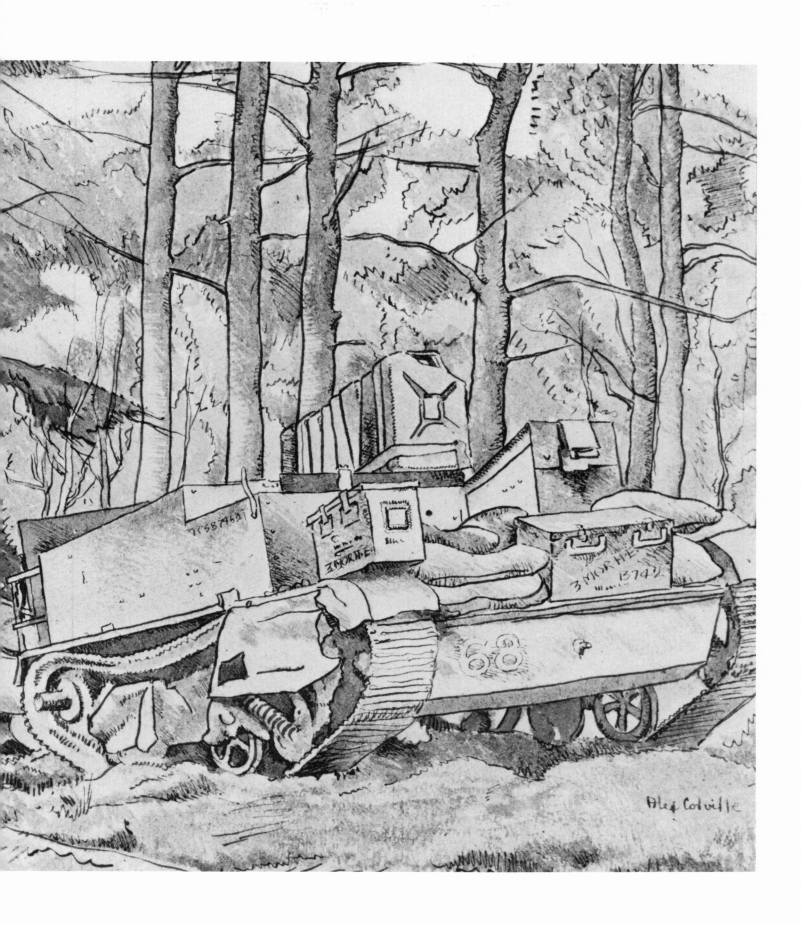

Carriers in a Wood 2 Dec. 1944, Watercolour Drawing, 14¼ × 18⅞,
12132

On 10 December I was able to get to a platoon position where I was screened from enemy observation and painted *Platoon Position in an Orchard*.

The war artist would spend a certain time in the field, in theatres of war, and a certain amount of time back in London or Ottawa doing bigger paintings. Studio works from sketches. In my case due to accidents of time, I spent the whole part of my time in the field. Except for a brief period in London after the Italian operation, the oils were all done after the war. There was only one war artist in each division, a division being 15,000 men. We were often living in pup tents. The winter was quite long and the German-Holland area has a severe climate. What you could do in the field was clearly limited. What we did were watercolours and drawings which were portable. I actually did some in my pup tent on a rainy day. I would make watercolours from rough drawings. I had brought a reducing glass which allowed me sitting in my pup tent to look at what I was doing as if I was twenty feet away. In my studio I always sit back at the other end of the room to look at what I am doing. The reducing glass served to overcome this technical problem. Limitations like this are actually intriguing and stimulating.[3]

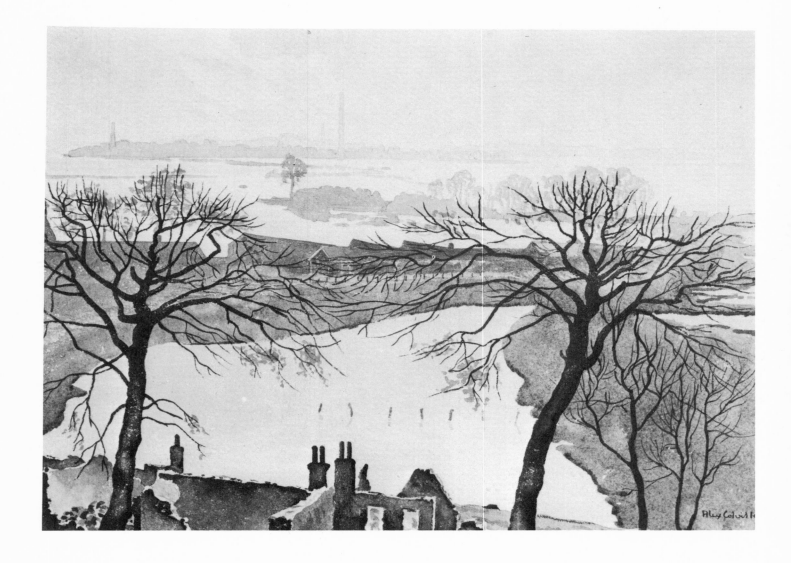

The River Waal in Flood Dec. 1944, Watercolour Drawing, 15½ × 22¾, 12206

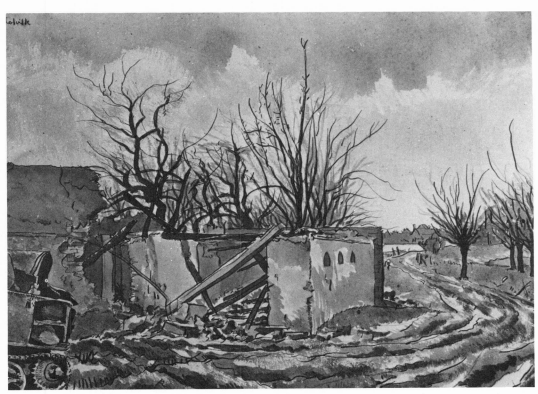

Platoon Positions in an Orchard 10 Dec. 1944, Watercolour Drawing,
15¼ × 22½, 12196

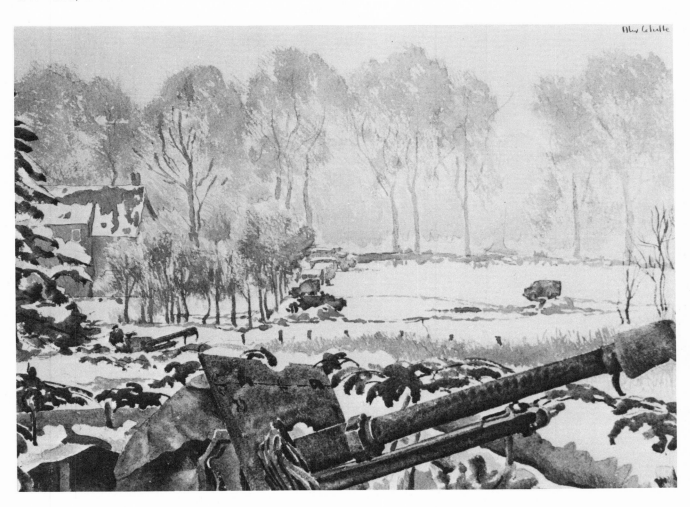

Field Guns in the Snow 9 Dec. 1944, Watercolour Drawing,
15¼ × 22¾, 12154

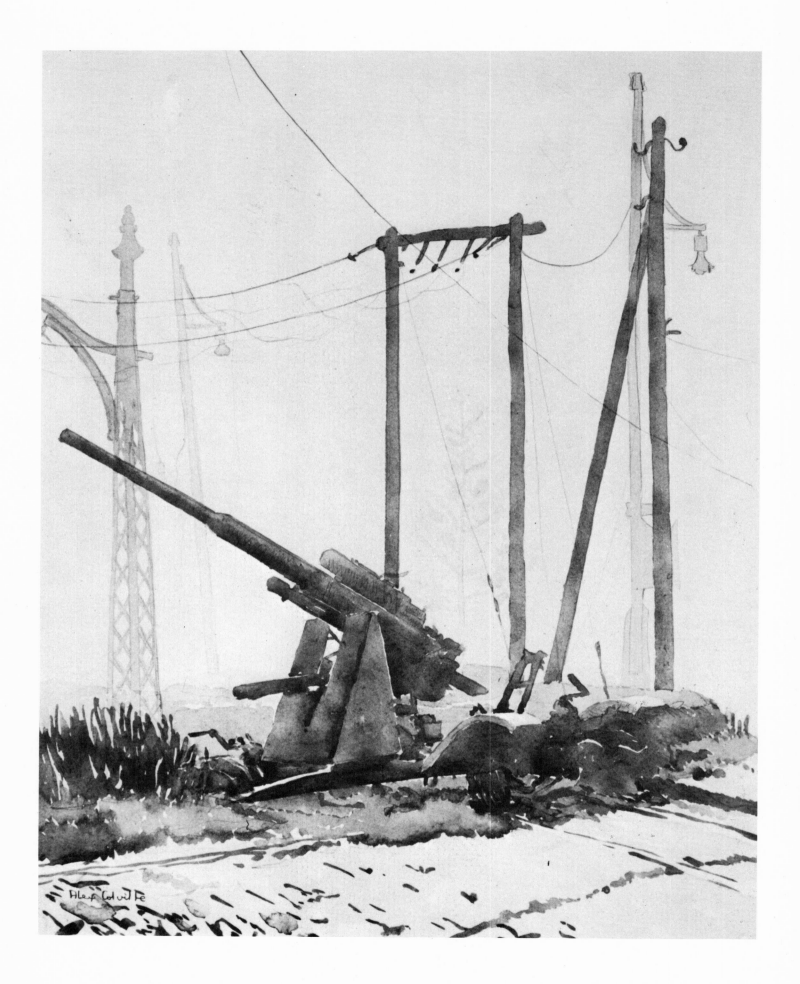

A German Gun in Fog, Holland 19 Dec. 1944, Watercolour Drawing,
22³/₄ × 15⁵/₈, 12163

On 13 December I went to A Company Regina Rifles where I did a drawing of two riflemen cleaning a Bren gun beside their dugout.

On 15 December I drove all morning looking for subjects. That afternoon I found one and did *Derelict Gliders*. As it was very cold, I worked inside the jeep, looking out the windshield, and using an oil heater to keep my hands warm and to dry washes.

On 16 December I visited Battalion Headquarters North Shore Regiment. Arrangements were made for me to go up to B Company the next day. I rose at 0400 hours 17 December and went to B Company Headquarters arriving at 0545, before first light. Shortly after my arrival, a German patrol attacked and captured an outpost about 600 yards away on our left flank. Once it became light, it was impossible to move out of the Company Headquarters except to a shattered barn which was being used as a 3″ mortar observation point about 5 yards away from the dugout. It rained intermittently all day, but in the morning I was able from the attic of the barn to do a sketch of parachutes in No Man's Land. In the afternoon I started a large pen and watercolour of the Company Headquarters.

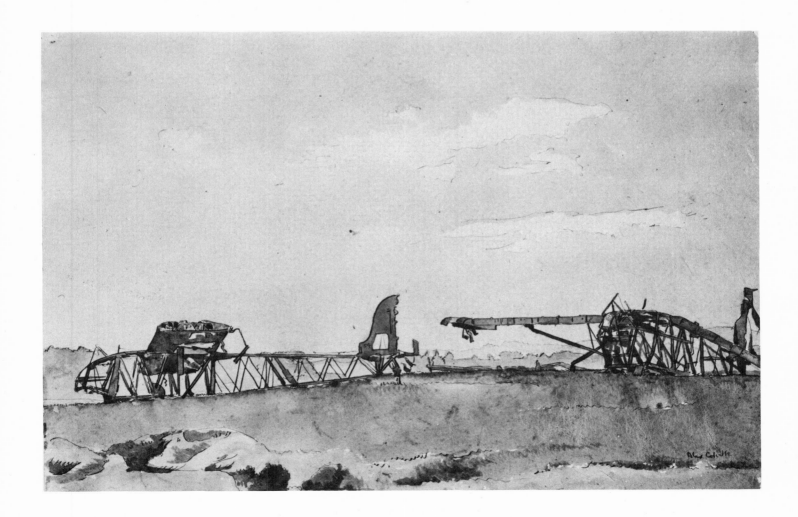

Derelict Gliders of an American Airborne Division 15 Dec. 1944, Watercolour Drawing, 15 × 22, 12146

The image contains the handwritten labels: *yellow*, *green*, *green*, *sand*, *yellow*, and *green*.

Sketch for Parachutes in No-Man's-Land pencil on paper, 9 × 11, Coll. Alex Colville

On 18 December it rained and I completed yesterday's study. The next day I went into Nijmegen and painted a wrecked 88 mm gun in one of the roundabouts — *Enemy Gun in Fog*. On 20 December I returned to the same area — it was still foggy — and painted *A Light Anti-Aircraft Crew near the Nijmegen Bridge*. As there is no war artist at Corps now, I consider that it is quite in order that I paint some 'Corps subjects'. This one fascinated me.

One evening a General came into our junior officers' mess and talked in an informal way about the Ardennes offensive. He used a vivid figure of speech: the Germans are like a man in a tunnel and the tunnel is starting to collapse and they are holding it up with their arms. They had penetrated a long way and now were being hammered from all sides.[1]

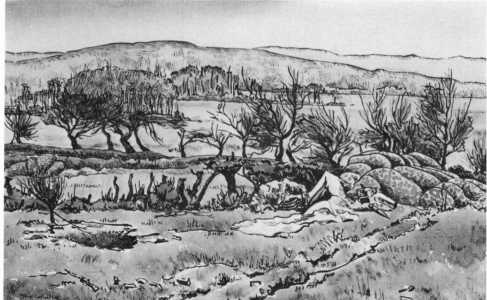

Parachutes in No-Man's-Land, Holland 17-30 Dec. 1944, Watercolour Drawing, 15$\frac{1}{2}$ × 22$\frac{3}{8}$, 12193

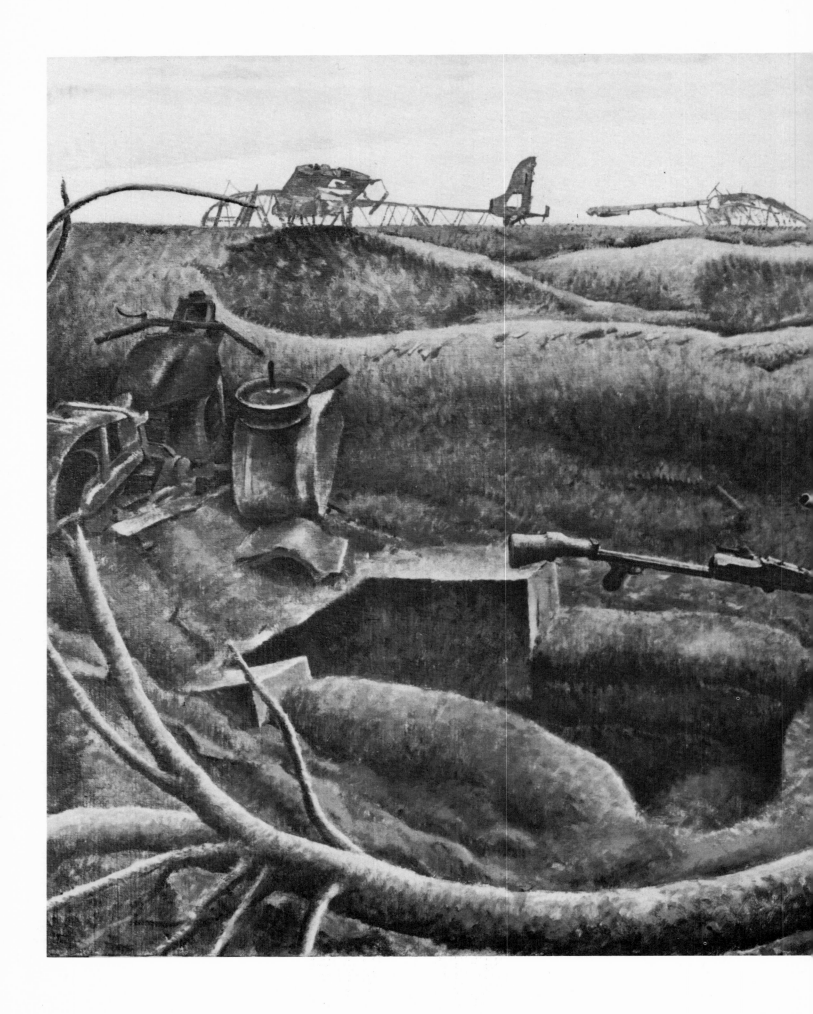

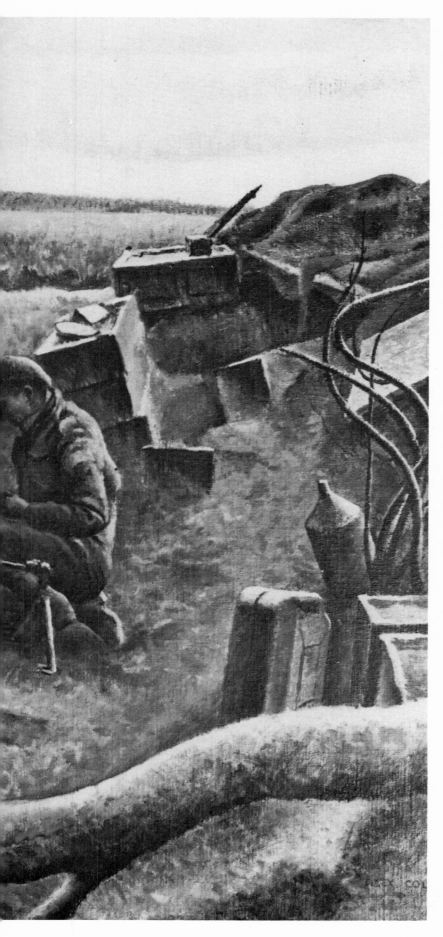

THE ROAD TO NIJMEGEN

December my dear on the road to Nijmégen
between the stones and the bitten sky was your face

Not yours at first but only the countenance of lank canals
and gathered stares too rapt to note my passing
of graves with frosted billy-tins for hats
of bones of tanks beside the stoven bridges
of old men in the mist who hacked at roots
knifing the final chips from a boulevard of stumps.

These for miles and the fangs of homes but more the women
wheeling into the wind on the tireless rims of their cycles
like tattered sailboats tossing over the cobbles
and the children groping in gravel for knobs of coal
or clustered like wintered flies at the back of messhuts
their legs standing like dead stems out of their clogs

Numbed on the long road to mangled Nijmégen
I thought that only the living of others assures us
the gentle and true we remember as trees walking
Their arms reach down from the light of kindness
into this Lazarus tomb

So peering through sleet as we neared Nijmégen
I glimpsed the rainbow arch of your eyes
Over the clank of the jeep your quick grave laughter
outrising at last the rockets
brought me what spells I repeat as I travel this road
that arrives at no future

and what creed I bring to our daily crimes
to this guilt
in the griefs of the old and the tombs of the young

Earle Birney
Holland, January 1945

Nijmegen Salient Dec. 1944, Oils on canvas, 30 × 40, 12188

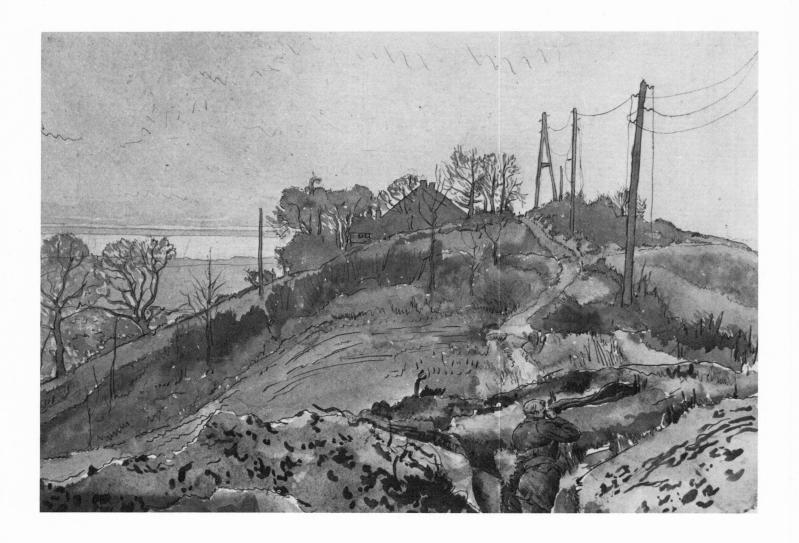

A Machine Gun Position in Germany 21 Dec. 1944, Watercolour Drawing, 15³/₈ × 22³/₈, 12180

Painting in cold weather presents several problems. On the average winter day I find it impossible to work outside for more than an hour at a time as after that my hands are numb. Watercolours will not dry outdoors, and sometimes even freezes on the paper or in the pans. One solution to these problems is to drive the jeep to a selected point of view and paint from inside the vehicle, warming the interior with an oil heater. Another, in places where the jeep cannot be taken, is to paint outdoors, but to go into a dugout or house at intervals to dry washes before a stove. A third solution is to make quick drawings on the spot and paint large works in billets from these sketches. At present I find this last method most satisfactory, for, although it is slow, my impressions cohere immediately after being registered.

Frost in a Wrecked Town 27 Dec. 1944, Watercolour Drawing, 22¹/₈ × 15³/₈, 12161

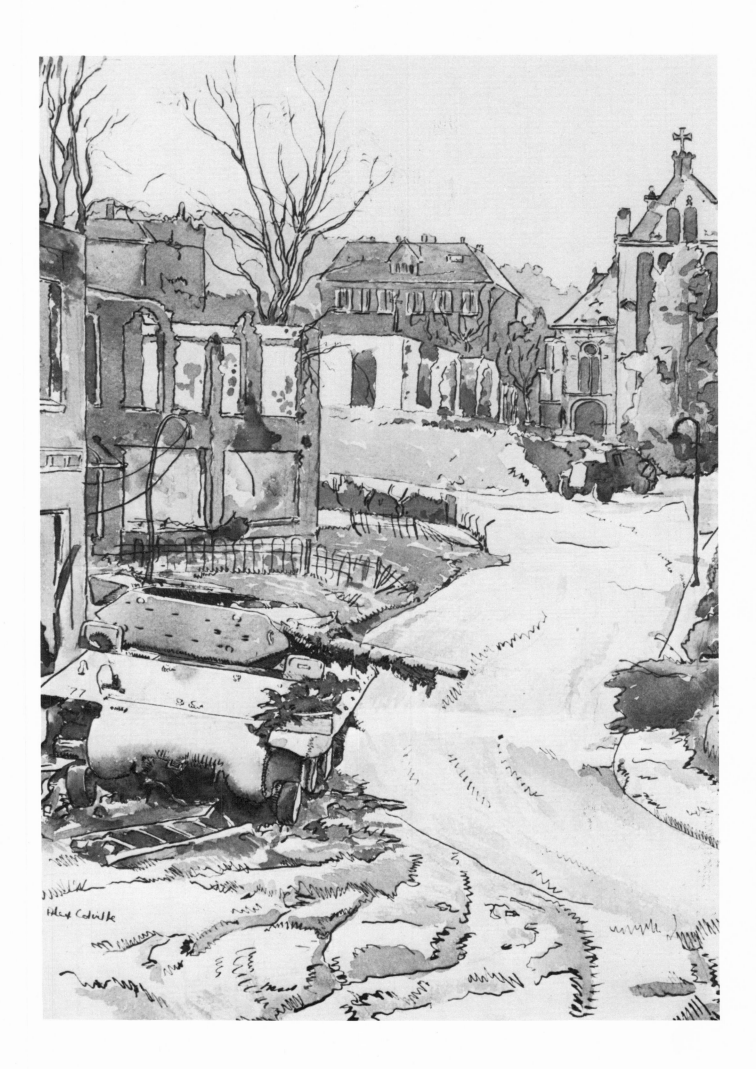

Alex Colville

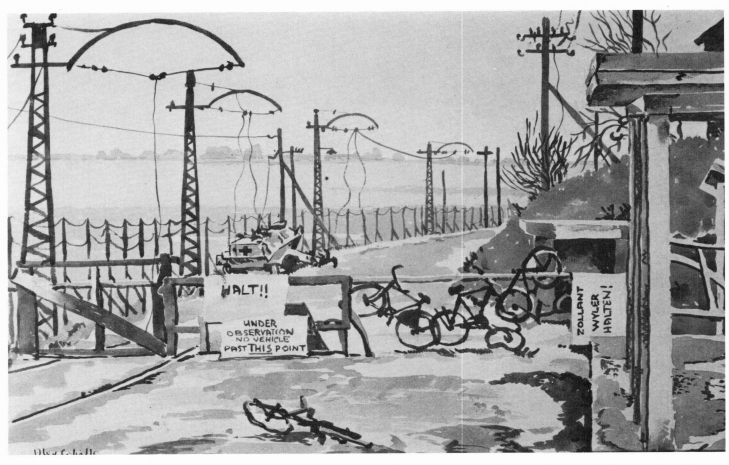

The Barrier, Holland 10 Jan. 1945, Watercolour Drawing, 22 × 18, 12117

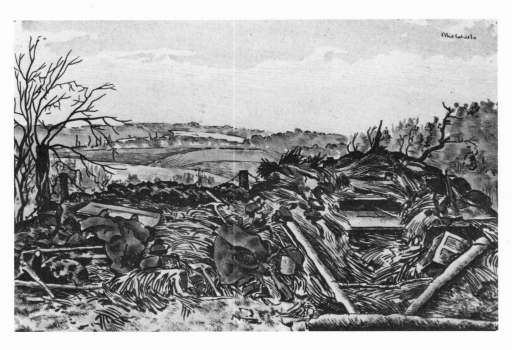

A Littered Dugout, Holland 6 Jan. 1945, Watercolour Drawing, 15³/₄ × 22¹/₂, 12176

One of the border crossings is just outside Nijmegen. The Germans were on the other side in some houses and various units were in various places in the low hills overlooking this valley. One of these positions was on a street. Yellow streetcars that had been shot up were still there. There was a barricade and a German eight-wheeled armoured car all shot up on the side of the road. These crossings seemed to have a symbolic meaning to me. [1]

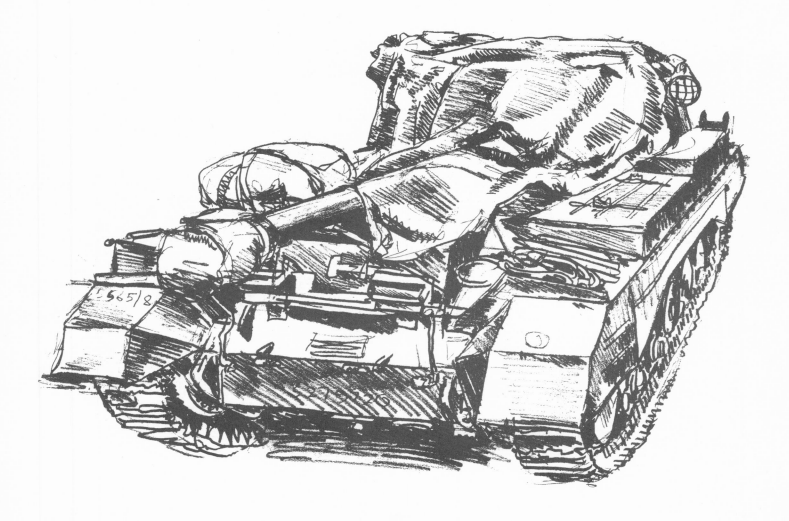

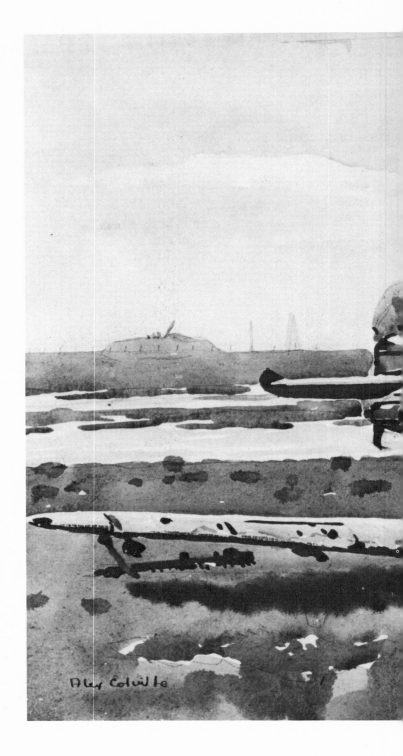

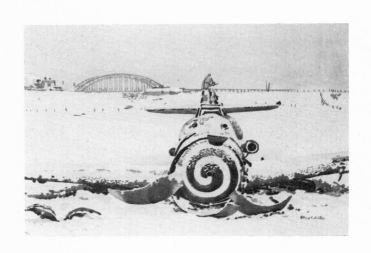

Me. 109 In the Snow, Holland 11 Jan. 1945, Watercolour Drawing, 14 × 20, 12183

The Raider 4 Jan. 1945, Watercolour Drawing, 13¹/₂ × 22¹/₄, 12203

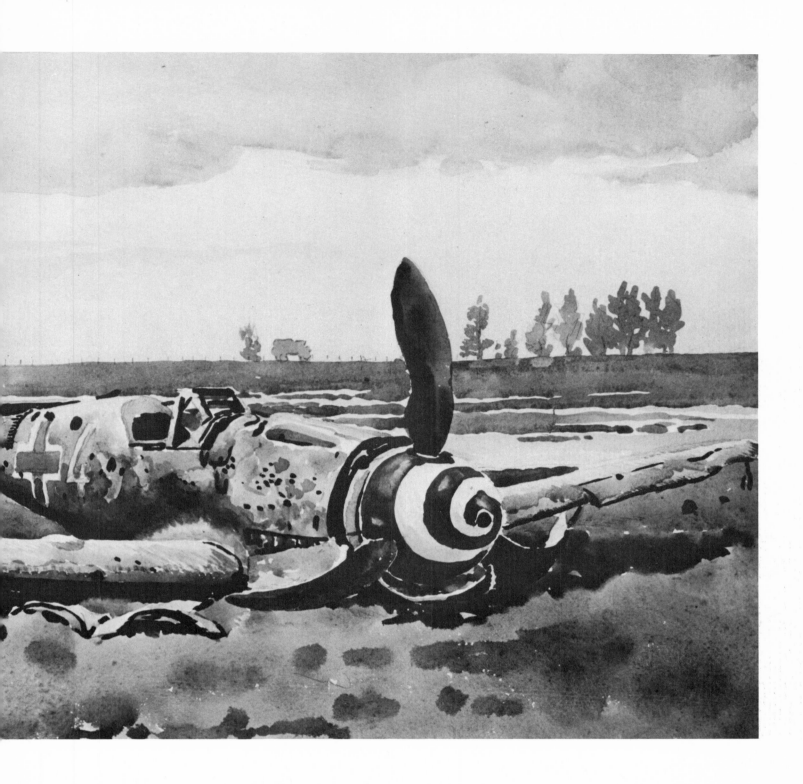

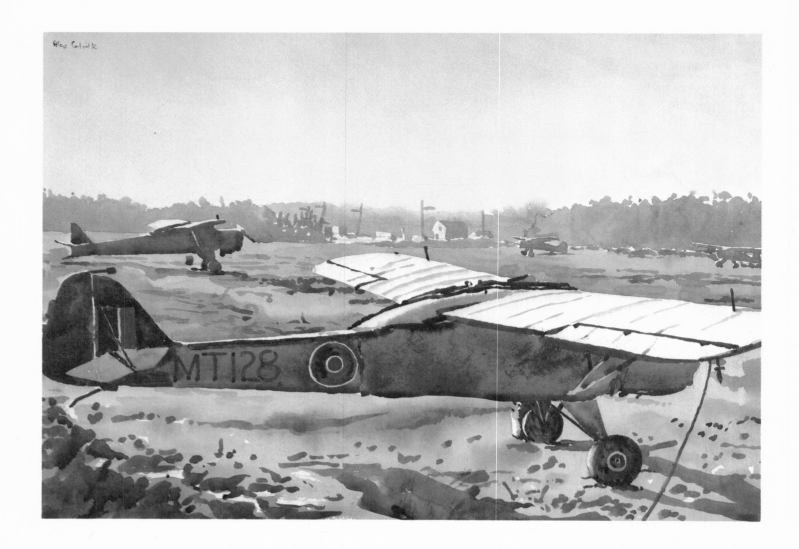

On 21 December I visited a high knoll in Germany overlooking the flat ground south of the River Waal. It was foggy. I painted *MG Positions in Germany* showing the trenches, the misty knoll, and the flat half-flooded country beyond. I returned to this position the next day and painted *The Machine Gun* — a Vickers with a guard lounging beside it and gazing out toward the German positions on the flat ground.

On Christmas I went to De Ploeg where I painted *Frost on Aircraft* from the jeep. It was very clear and cold.

On 29 December I matted 18 watercolours. That afternoon, following instructions, I showed them by appointment to Lieutenant General Simonds. Almost immediately he asked me about my pre-military occupation and experience. I outlined this and then showed my works. There was no expression of praise or condemnation but I gathered that the paintings met with his favour. During the showing the General Officer Commanding asked me if I would paint larger works than these. I explained our method of working approximately six months in the field then several months in London and said that I hoped to be able to paint large canvases after this attachment. I then explained that I would improve upon and dramatize the composition, possibly embracing details from other sketches, and aiming at a more powerful effect. During this interview I was greatly impressed with the

Frost on an Aircraft 25 Dec. 1944, Watercolour Drawing, 15⅝ × 22, 12162

intensity bestowed upon each watercolour, the piercing logic of each question, and the attentive reception to each answer.

On 30 December I remained indoors and did *Parachutes in No Man's Land* from my sketch of 17 December. I felt that I wanted to do something expressive of war, rather than of local atmosphere, so I worked in a powerful medium, using black ink, dry brush and pure watercolour, but I feel that the loss is compensated for by the resultant strength. I realize that my front-line works may be criticized as lacking action, and appearing quiet and peaceful but it is my experience of static warfare that during daylight the front line is a deserted expanse of country with live figures very much out of sight.

On 31 December I painted *Flak Over the Nijmegen Bridge*, from the south side of the River Waal. Numerous flying bombs passed over and I included one in my painting. It was unusually cold and clear and I was struck by the effect caused by the low sun. I have done numerous paintings of this bridge; it is an interesting subject and, I believe, an important one from a documentary point of view.

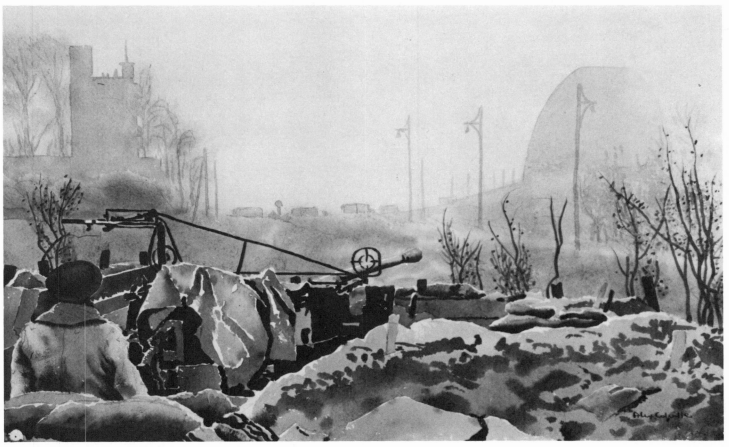

Anti-Aircraft Gun Near Nijmegen Bridge 20 Dec. 1944, Watercolour
Drawing, 15$\frac{1}{2}$ × 22$\frac{3}{4}$, 12113

Flak Over the Nijmegen Bridge 31 Dec. 1944, Watercolour Drawing,
15$\frac{1}{2}$ × 22, 12158

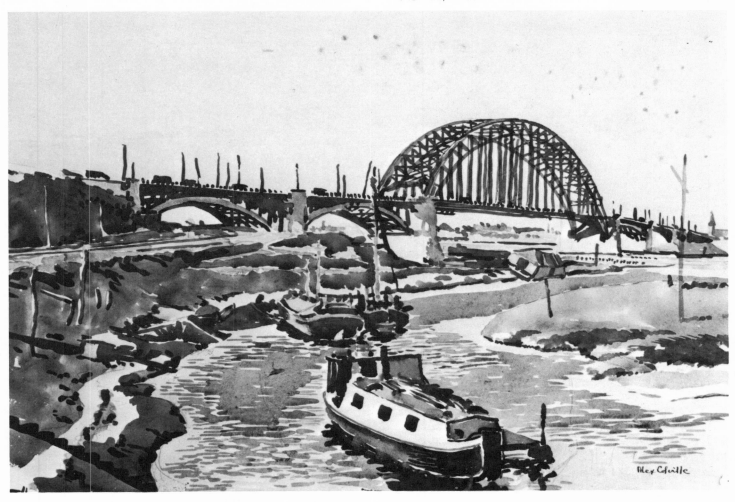

Dugout Near Nijmegen 7-9 Jan.1945, Watercolour Drawing, 15³/₈ × 22¹/₂, 12148

On 8 January the Commanding Officer took me from here to the marshalling area in a wood on the reverse slope of a hill. There had been a heavy snow during the night, so the men, approximately ninety in strength, were dressed in white snow suits. To watch the attack I went to a trench which overlooked the enemy position, about 1600 yards away. Visibility was poor and the enemy area soon became obscured by smoke. I saw nothing of use to me.

I stayed indoors on 9 January and completed *In a Dugout*, one of my most finished works. Most of the next day was spent in arranging for my driver to go on leave, but in the afternoon I started *The Barrier* from a drawing, the weather being still cold and snowy. The following morning I finished this picture, which I painted in watercolour and tempera on gray paper. That afternoon I painted *An Me109 in Snow* from inside the jeep. The roof was covered with ice, which melted and leaked through after we lit the oil heater. It was snowing furiously outside and flakes infiltrated through the curtains, spotting the sky on my watercolour. In spite of these trials, the subject was so good (very bleak and colourless) that I felt fairly satisfied with the finished work.

On 6 January I took a photographer of the Canadian Film and Photo Unit to No. 5 Platoon, North Shore Regiment, one section of which is living in mud and straw dugouts. Here I painted *Littered Dugouts* in ink and watercolour while the photographer took moving pictures of me. I finished the painting that afternoon in my room. I showed three paintings of North Shore Regiment to the Commanding Officer, Lieutenant Colonel A. J. Rowlie, who gave me permission to witness a raid planned for the next day. The rest of the day was spent working on a large ink and watercolour from the morning's sketches.

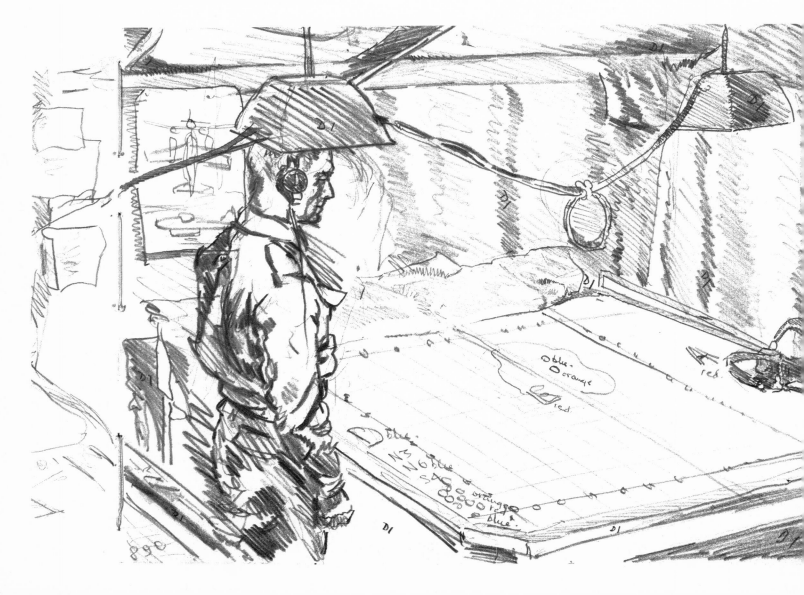

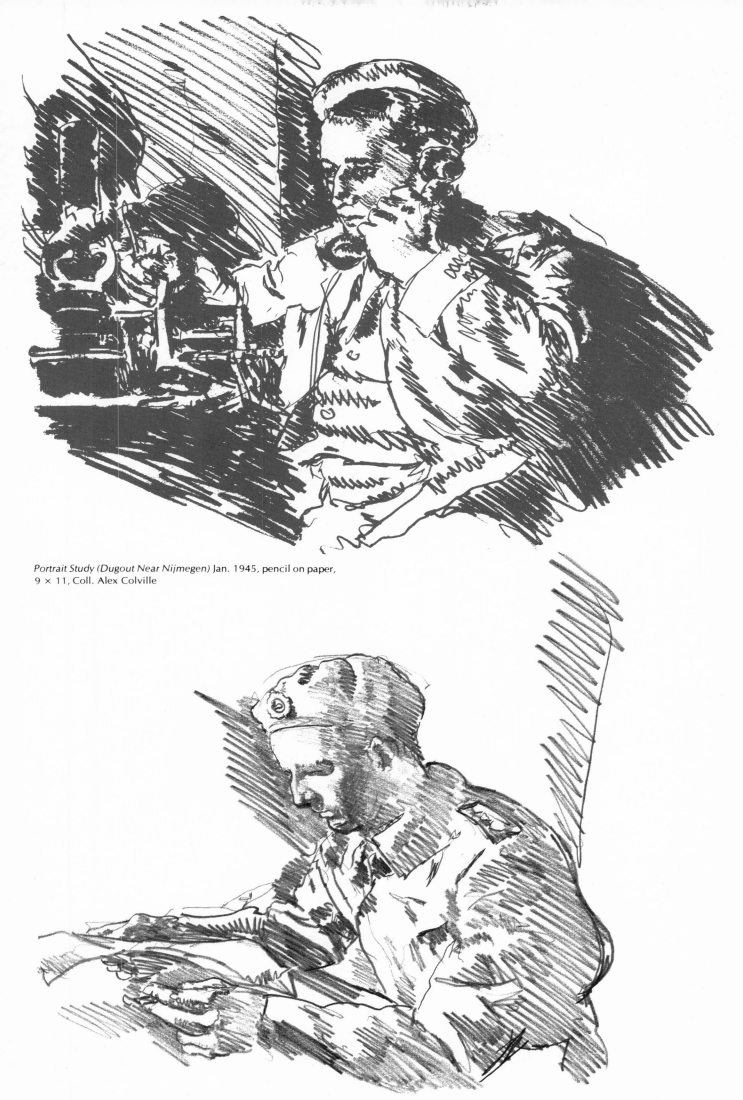

Portrait Study (Dugout Near Nijmegen) Jan. 1945, pencil on paper,
9 × 11, Coll. Alex Colville

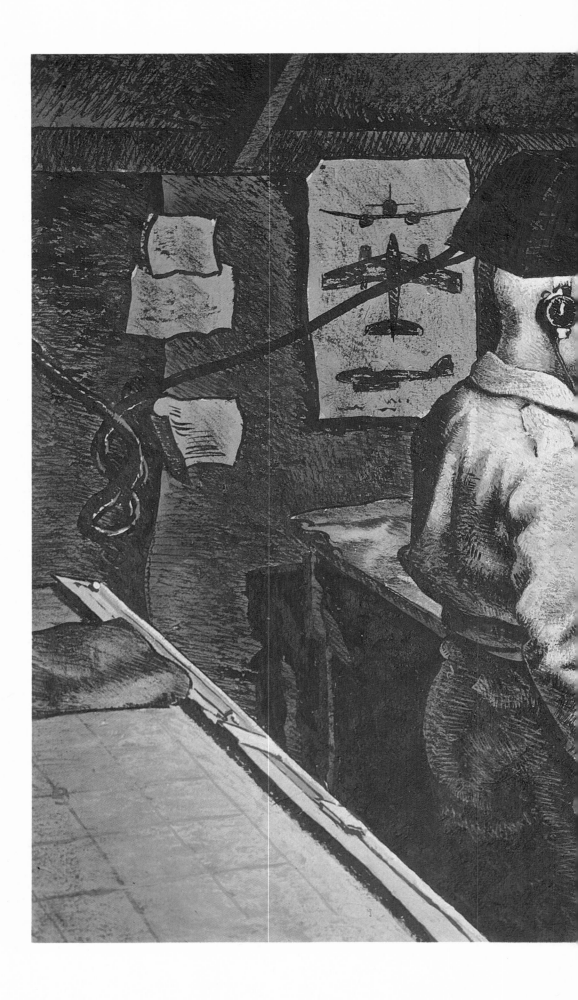

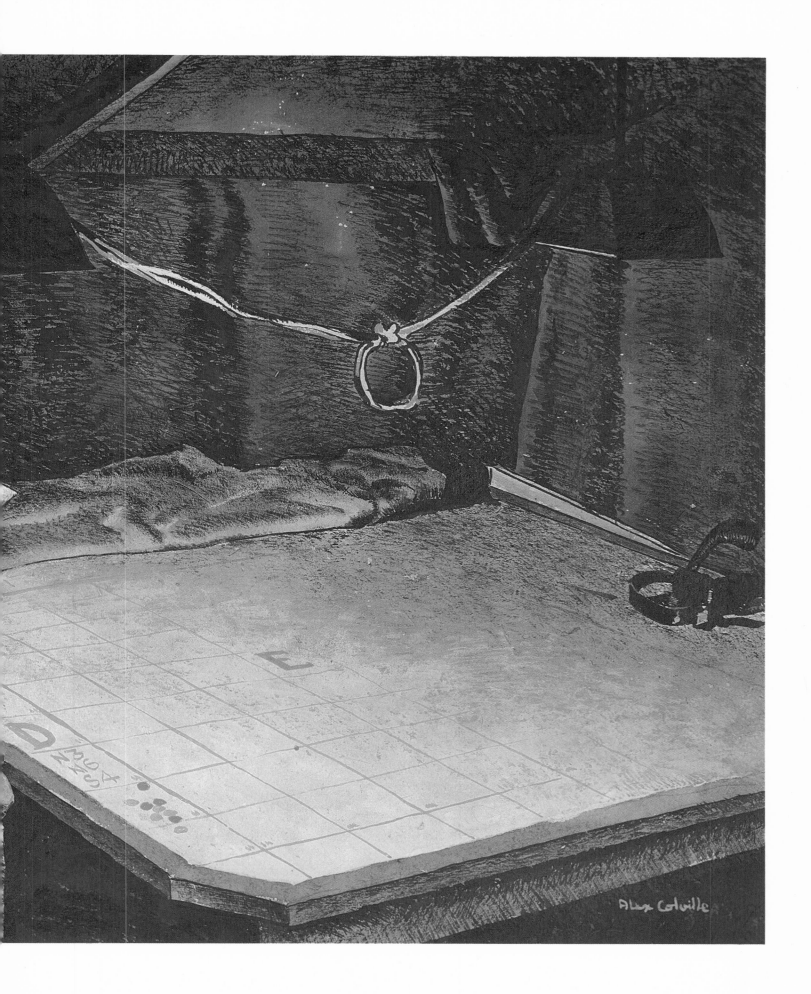

The Plotting Table 22-24 Jan. 1945, Watercolour Drawing, 15¹/₂ × 22¹/₂, 12197

The General Officer Commanding had suggested that I might find the interior of the Anti-aircraft Operations Room an interesting subject so on 22 January another glaring day, I went to the Anti-aircraft Operations Room of 74 A.A. Brigade, where I made a drawing from which I painted *The Plotting Table*. I worked for the next two days on this, using ink, watercolours and tempera to get richness of tone.

I visited No. 3 Anti-tank Regiment, R.C.A., on 15 January, having been told that they had some new BH guns, Valentine 17-pounders. After visiting Regimental Headquarters and Battery Headquarters I went to a troop and started sketching one of these guns, but had to stop because of a violent hailstorm. The gun sergeant, not being satisfied with my explanation of my job and identity, took me to the troop commander who took me to the Battalion Headquarters, as I had no credentials, excepting my identification card. I spent rather a long time convincing them that I was authentic. They were very courteous, and certainly had cause to be suspicious. As this was my second experience of this sort I went to the General Staff Officer and had a pass made out. This I find very useful when visiting a unit which does not know me.

By 19 January most of the snow had disappeared but it was still cold. I went to a dugout in a pine grove at a crossroads, and drew *The Pine Grove*. This I finished by the end of the following day. On 21 January, a sunny day with fresh snow on the ground, I drove around looking for subjects. I much prefer the effect of snow on an overcast day, unless the sun is so low that most of the snow is in shadow.

The Pine Grove, Holland 19 Jan. 1945, Watercolour Drawing, 13¼ × 21½, 12195

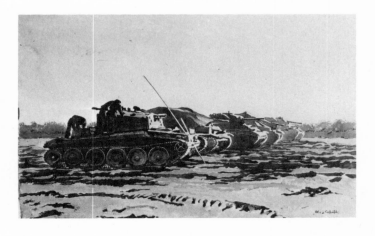

Tanks in Harbour, Holland 18 Jan. 1945, Watercolour Drawing, 15 × 21, 12217

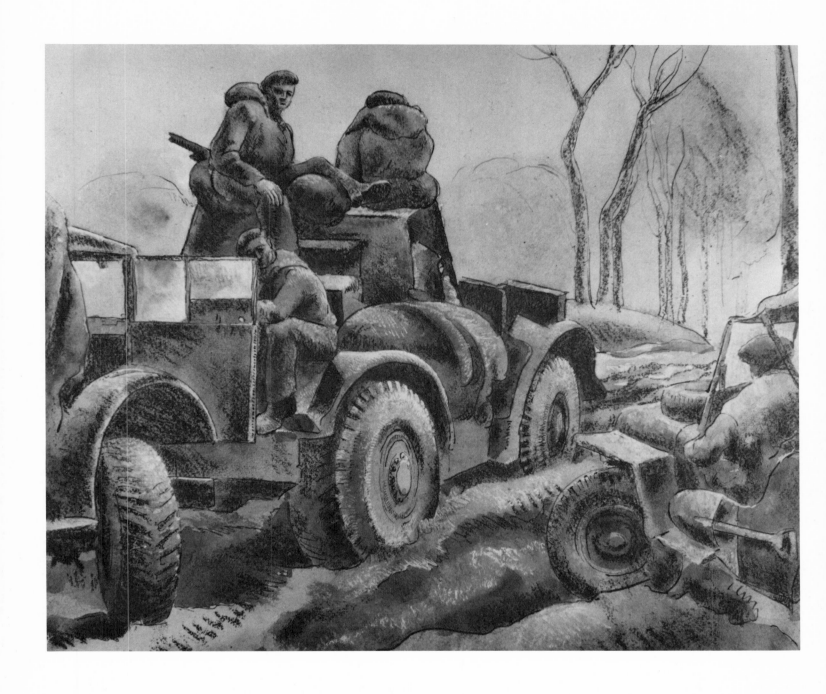

Wet Morning Watercolour Drawing, 15 × 16¹/₂, Coll. Alex Colville

In a certain sense I was writing letters home for these people, depicting their lives, the dugouts, tanks, where they lived. I was making a kind of record. There is always this element in art. ''Life is short, but art is long.'' A lot of these people were killed. They would be very interested in what I was doing, kind of astonished at it in a way.[3]

Infantry, Near Nijmegen, Holland 1946, Oils on canvas, 40 × 48, 12172

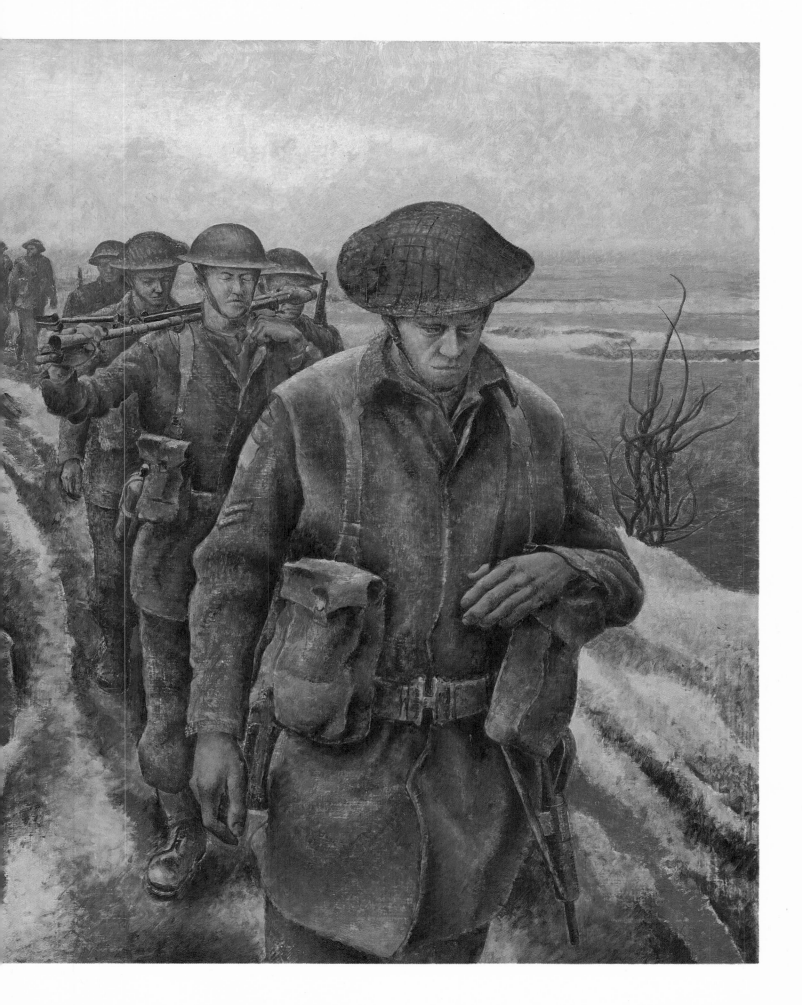

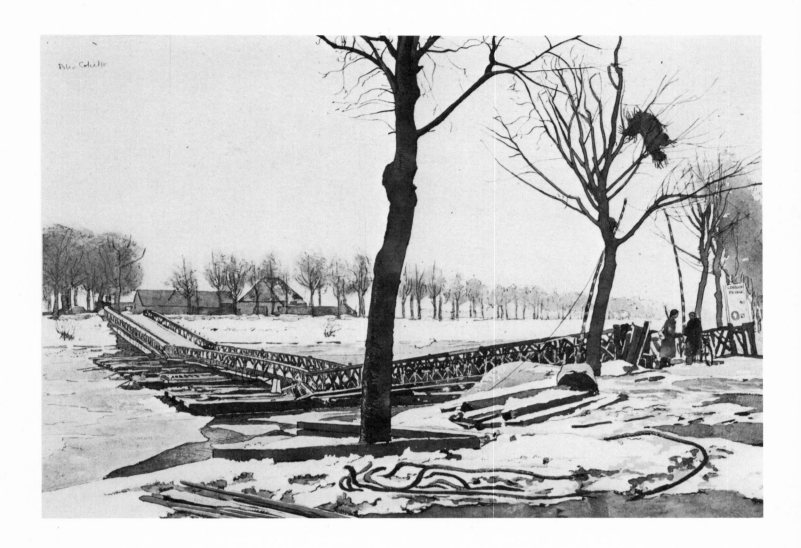

On 25 January I drove to the 4.2" mortar company. It was very cold and snowing, but I succeeded in getting a pencil sketch. From this I worked for the next two days on *Mortar Line in a Snowstorm*. Again I used tempera because watercolour seemed inadequate for the effect I wanted.

On 31 January I returned to the bridge I had seen on Sunday (Bailey Pontoon Bridge). It was still raining, but I drew in *London Bridge* from inside the jeep, and that afternoon started painting on it in my room. This is a beautiful bridge, the two outer sections drop from the high banks of the Maas-Waal Canal to the floating centre section. The canal is covered with gray-green ice, and each bank has a row of the small gnarled trees which I will always associate with Holland, perhaps because they are so conspicuous in this flat country.

On 1 February I envisaged my first big canvas — the subject being infantry marching in single file along a road. That morning I made numerous sketches of the Royal Winnipeg Rifles marching, then a study of a desolate road. The following day I spent on *London Bridge*, a tempera painting begun on 31 January and that evening I did a pen and wash drawing, *Infantry*, from the previous day's sketches.

Abandoned Munitions 6-7 Feb. 1945, Watercolour Drawing, 12³/₄ × 19, 12112

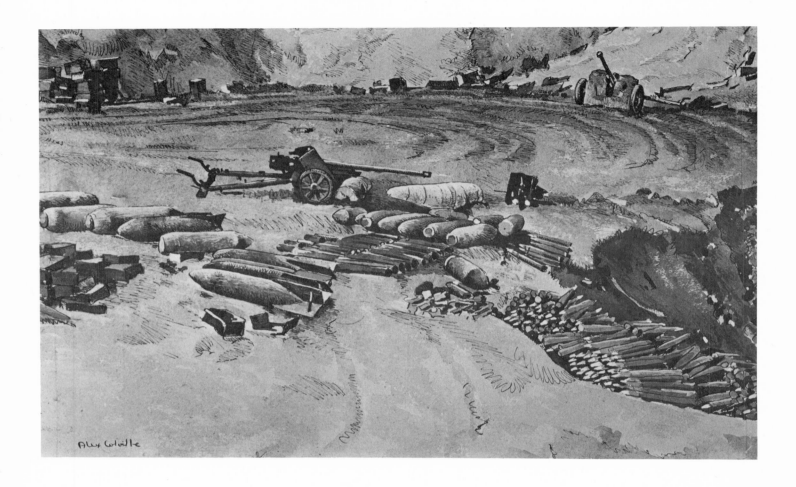

I painted *Tanks in Workshop* on 5 February in 2nd Canadian Armed Brigade Workshop. This workshop was in a large garage and, because it was dull and raining outside, the large high windows in the side of the building threw a subdued yet luminous light over the interior, which would have been ugly on a bright day.

On 6 February I painted *Abandoned Munitions*. These were in a large sandpit and had been rusted by exposure into beautiful orange and red colour combinations. The next day non-essential vehicles were barred from the roads, so I completed yesterday's painting and walked all afternoon, observing the preparations for the morrow's attack. I was unable to make any sketches as it was raining heavily.

I arose at 0500 hours on 8 February and I watched medium guns firing the barrage that preceded Operation Veritable. I returned to this spot after breakfast, when it was light, and made studies. The rest of the day I spent painting *Before Zero Hour,* a nocturne. That evening at zero hour (1800 hours) I walked to a knoll and watched the attack. In spite of the searchlights, I saw very little: a few fires in Zyeflich and some tracer.

On 9 February I walked over the crumbling Ouer Damm to the western part of Zyeflich but was unable to linger there because of the imminent danger of the dam's utter collapse. The dam later broke down. It is difficult to describe the extent of the flooding and the difficulty of driving. Frequently the water on the roads comes up to the floor of the jeep covering the exhaust and muffler, and stalling the engine. The roads which were not flooded were either seemingly bottomless pits of mud or under repair and therefore barred.

Before Zero Hour 8 Feb. 1945, Watercolour Drawing, 14³/₄ × 21, 12120

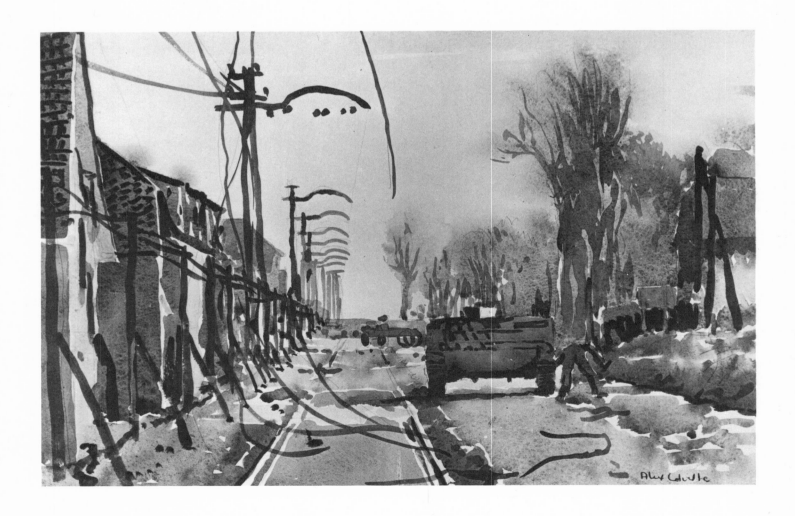

A Street on the Forward Defence Line in Germany 3 Feb. 1945, Watercolour Drawing, 14 × 20, 12212

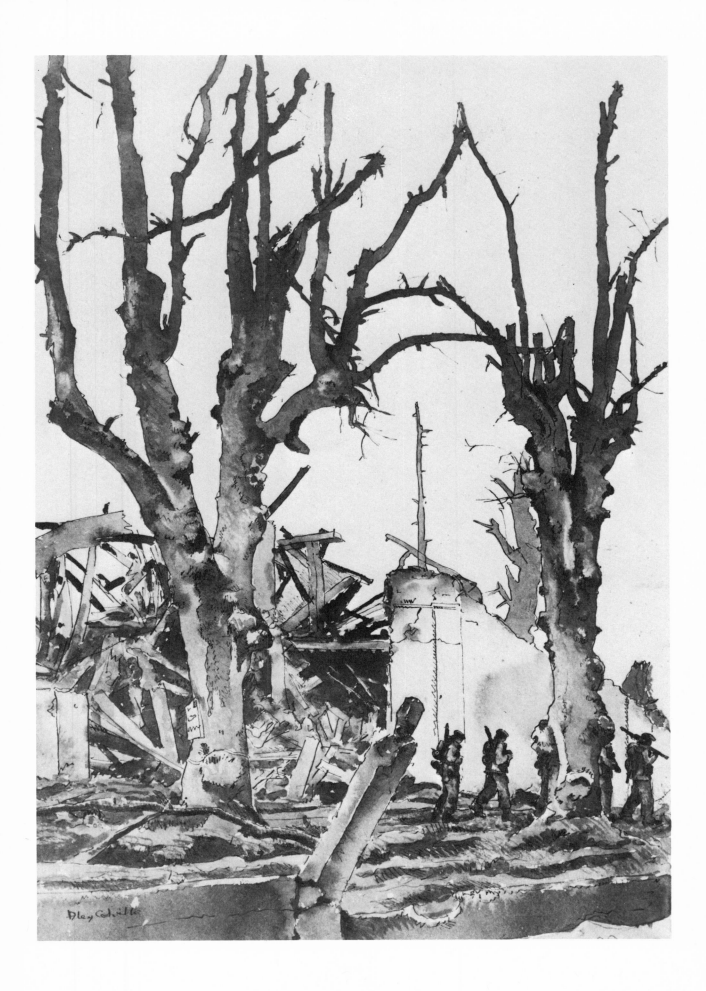

Shattered Landscape, Cleve 9 Feb. 1945, Watercolour Drawing,
22¹/₂ × 15¹/₄, 12209

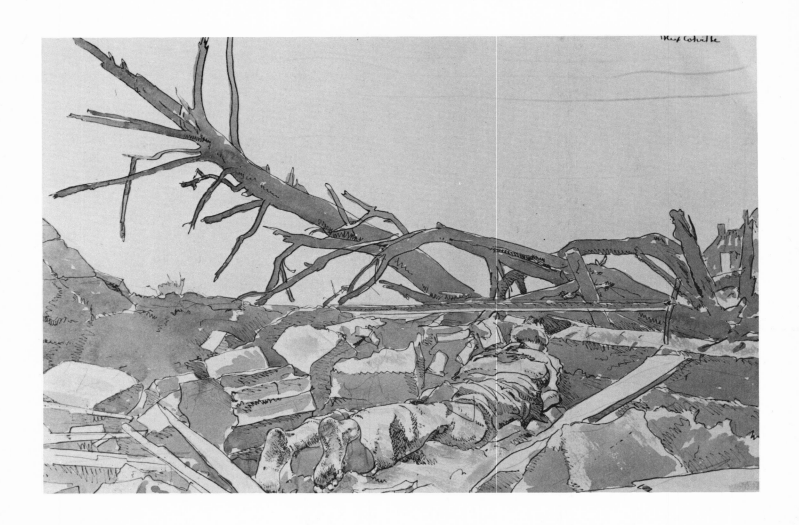

A Dead Civilian in a Prison Yard at Cleve, Germany 15 Feb. 1945,
Watercolour Drawing, 14 × 20, 12140

On the morning of 24 February I made a drawing of three
bodies wrapped in blankets, lying on a road. That
afternoon I climbed to the top of the ruins of Cleve castle
and painted *Dead City*.

On 27 February I went for a flight in one of the aircraft
attached to 3rd Canadian Infantry Division. We flew over
Udem, Cleve, and vicinity, and I made a number of very
rough sketches of a battlefield as it appears from the air. I
may paint a picture from these sketches later; I feel that the
subject requires too much careful consideration to attempt
in the field. Later that afternoon drove towards Udem,
made some sketches of a C.C.P. of the 14th Field
Ambulance R.C.A.M.C. This was an excellent subject —
the ambulances and tents were in a deep hollow (they are
common in this area, and must at one time have been
sandpits).

On 13 February, a day of continuous rain, I painted *The Flood,* a buffalo swimming through the broken Ouer Damm. The next day I walked through Berg En Dal to Wyler, past scores of Germans who had been killed in October. Made a sketch of a glider and another of an artillery quad which had run over a mine.

I drove to Cleve on 15 February and painted *Corpse in Ruins* at the Cleve prison. There were several dozen civilian dead lying around, apparently prisoners who had escaped when the prison was bombed and then had been killed outside by more bombs. Cleve was a scene of complete devastation.

On 19 February I painted *Shattered Landscape* on the outskirts of Cleve. This was a broken house surrounded by huge trees which had all their branches torn off by bombs and shells. German shells kept passing over my head at ten-minute intervals, harassing a crossroads a few hundred yards behind me.

Near Bedburg on 21 February I found a good subject in a large flat field — dead German paratroopers — but was driven away from here by mortar fire. That afternoon I made more sketches of prisoners of war on the floor of the cage.

The Church in Wyler, Germany 12-13 Feb. 1945, Watercolour Drawing, 10 × 14, 12135

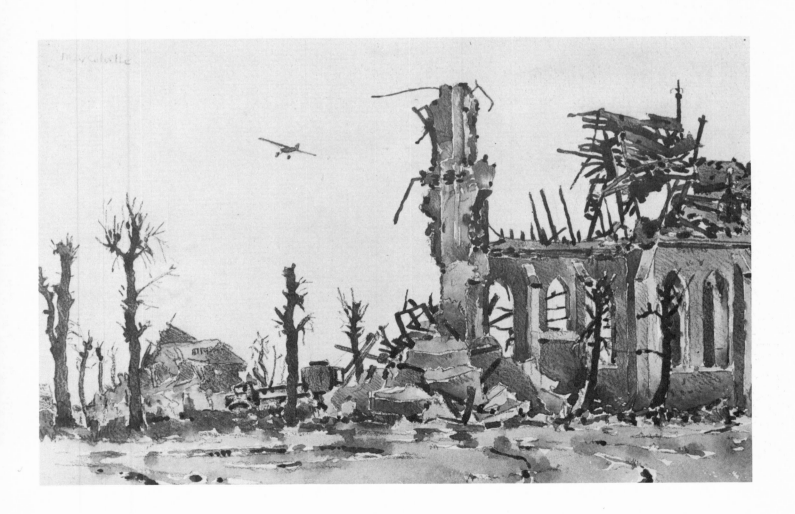

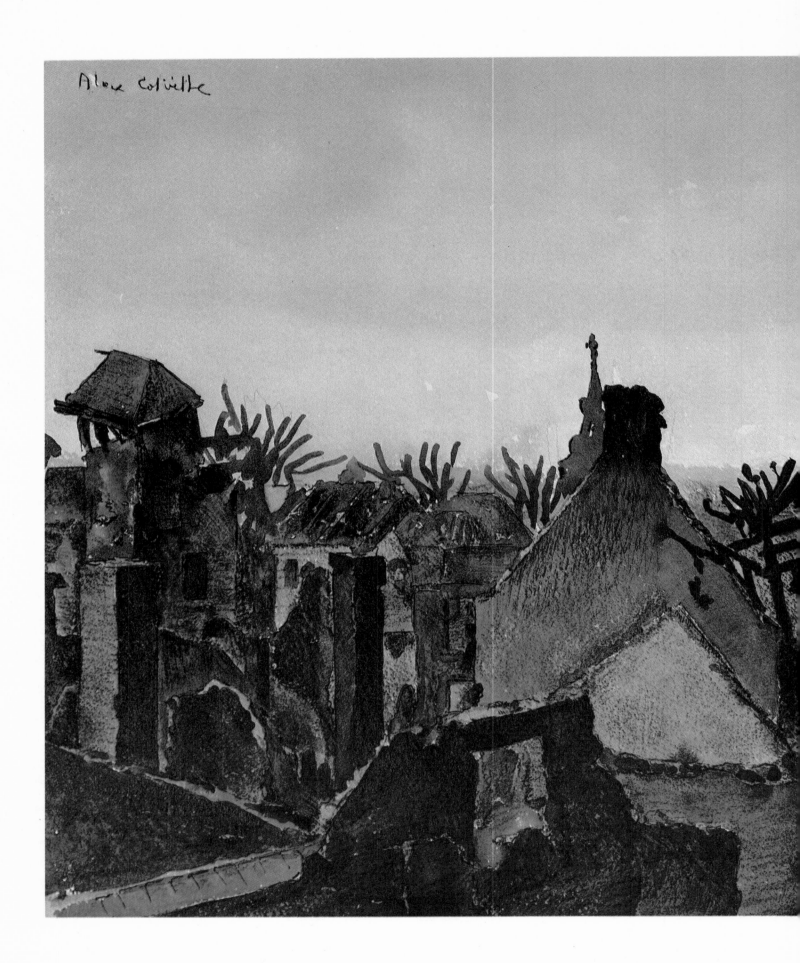

Alex Colville

Dead City 24 Feb.-2 Mar. 1945, Watercolour Drawing, 15¼ × 22¾, 12139

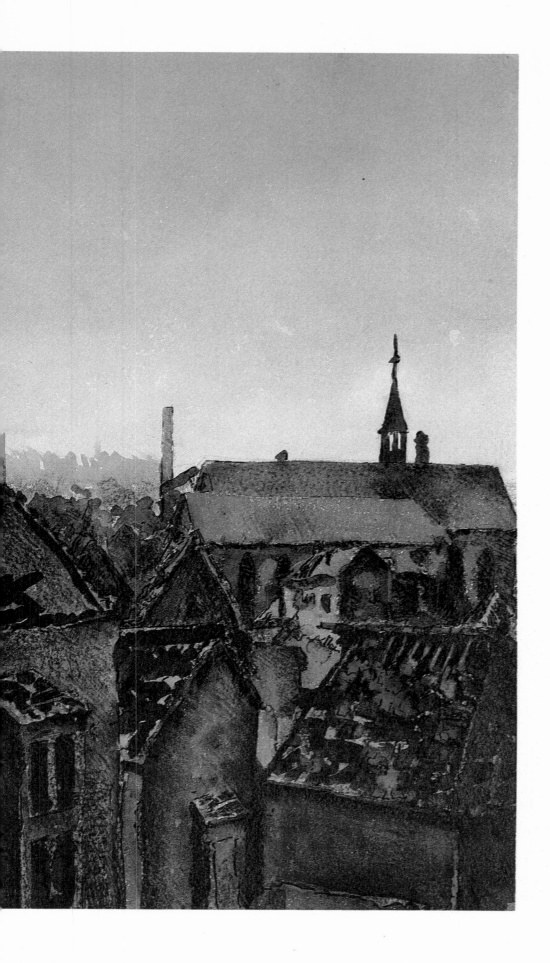

People were always very nice to me. During the war the people who are involved have the feeling that they are likely to be killed and they like the idea of someone making a record of their activities, what they are doing, what life is like and so on. [3]

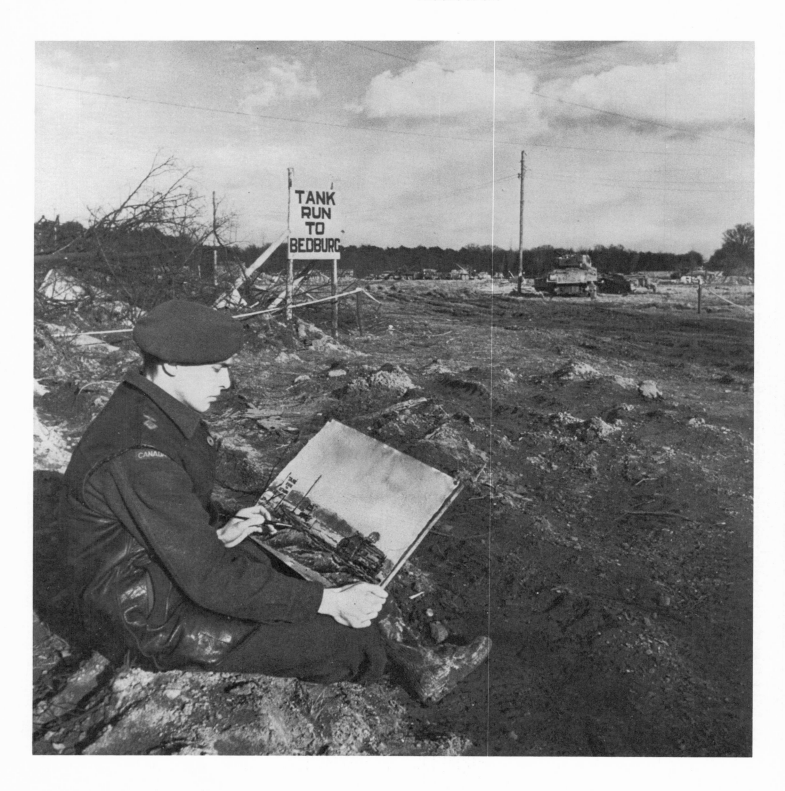

An official news photo of Lieut. D.A. Colville, January 1945.

When we were children we used to look at the war book that we had, a book of photographs of the first War. You would see all the soldiers marching or leaving on trains and waving, the women on the platforms throwing kisses. I had the feeling that I was part of the past, is this really me or am I taking part in something that's all been gone through many times before.

Everything was changed suddenly, you couldn't count on going ahead and having the kind of life you'd been thinking about. You think 'what will this do to us, what will we do now.' RHODA COLVILLE[5]

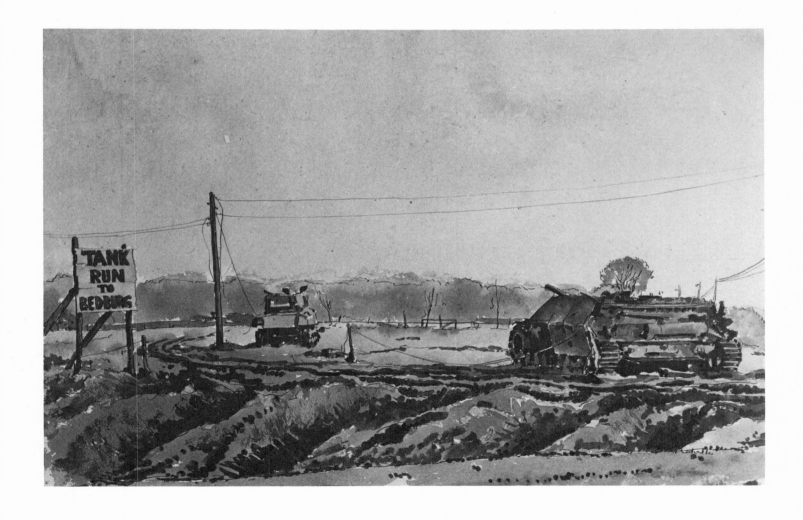

Wrecked German Self-Propelled Gun Watercolour Drawing,
15 ³/₈ × 22³/₈, 12222

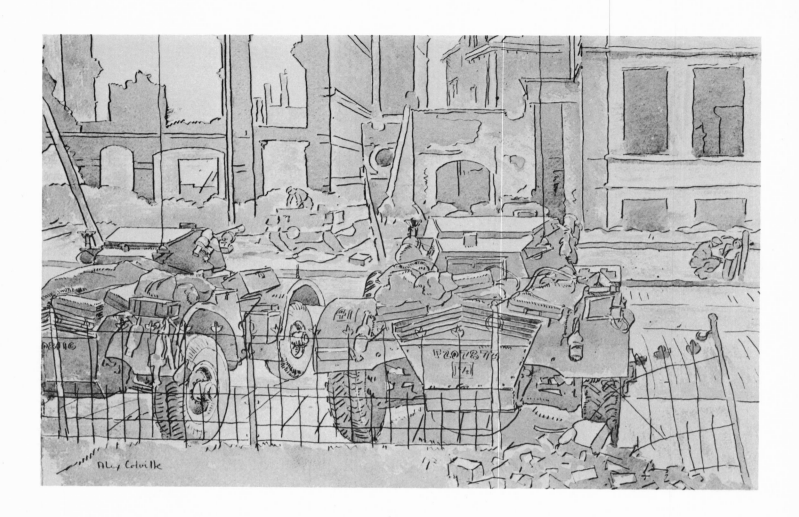

8 March was a day of intermittent rain. I drew *Crossroads in Udem* — shattered houses, route signs, tactical signs, a provost and a few pioneers. On 9 March I drove through the Hochwald Forest, in and around a battered farm. Here I painted *Farm Yard* and also did a drawing, *Burned Vehicles*. The next day I returned to this farm and made a pen and watercolour drawing of a mined Staghound and an armoured bulldozer. The latter was one of the best subjects that I have ever seen; the two vehicles fell into a most striking design.

On 18 March I went on a 48-hour leave to Brussels, where I bought films and also some art materials of various sorts that are not obtainable in England. I returned to Headquarters 3rd Canadian Infantry Division on 20 March. The weather was now sunny and warm, and the whole landscape was transformed. Often a purple haze hangs over the horizon, caused by dust, smoke generators and various smokes of war.

Troops of the 3rd Canadian Infantry Near Nijmegen, Holland 2 Feb. 1945,
Watercolour Drawing, 11¼ × 15¼, 12170

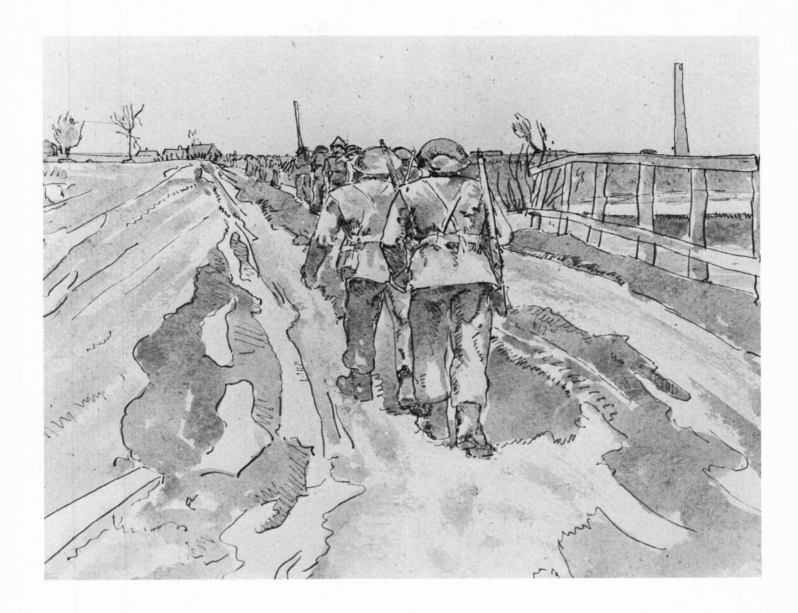

We moved to a new location west of Udem, on 28
February. After we had set up our new camp I completed
Air O.P., using chalk and watercolour.

On 1 March I worked inside, completing *Bodies on a Road.*
In this work I strived for a mood of tragedy through
simplicity of design and colour, and sombreness of tone.

On 2 March completed *Dead City,* again interested in
simplicity and mood rather than detail.

With the prisoners one was conscious of immense fatigue.
They were simply exhausted and relieved that they were
still alive. [1]

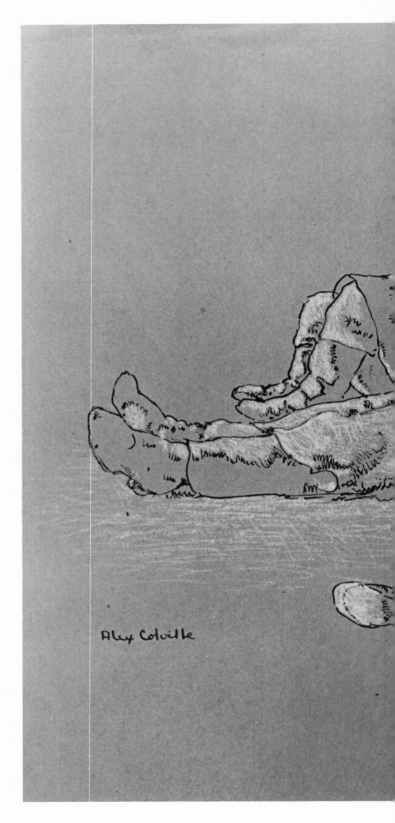

Prisoners Taken by the 3rd Canadian Infantry Division 21-23 Feb. 1945,
ink and pencil on paper, 15 × 22, 12201

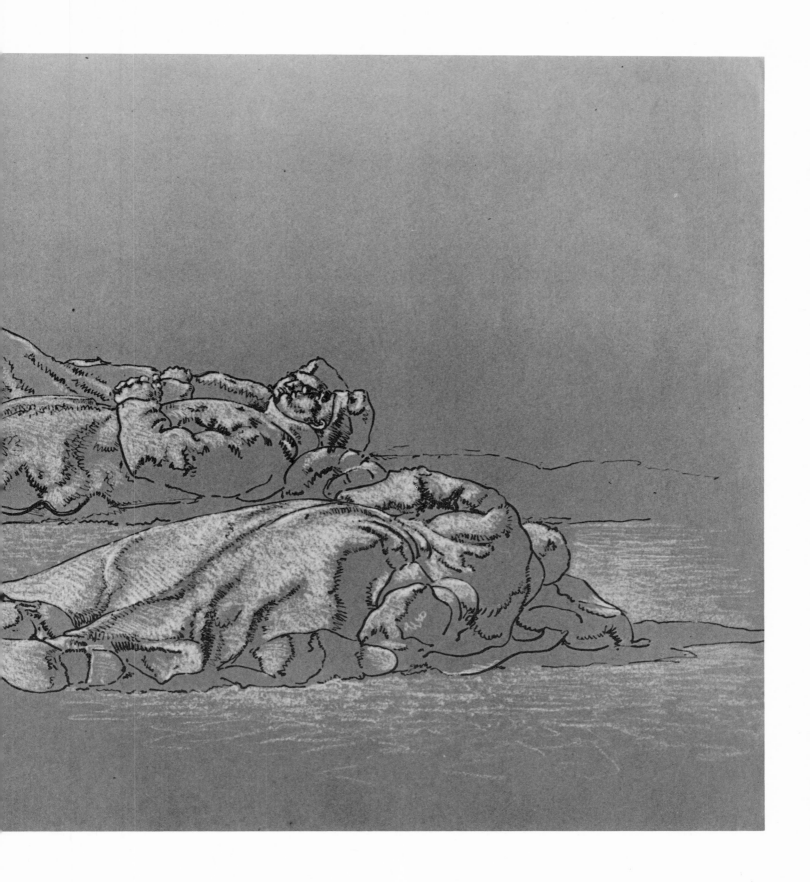

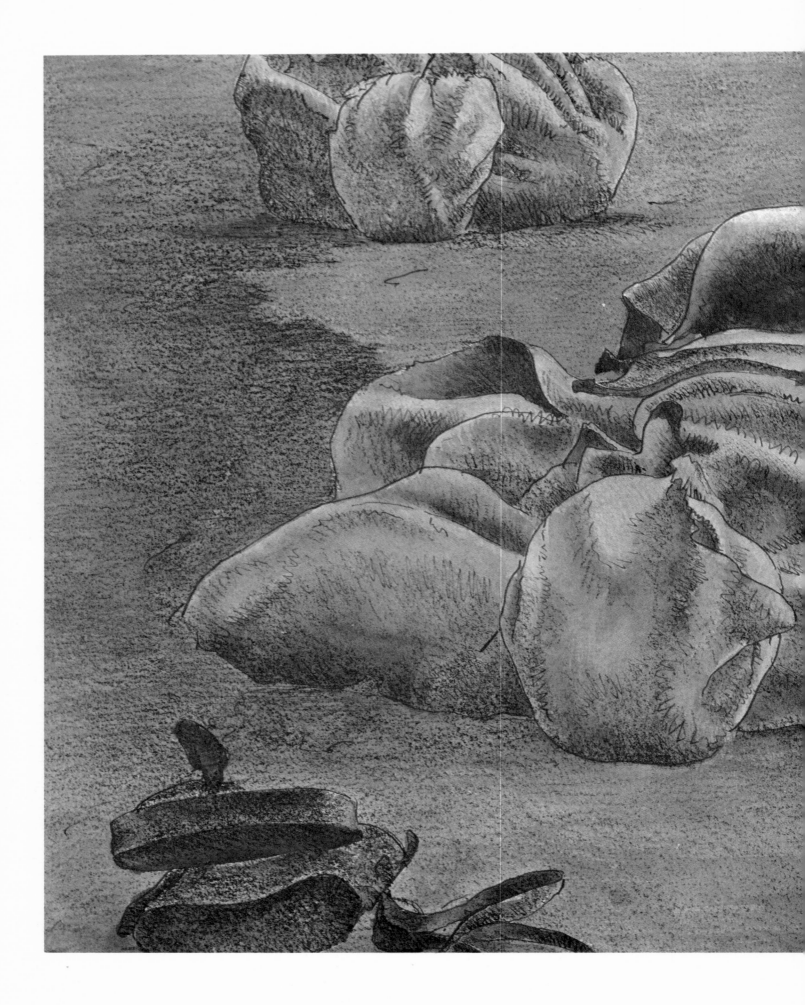

Bodies on a Road 23 Feb. 1945, Watercolour Drawing, 10¹/₄ × 14, 12124

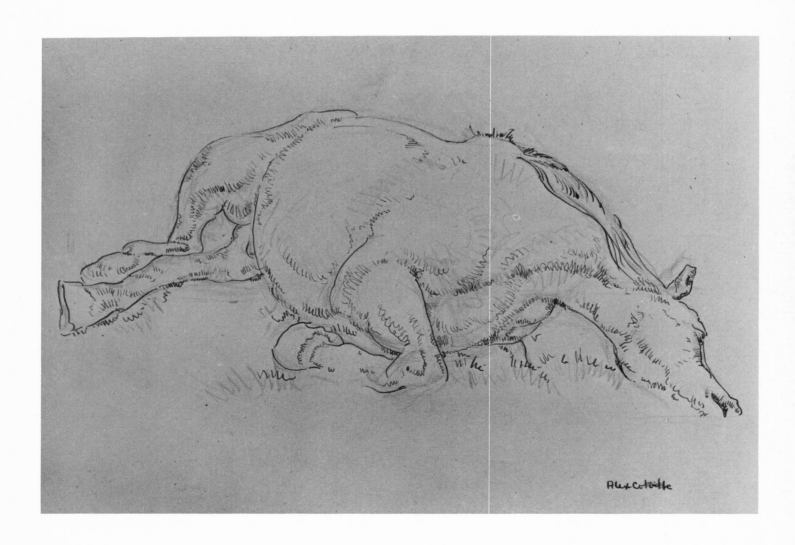

Dead Horse 7 Mar. 1945, coloured pencil, 10 × 14, 12141

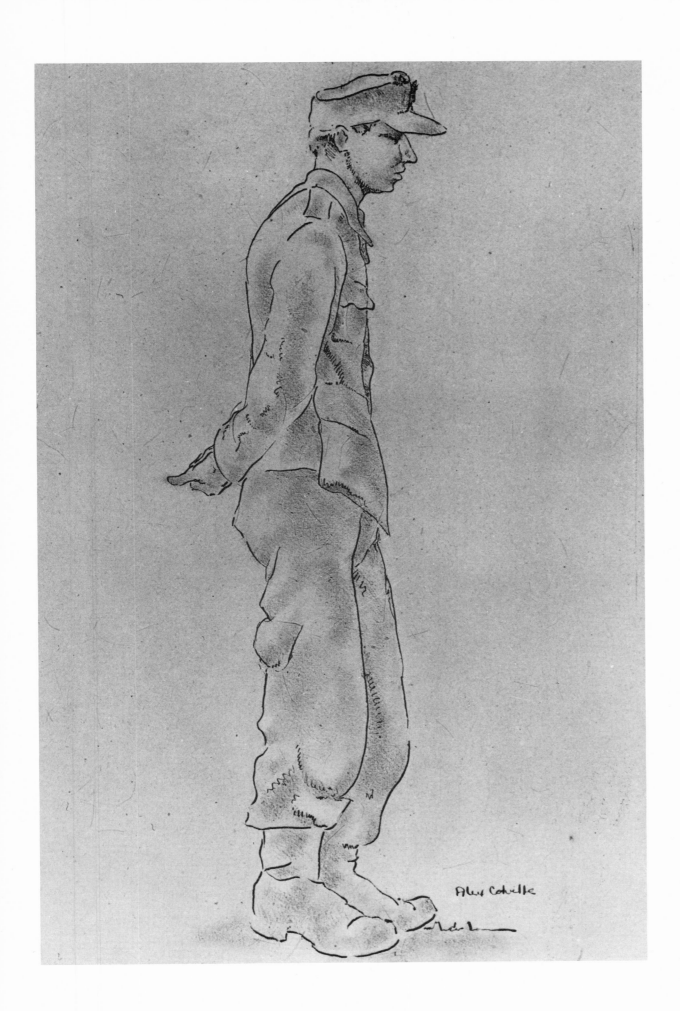

Young Prisoner Near Udem, Germany 5 Mar. 1945, pen and ink and
watercolour on paper, 20½ × 13, 12223

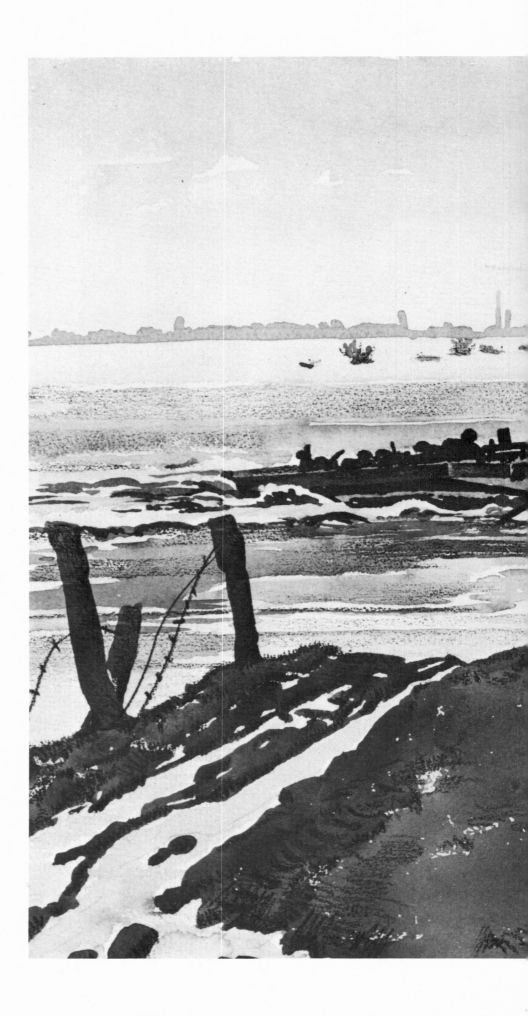

The Broken Dam 10-13 Feb. 1945, Watercolour Drawing, 15$\frac{1}{2}$ × 22$\frac{3}{8}$, 12127

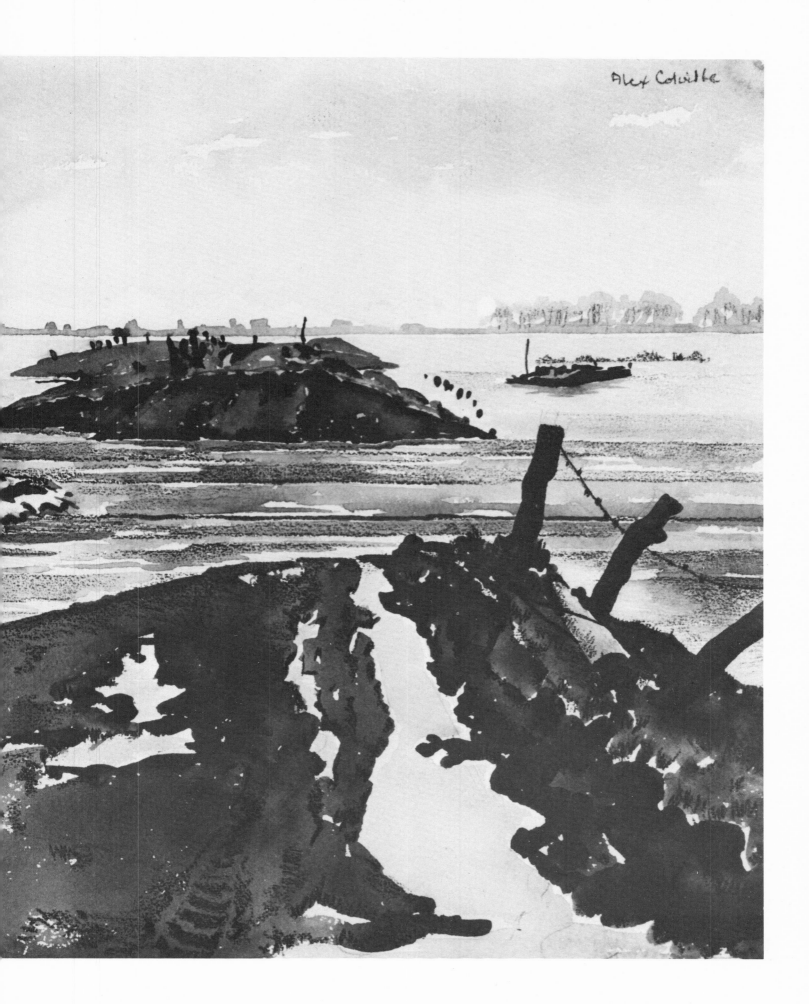

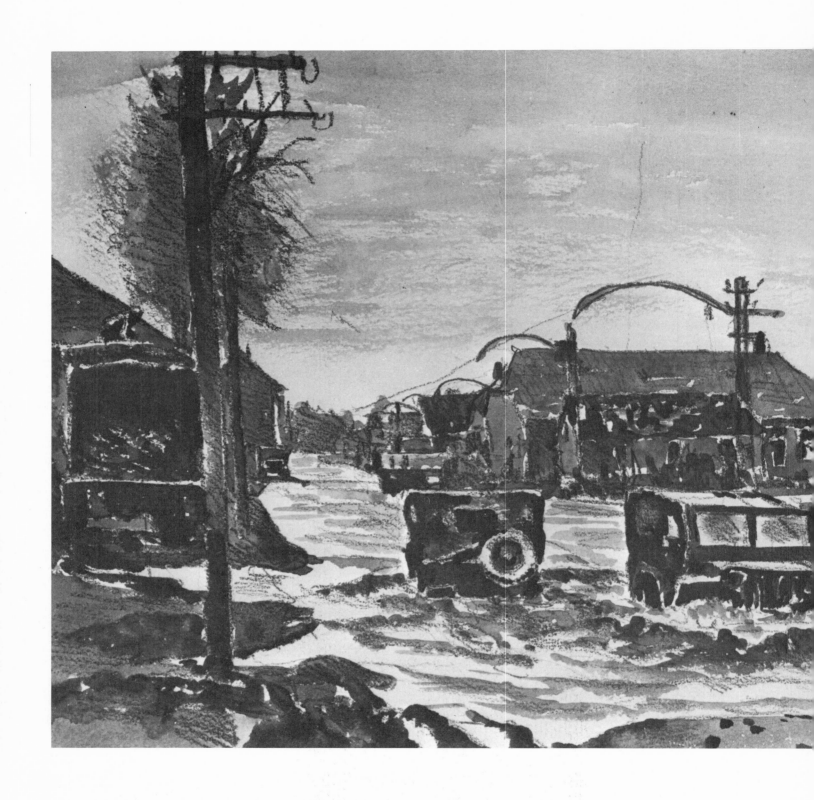

A Flooded German Road 9 Feb. 1945, Watercolour Drawing, 10 × 14, 12159

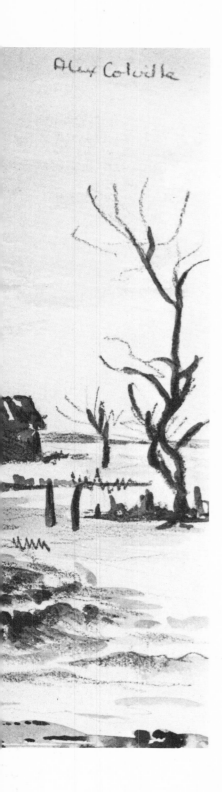

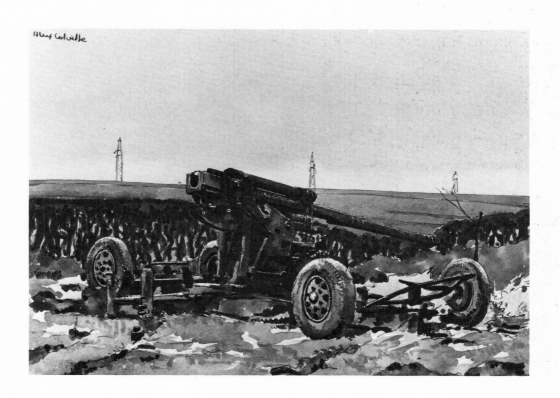

A Gun of the 3rd Canadian Division by a Hedge in Bedburg 23 Feb. 1945,
Watercolour Drawing, 10 × 14, 12165

I was born in 1920, this was the year which most of the people who were killed in the Second World War were born. They were in their early twenties. A great many of the people I went to school and university with were killed.[1]

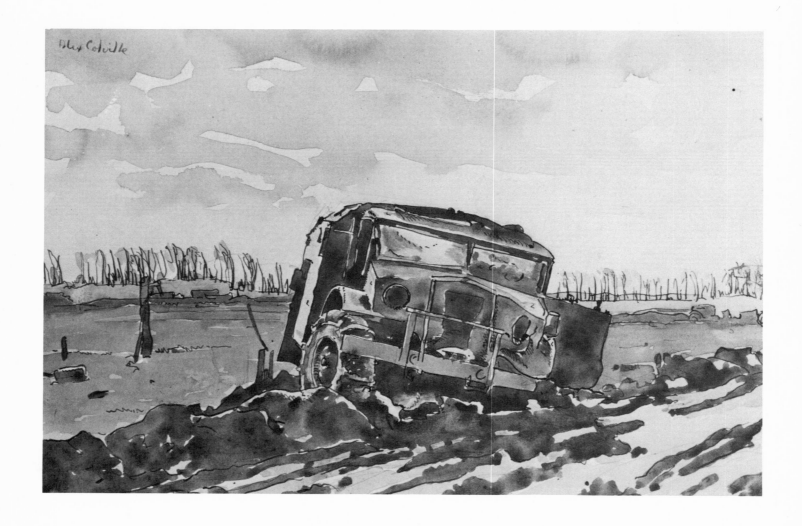

Wrecked Artillery Bug 14 Feb. 1945, Watercolour Drawing, 9¹/₂ × 13⁷/₈, 12221

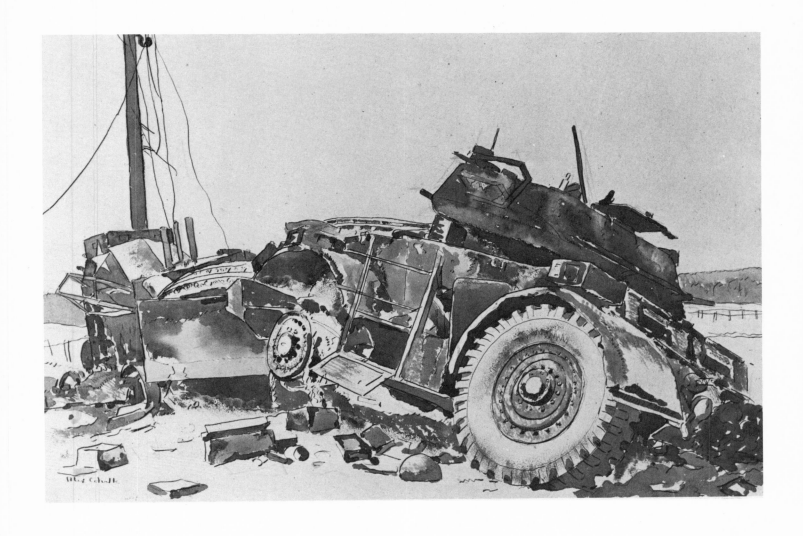

Destroyed Vehicles Near Xanten, Germany 10 Mar. 1945, Watercolour
Drawing, 15$\frac{1}{2}$ × 22$\frac{3}{8}$, 12147

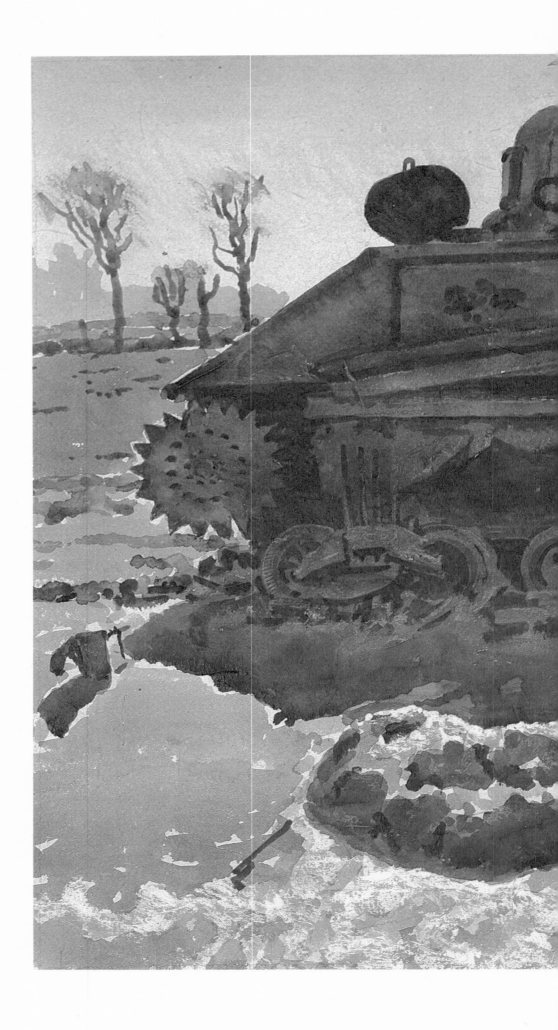

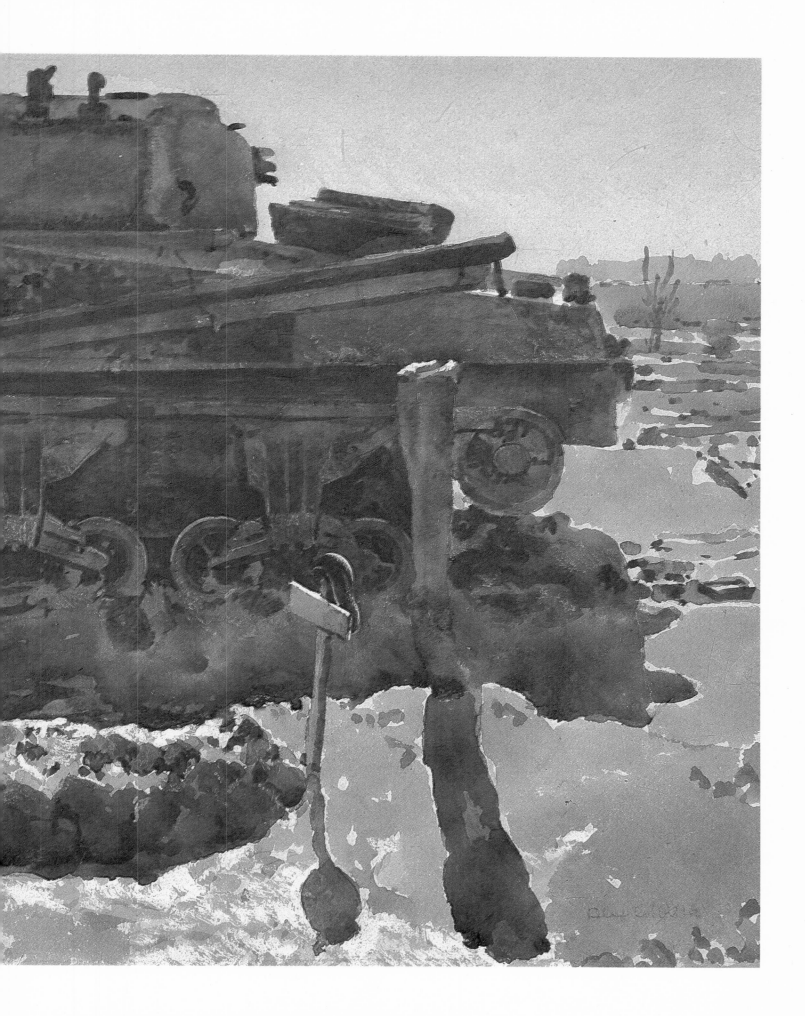

Grave of a Canadian Trooper 22 Mar. 1945, Watercolour Drawing, 14¹/₂ × 20⁵/₈, 12164

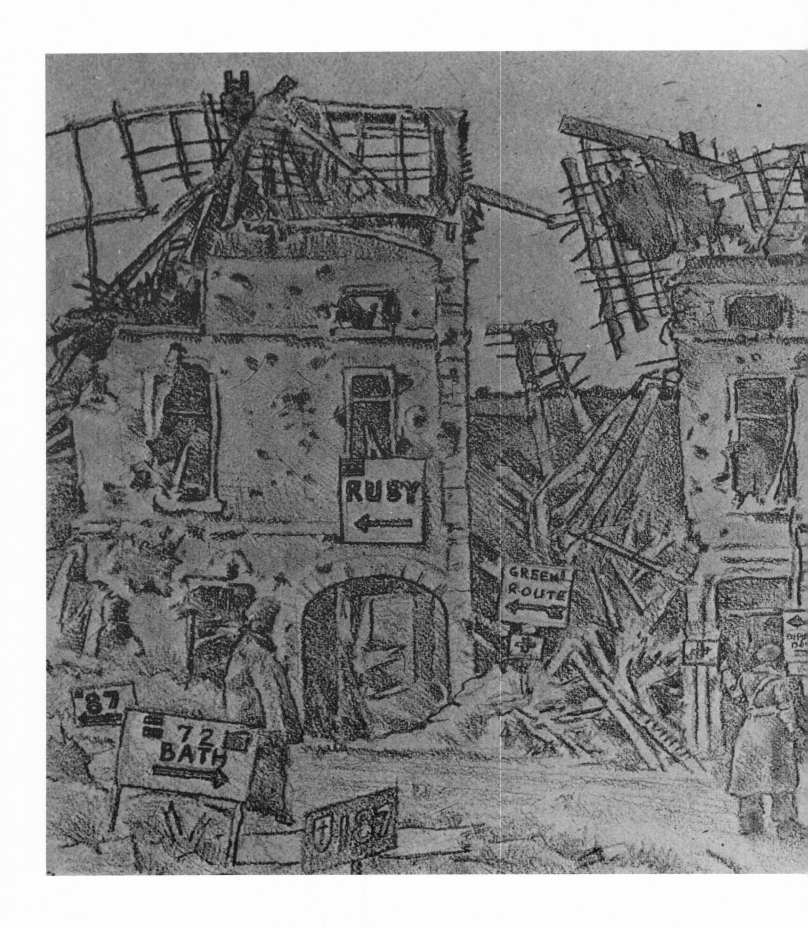

Cross Roads in Udem, Germany 8 Mar. 1945, coloured pencil,
15 × 22¹/₂, 12138

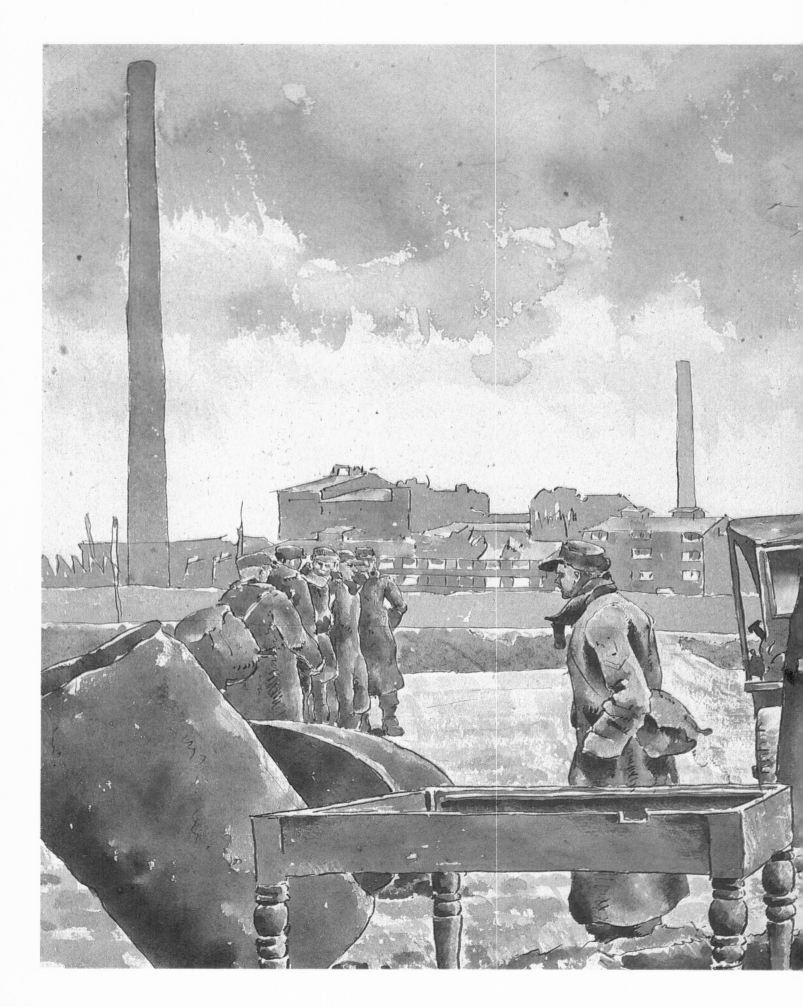

Prisoner of War Cage 31 Mar. 1945, Watercolour Drawing, 15¹⁄₂ × 22¹⁄₂, 12200

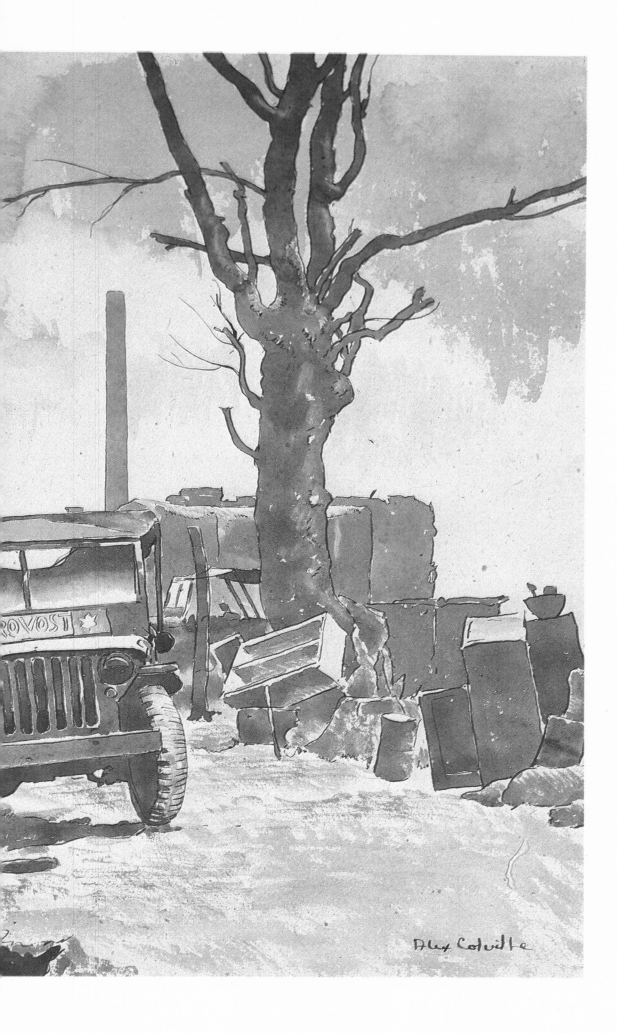

Alex Colville

The Highland Light Infantry of Canada Advancing Toward Wesel
Watercolour Drawing, 15³/₈ × 22¹/₂, 12171

Buffaloes Beside the Rhine 24 Mar. 1945, Watercolour Drawing,
13¼ × 21, 12128

There is a long tradition of topographical drawing by
military people. The Canadian war art was unusual in that
the war artists were part of the service; we were not
civilians and most of us had been in before we became war
artists. Professional soldiers have a great sense of making
history. In every Canadian division there was an historical
officer who was gathering material while the war was on.
The war artist was attached to the Historical Section.[1]

At the same time there was a film and photography unit
which was also part of the army. They were shooting
footage all the time. The difference of course is a
conceptual one. The camera can record, can make
extraordinarily good, affecting records, but a painter is
more likely to select and reject, to edit, to interpret. You are
not a camera, you are doing essentially different things.
There is a certain subjectivity, an interpretive function. I
wasn't a mature artist. I was a young, bright person. I had
been a good student, and I was technically competent. I
considered my job essentially to record.[1]

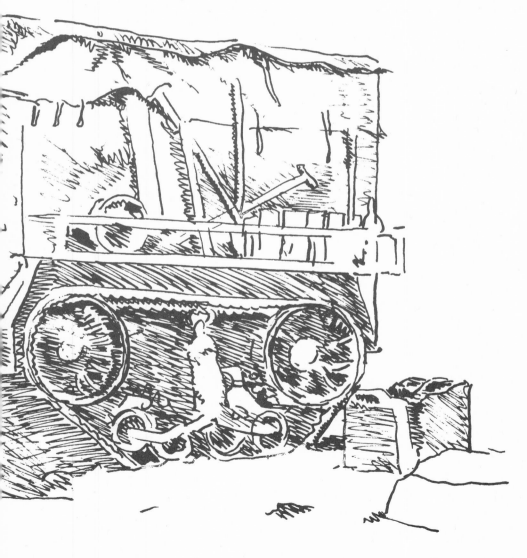

4 Feb 45

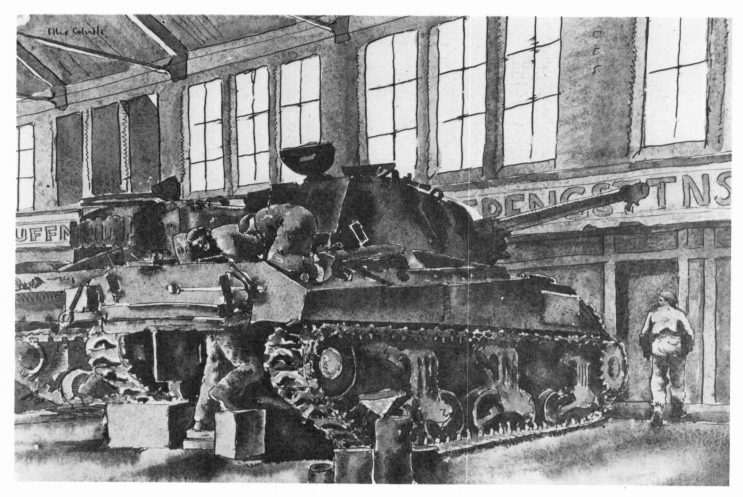

Tanks in a Workshop 5 Feb. 1945, Watercolour Drawing, 15½ × 22½, 12218

Survey Beacon pencil, 9 × 11½, Coll. Alex Colville

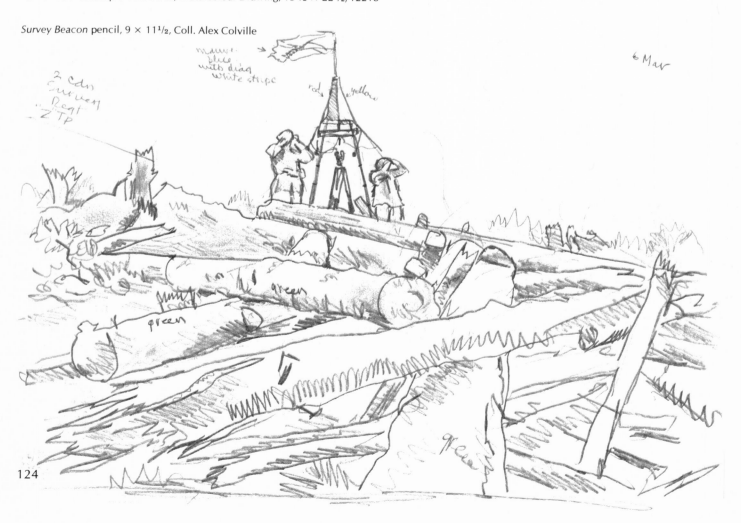

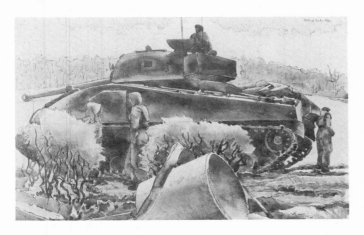

Before an Attack 2-3 Mar. 1945, Watercolour Drawing, 12 × 19, 12119

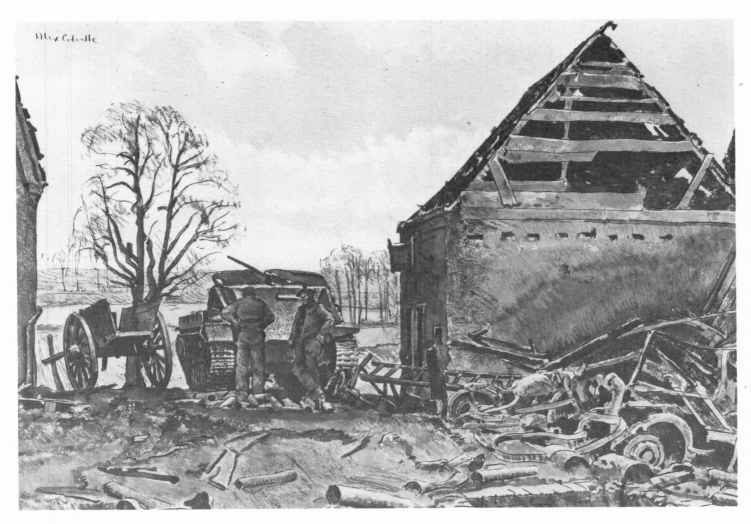

Farmyard, Germany 9 Mar. 1945, Watercolour Drawing, 15³/₈ × 22¹/₄, 12153

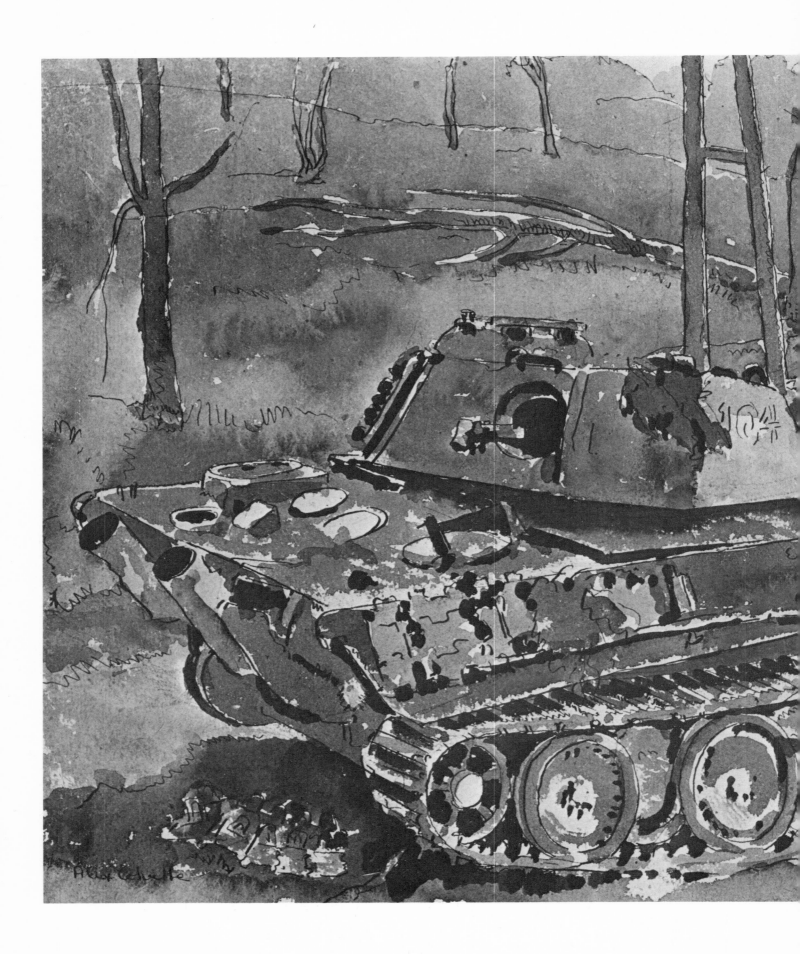

126

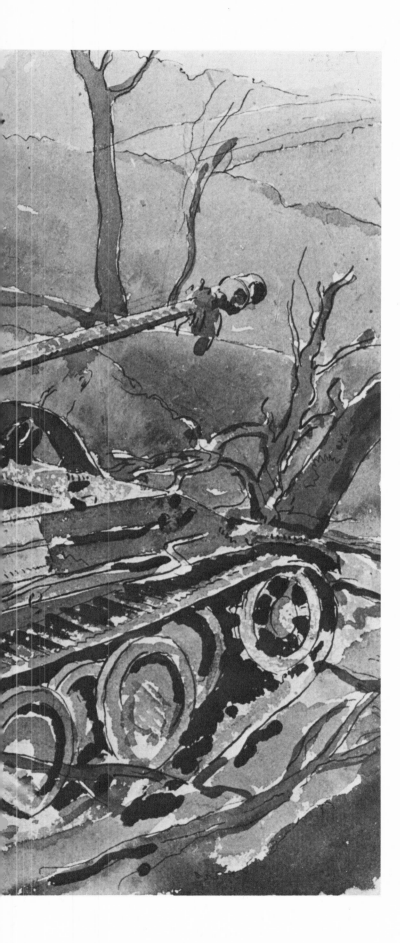

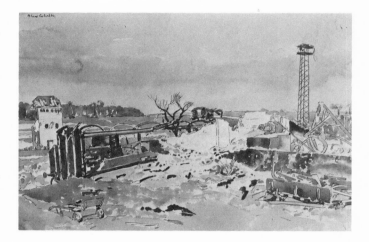

Railway Station at Labbeck, Germany 23 Mar. 1945, Watercolour
Drawing, 15¹/₂ × 22¹/₂, 12204

Panther Tank Near Sonsbeck, Germany 7 Mar. 1945, Watercolour
Drawing, 10 × 14¹/₄, 12192

Germans at a Telephone Station, Holland 20 Apr. 1945, Watercolour
Drawing, 15¹/₂ × 22⁷/₈, 12210

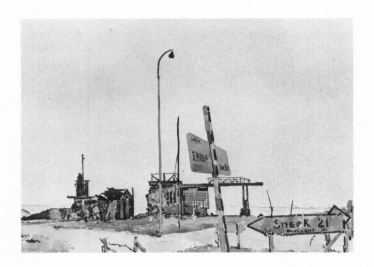

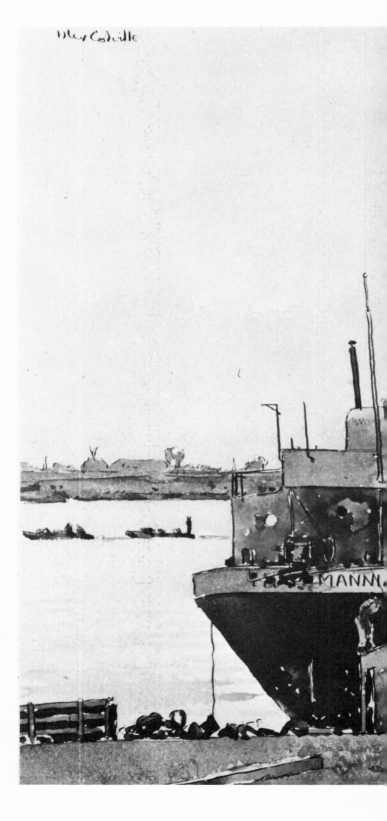

On the Rhine — *Germany* 25 Mar. 1945, Watercolour Drawing, 14 × 22¹/₄, 12191

Demolished Bridge, Germany 30 Mar. 1945, Watercolour Drawing
14 × 20, 12144

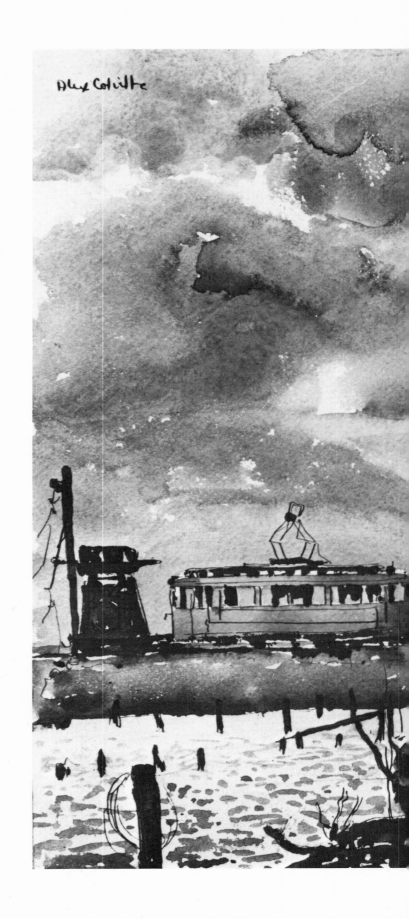

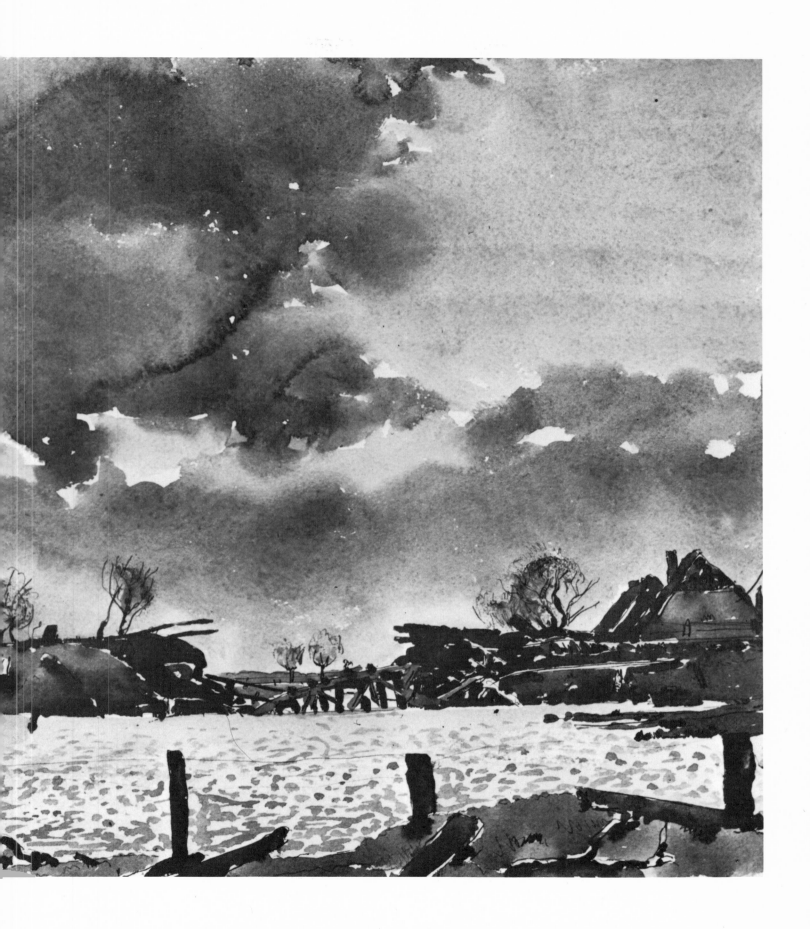

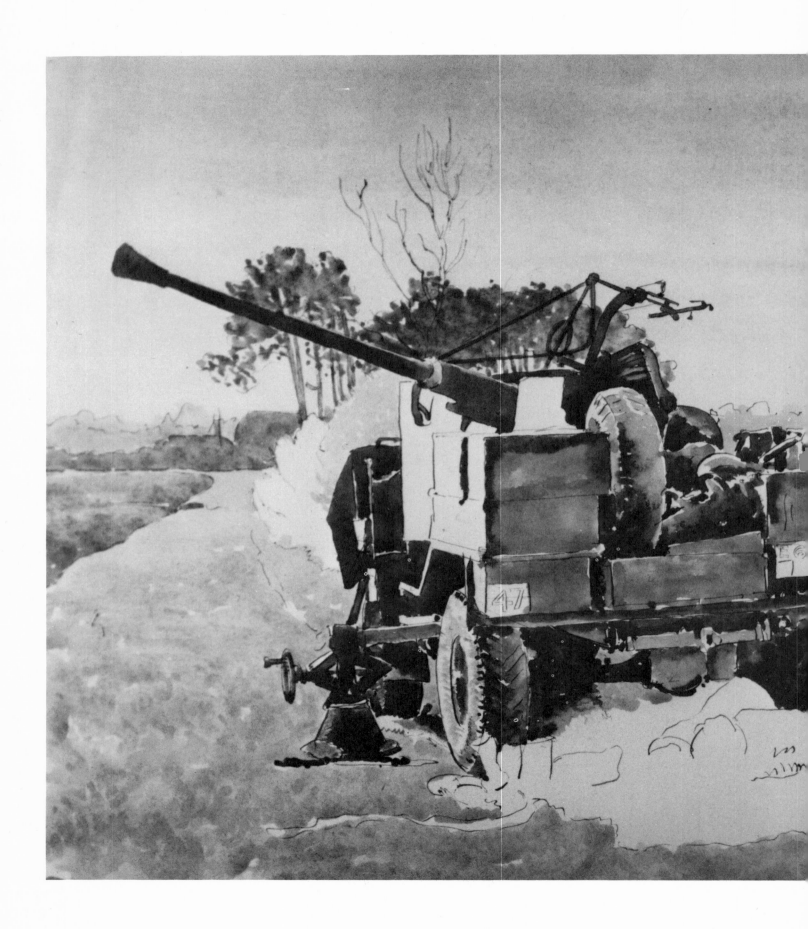

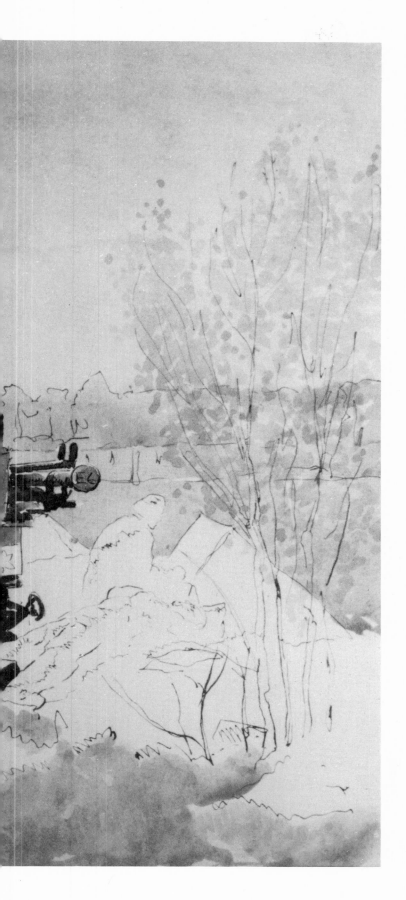

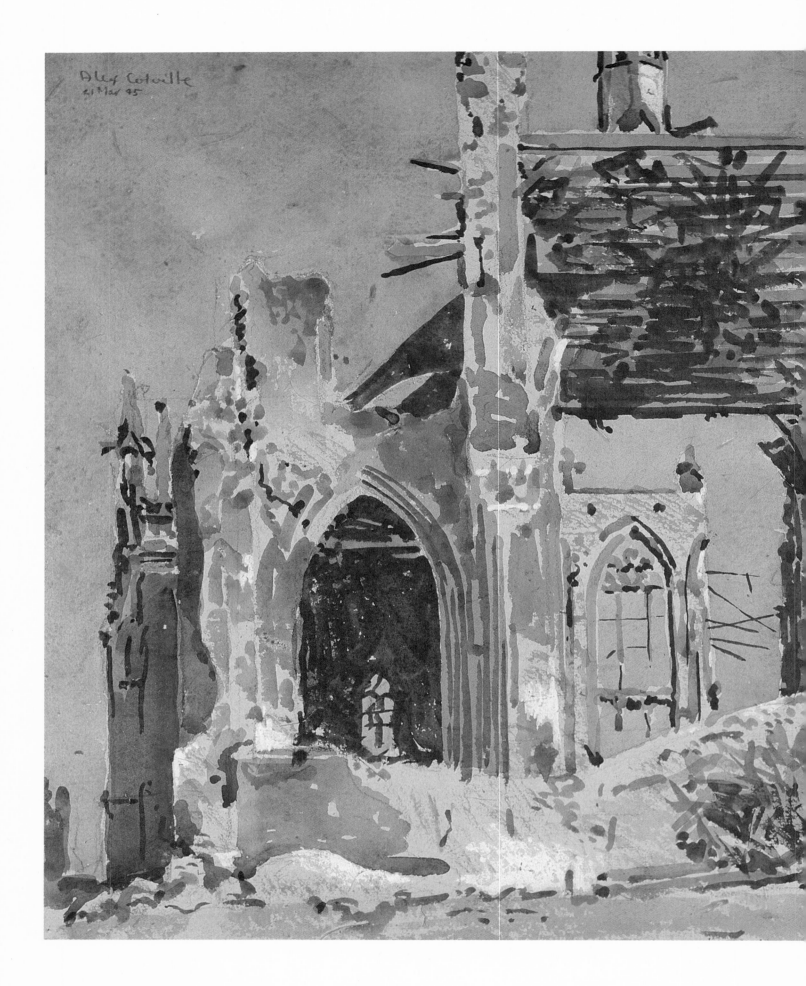

134 *Church in Cleve, Germany 21 Mar. 1945, Watercolour Drawing, 15³/₈ × 22¹/₂, 12134*

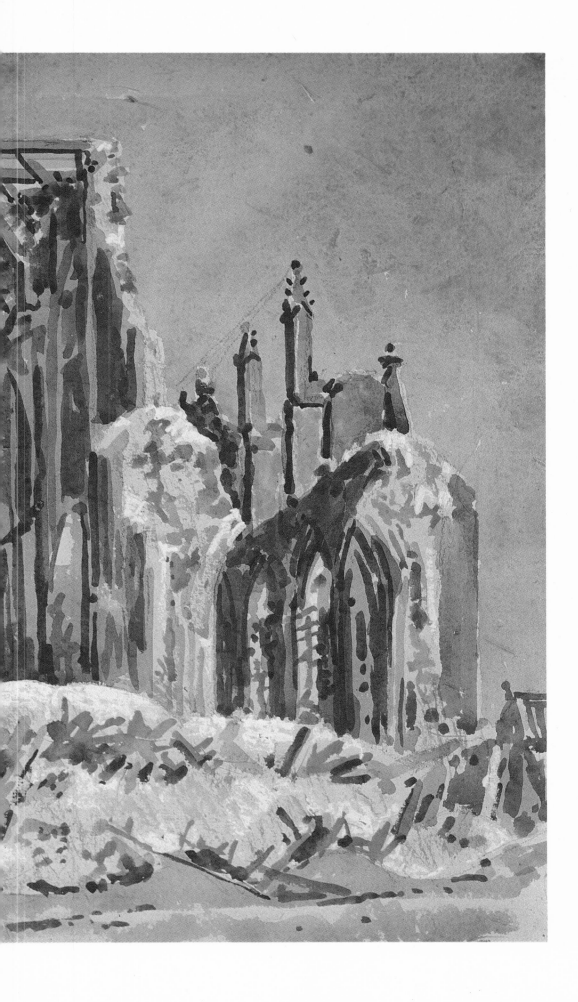

There was a Canadian Film and Photo Unit and of course, they could cover things very accurately. One had the sense that knowing that this was being covered photographically that one should be trying to get something else. I'm not quite sure but I think I was young enough not to worry about that; I simply thought I will do something each day. If it's good, fine; if it isn't good, that's too bad. There aren't too many situations in which a very young painter, who is really an unknown person, is encouraged to work every day, and I was. It was a great thing.[3]

Heavy Regt. R.A. AGRA 12 April 1945, Pen and Ink, 11³/₈ × 8³/₄

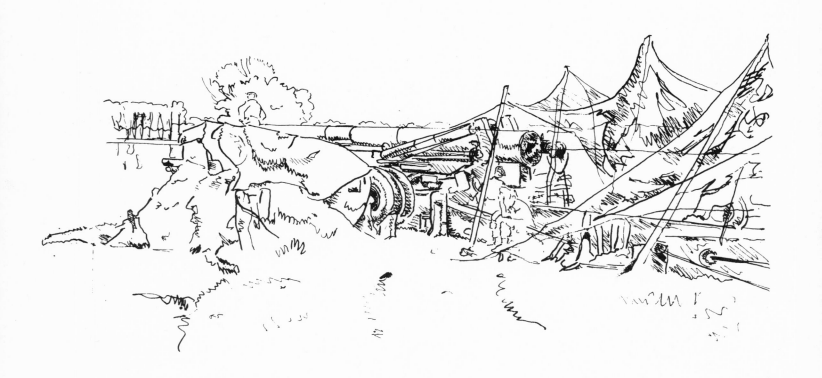

Sketch of Tanks and Landscape Pen and Ink, 11³/₈ × 8³/₄

Scotia Highlanders Resting, Near Emmerich, Germany 30 Mar. 1945,
Watercolour Drawing, 10 × 14¹/₄, 12173

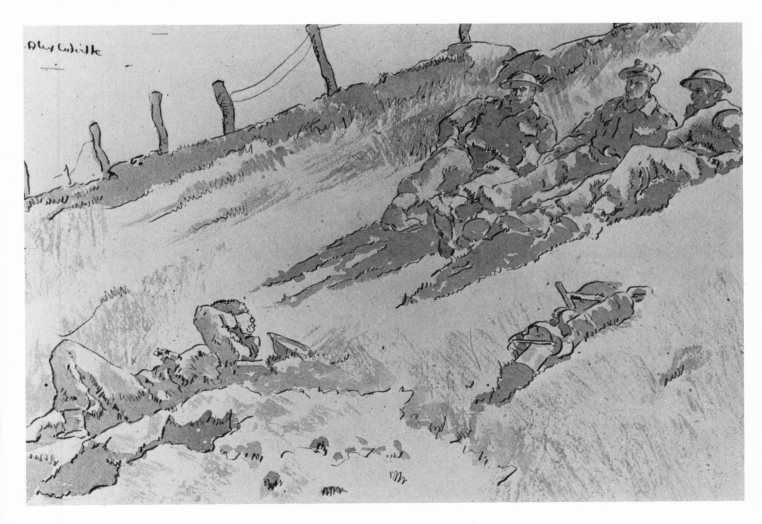

*I remember the paratrooper lying in a field. I later did a
painting,* Dead German Paratrooper, *based on the drawing.
He was about twenty. They would fight right to the very
end; they had put up a tremendous fight until they were all
killed.*[1]

Dead Paratrooper Near Deventer, Holland 11 Apr. 1945, Watercolour
Drawing, 14 × 20, 12142

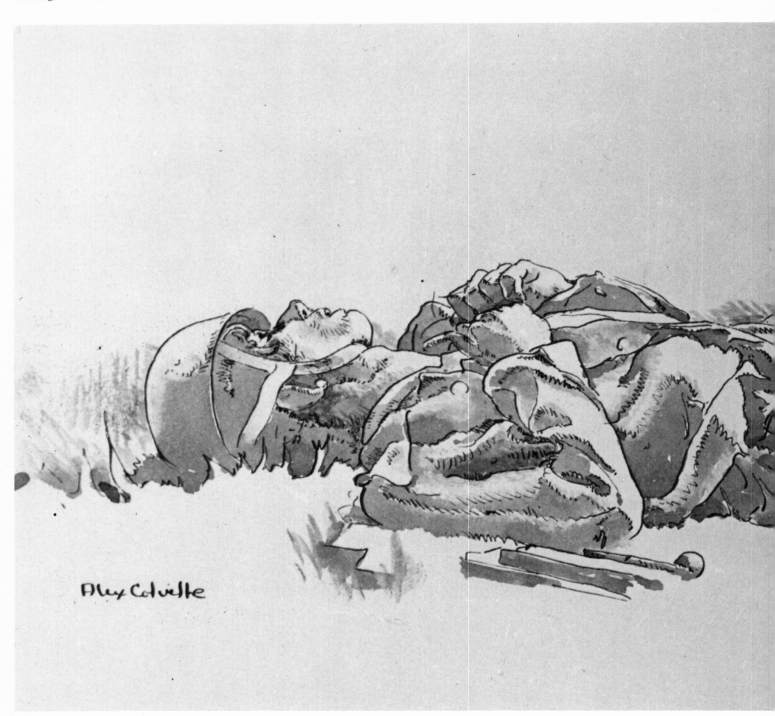

Soldiers don't have very strong feelings, deep enmity or malice toward the enemy. It is a curious relationship which in some ways could be compared to that of sport, a very serious kind of sport, one in which if you lose you get killed. [1]

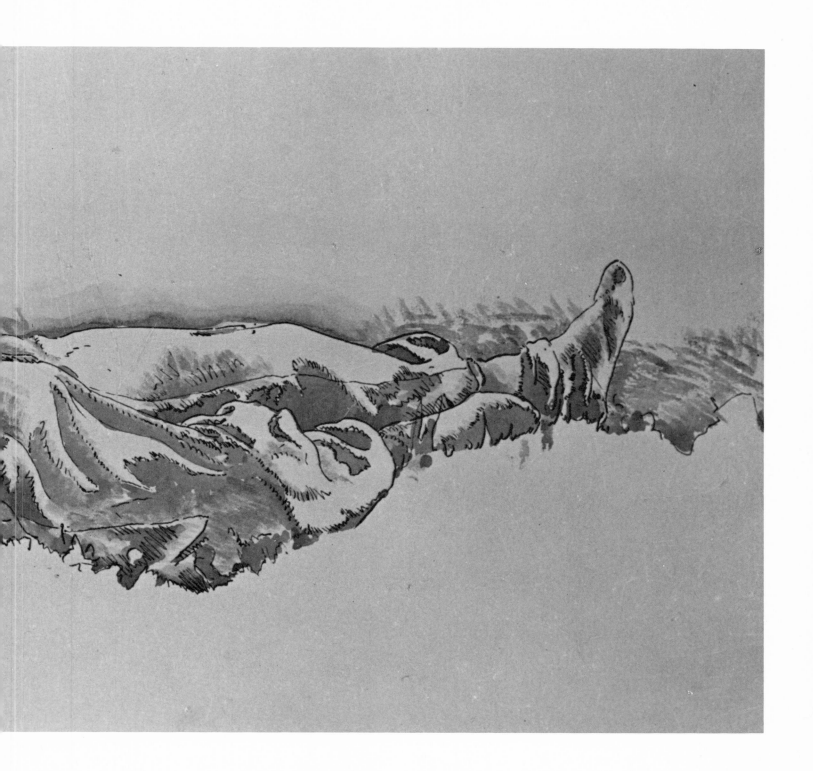

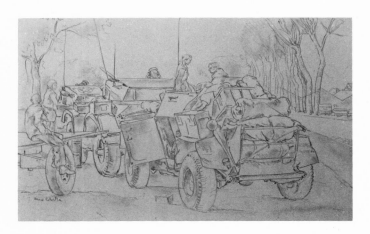

Awaiting Orders 23 April 1945, Pencil, 12³/₄ × 19¹/₂, 12116

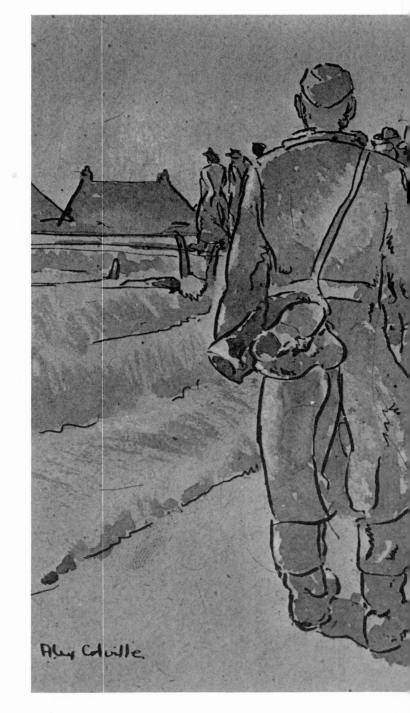

On 16 April I drove to Lefuwarde and was very moved by the enthusiastic reception given to us by the people of Friesland. I did a small sketch on this theme of *Liberation* and later a large watercolour drawing. I feel, however, that neither of these are successful; to me, watercolour is a too fixed and limited medium for what I wanted to express.

On 20 April I drove to the eastern end of the causeway, south of Harlingen, and painted *Desolate Landscape*. This was an excellent subject; there was a beautiful maritime greyness in everything, with the sun a yellowish blur behind high fog. I was interrupted by a heavy rainstorm, but finished this work the next day.

We were driving along, just after the liberation, behind one of our trucks with some German prisoners, parachutists, the elite troops. When we got into a heavily populated area of a small city, the Dutch people began to surge out around the truck where two Germans sat in the back. The Dutch people weren't fond of the Germans, to put it mildly. They were shouting insults at them. I remember this one young very tough paratrooper looking with contempt at this crowd of people, a contempt you can understand. That kind of mob psychology is always unpleasant when it manifests itself. [1]

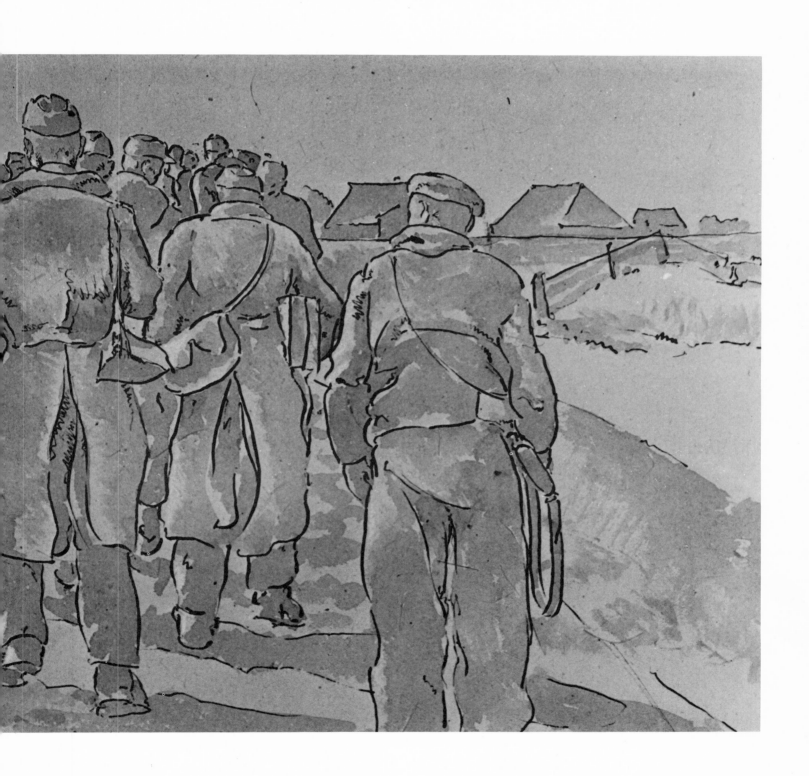

Prisoners Taken by "B" Company of the Queen's Own Rifles of Canada
18 Apr. 1945, Watercolour Drawing, 12¼ × 20⅝, 12199

Exhausted Prisoners 1946, Oils on canvas, 30 × 40, 12152

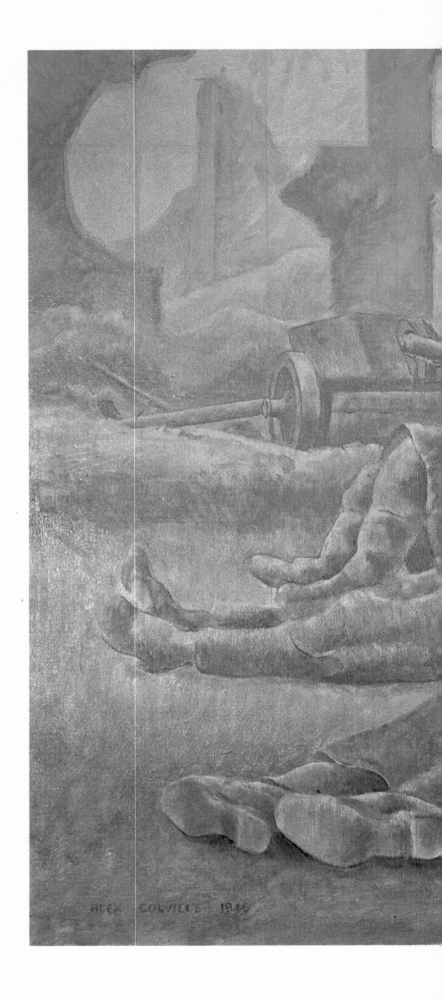

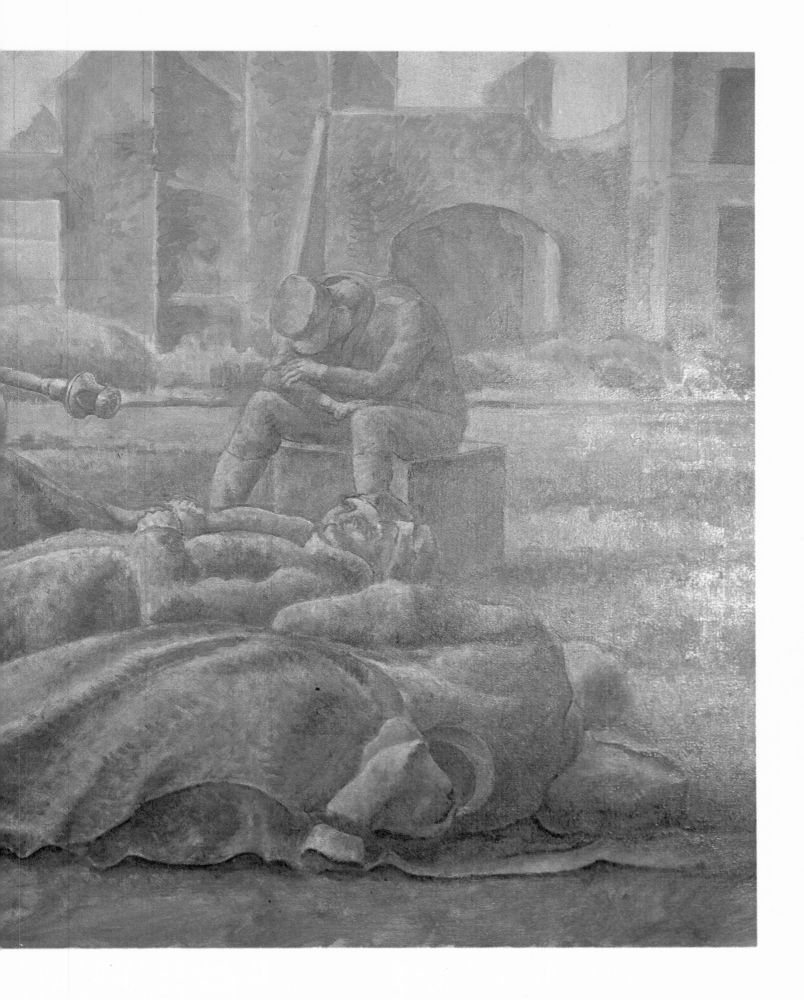

Sketch — Bodies in a Grave Belsen, Germany 1 May 1945, pencil on paper, 12 × 19¹/₂, 12123

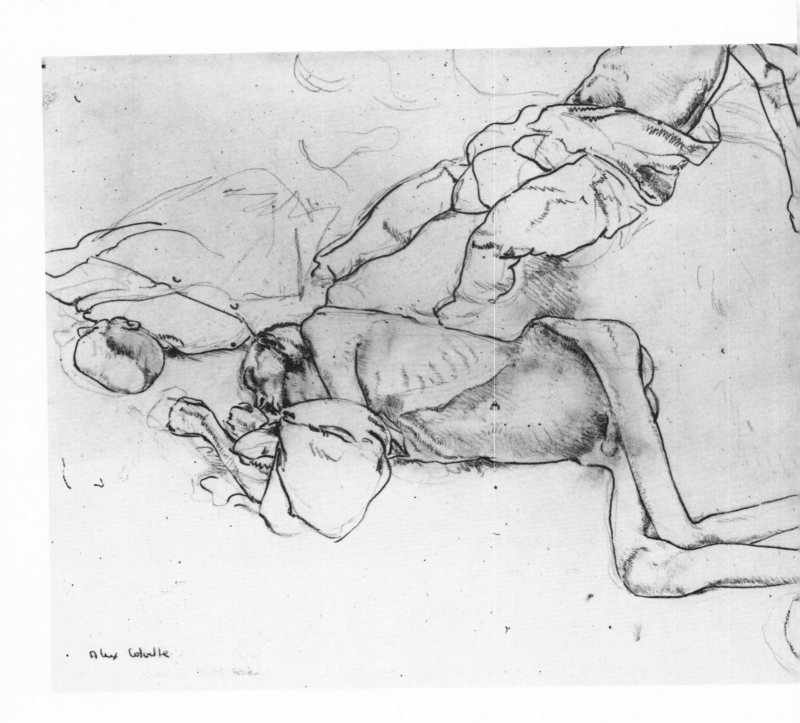

The High Commissioner for Canada asked that a war artist be sent as soon as a concentration camp was liberated, no matter where or by whom. The Major picked me to do this.[3]

BELSEN

We drove to Belsen, we had our own jeep, two little pup tents and a trailer. The jeep was by this time pretty rimracked, the transmission leaking, and the roof torn, but we got there. We arrived in late afternoon and we looked around. There were huge graves full of thousands of bodies, there must have been at least 35,000 bodies in the place.[3]

On 27 April my instructions were to spend several days sketching Belsen, then if possible to visit 1st Canadian Parachute Battalion. I was given a letter of introduction to the Governor of the concentration camp. On 29 April I drove to this camp at Belsen, saw the authorities there, was dusted (as protection against typhus) and set up camp in a nearby barracks. That afternoon I visited No. 1 concentration camp. I will make no attempt to describe the conditions there as they have already been adequately described by others. The subjects were not of a sort which can be executed expressively at the time, on the spot. I felt that I would get the most out of this visit by making sketches, then returning to these sketches at some later time. On the first day I made a drawing of some women, dead from starvation and typhus, lying outside one of the huts. While I drew, the group of bodies was added to as more people died and were feebly dragged out of the hut by the inhabitants, who were themselves more dead than alive. On 30 April it rained all morning. In the afternoon I began a watercolour of one of the huge open graves, with the camp in the background. I finished this the next morning. This afternoon I made a drawing of bodies lying in a grave. These were soon obscured by other bodies which were being thrown from the back of a truck.

Belsen Concentration Camp 30 Apr. 1945, Watercolour Drawing, 15³/₈ × 22¹/₂, 12121

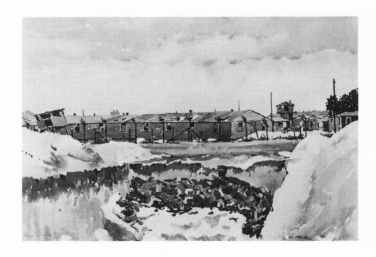

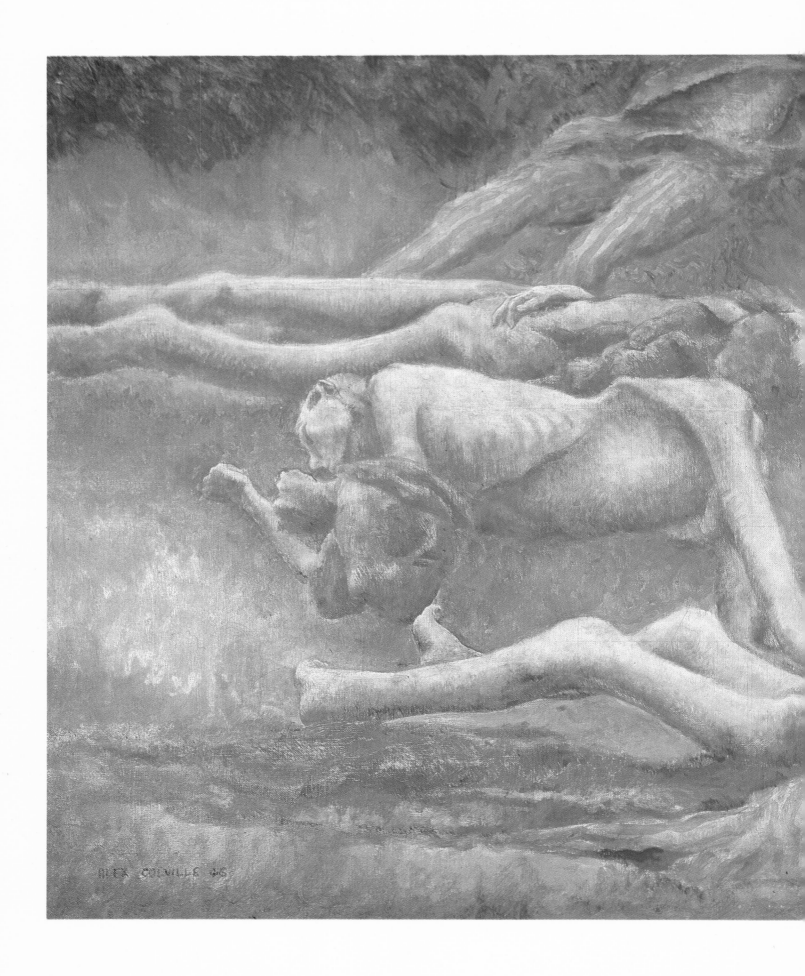

148

Bodies in a Grave 1946, Oils on canvas, 30 × 40, 12122

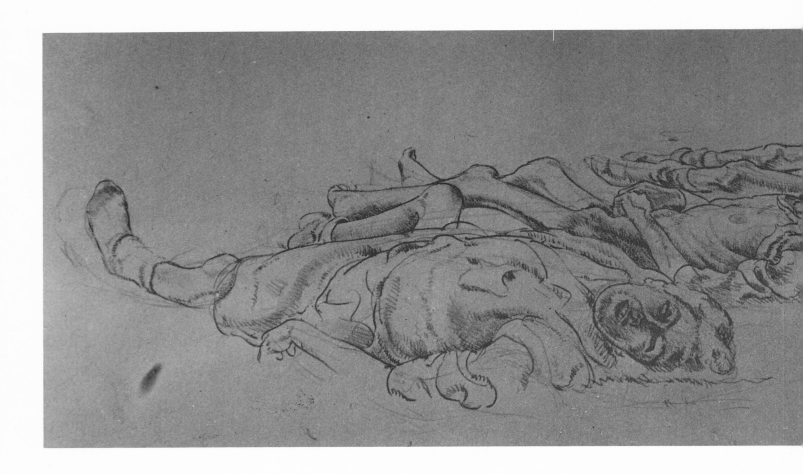

Dead Women — Belsen 29 Apr. 1945, pencil on paper, 12 × 19, 12143

This being in Belsen was strange. As I've said to a number of people, the thing one felt was one felt badly that one didn't feel worse. That is to say, you see one dead person and it is too bad, but seeing five hundred is not five hundred times worse. There is a certain point at which you begin to feel nothing.

I remember that soon after we got there, we put up our two little tents and we made supper. We cooked these canned food things, on our little gas stove. You realize that you are still hungry.

It was a profoundly affecting experience. Obviously it would be, unless a person was an absolute fool. You were bound to think about this quite a bit.[3]

FINAL WORK

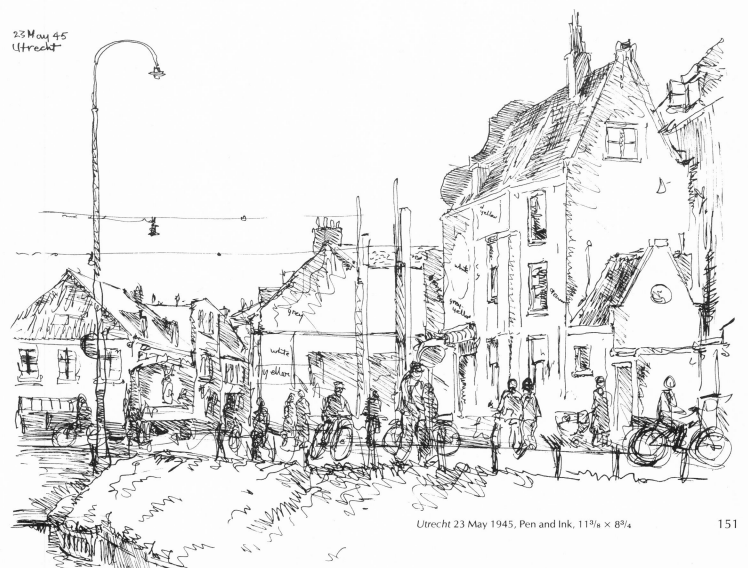

23 May 45
Utrecht

Utrecht 23 May 1945, Pen and Ink, 11³/₈ × 8³/₄ 151

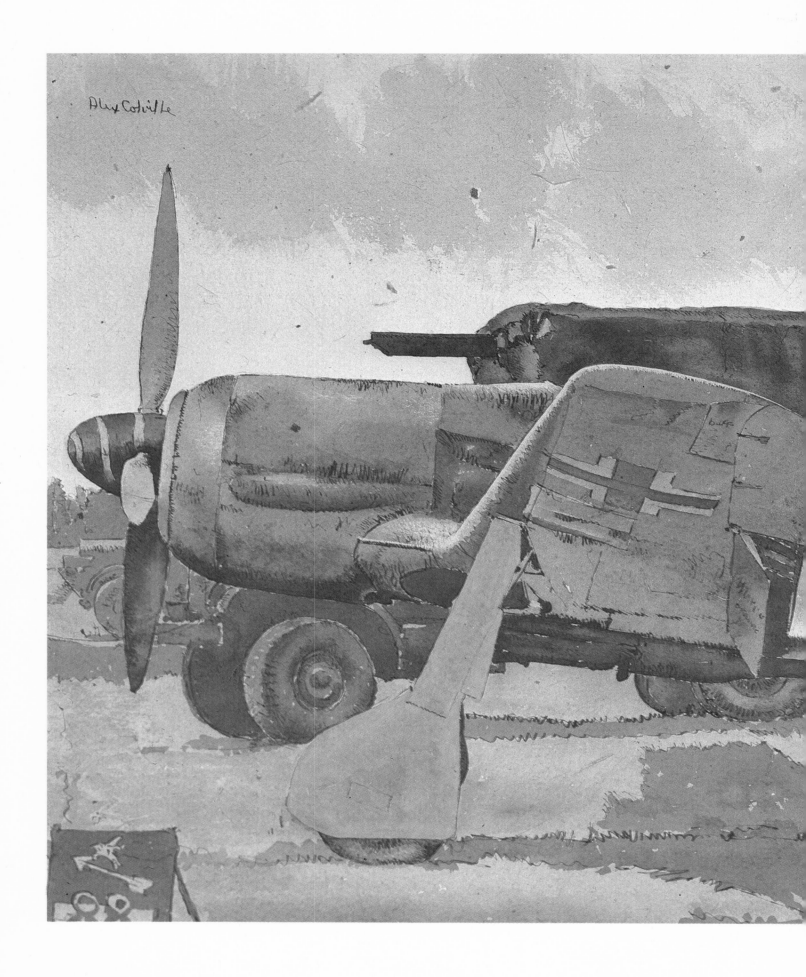

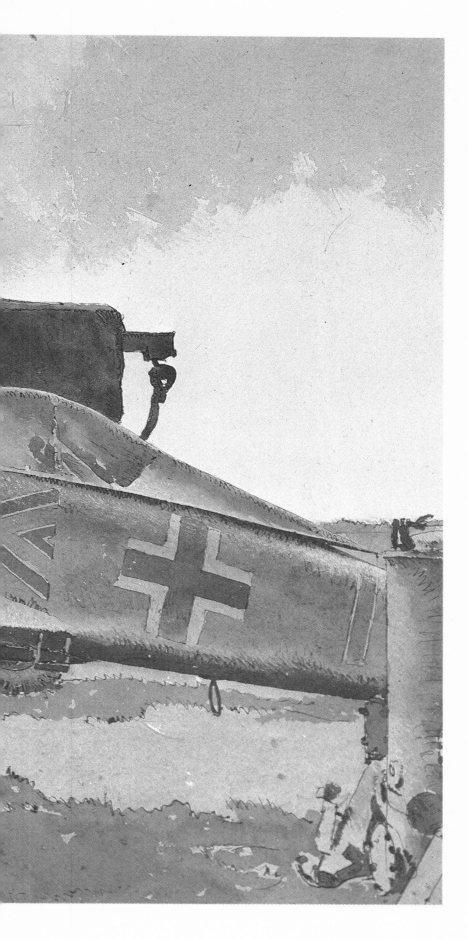

On 3 May I was given the location of the 6th British Airborne Division and drove to Wismar, on the Baltic Sea. On 4 May I started a large drawing at the airport which was being guarded by B Company of 1st Canadian Parachute Battalion. Unfortunately most of the troops were in billets resting, so that subjects directly connected with the Canadian Battalion were few.

Having arrived at Headquarters late on 7 May I spent most of the following day getting settled. My jeep, after travelling to the Baltic Sea and back, was in poor condition, so I tried to arrange to have it overhauled as quickly as possible. On 9 May I left it in a Brigade workshop, where it remained until 14 May. During these five days when I was without transport I completed *At a Captured Airport* (sketched with 1st Canadian Parachute Battalion) and drew *Infantry Resting No. 2*.

That was the end. I did some drawings up there, one of FOCKE-WOLFF *on an airfield. That was the last drawing I did.* [3]

At a Captured Airport 4 May 1945, Watercolour Drawing, $15^{1}/_{2} \times 22^{3}/_{8}$, 12115

Moving into an estate in Friesland, the country estate of a Count who was missing, his wife, a young woman was there. We sometimes had films when things were quiet. The Countess and her children watched a film with us, and when it was over the Countess stood up and gave a very emotional speech, welcoming us, telling us how grateful they were. We were overcome with shyness.[1]

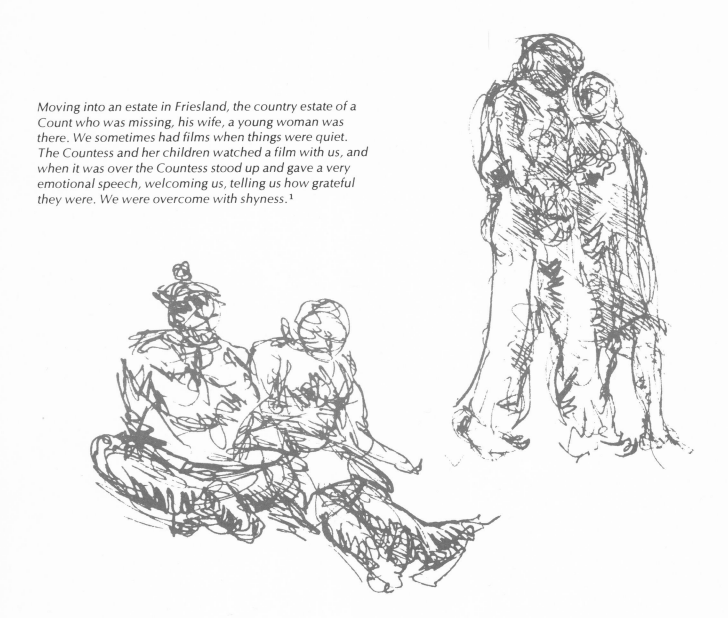

Road Accident 4 June 1945, Ink and Coloured Pencil, 10¹/₈ × 14¹/₈, 12207

Street in Utrecht, Holland pen and ink and wash on paper, 15 × 22, 12213

Ink Sketches of Couples April 1945, Pen and Ink, 11³/₈ × 8³/₄

*When a unit would move into a Dutch town that had just
been liberated the people were out in hordes, fathers
holding little children up in the air, people waving flags; it
was all quite emotional and moving. Sometimes the local
people would jump up on the armoured cars and trucks.
You'd see an armoured car with ten or twelve kids on it.* [1]

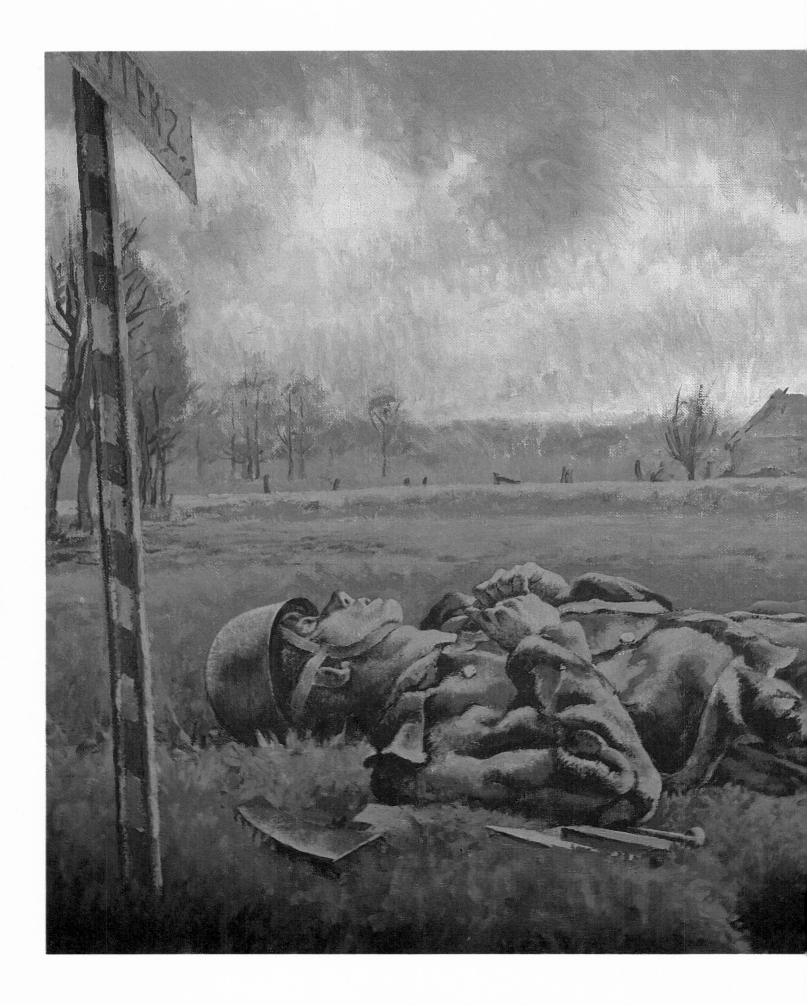

Tragic Landscape 1945, Oils on canvas, 24 × 36, 12219

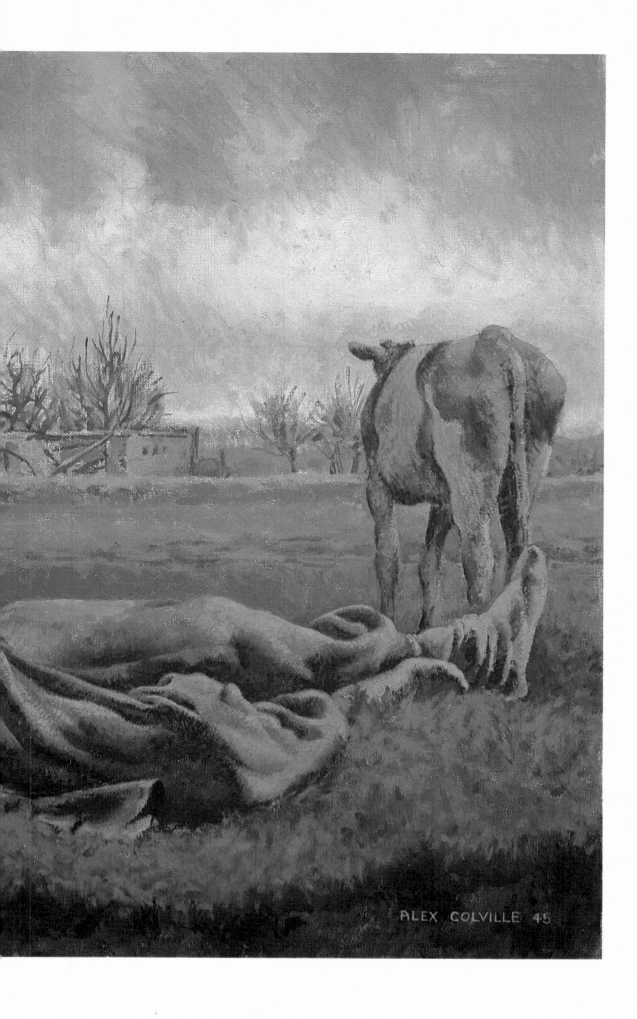

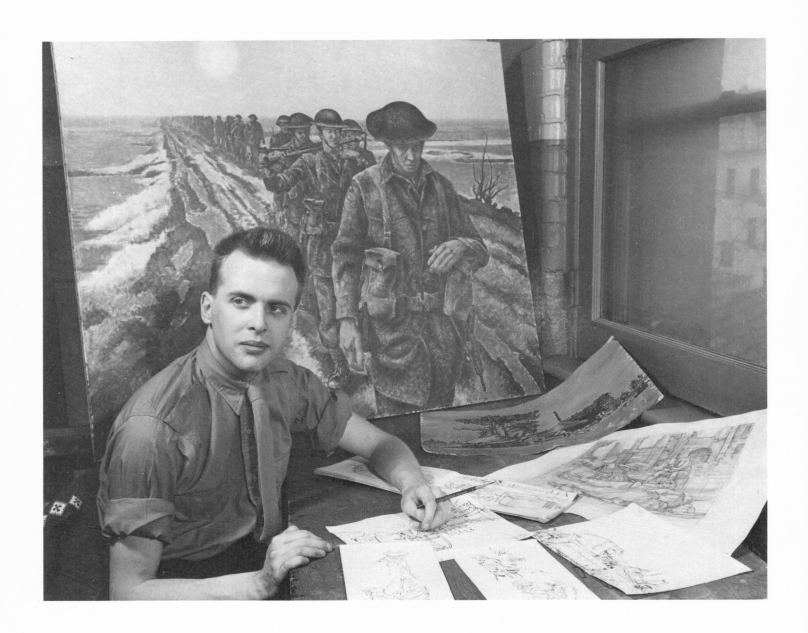

Official news photo with completed *Infantry Near Nijmegen, Holland.*
Captain D.A. Colville at work in Ottawa, 1946.

There was no resentment. Most artists of this century are
said to feel estranged from society; that is, they feel that
they're a kind of outcast, that people don't understand them.
It is said that there is a gap, that there is a barrier between
the artist and society in general. Well, you see through this
experience as a war artist. I never felt much of this gap
business. I didn't feel that I was misunderstood or not
sufficiently appreciated. [3]

I don't think wars will ever end. I can't see that war art
serves any moral function in depicting the horrors of war.
The war had a profound influence on me. There was some
technical influence. The parallel I would make would be
for a novelist to be a police reporter doing factual reporting,
physical, sordid, and concrete rather than philosophical or
abstract. The immediacy had a philosophical effect on me. [1]

The war ended in May, I stayed with the 3rd Division for some months. There was an exhibition of War Art in Amsterdam which I helped to organize along with some other war artists. I got back to England in September and returned to Canada in October of 1945.[1]

I came home on the ISLE DE FRANCE *with 11,000 other people. We sailed into Halifax harbour on a Sunday morning, the 21st of October. It was a very beautiful morning, clear and sunny. I had never thought of myself as a patriot or even as a sentimental person, but I was very moved by this experience.[3]*

Homecoming with Rhoda and 15 month old Graham, October, 1945.

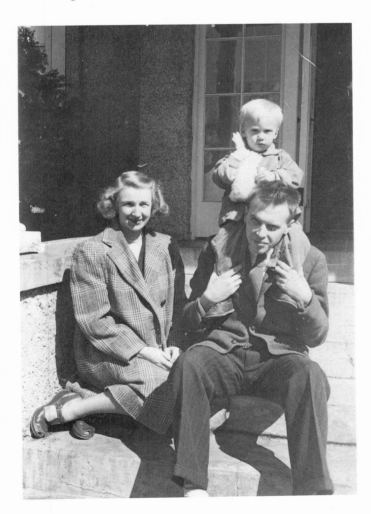